Two Hundred Years of
English Naive Art

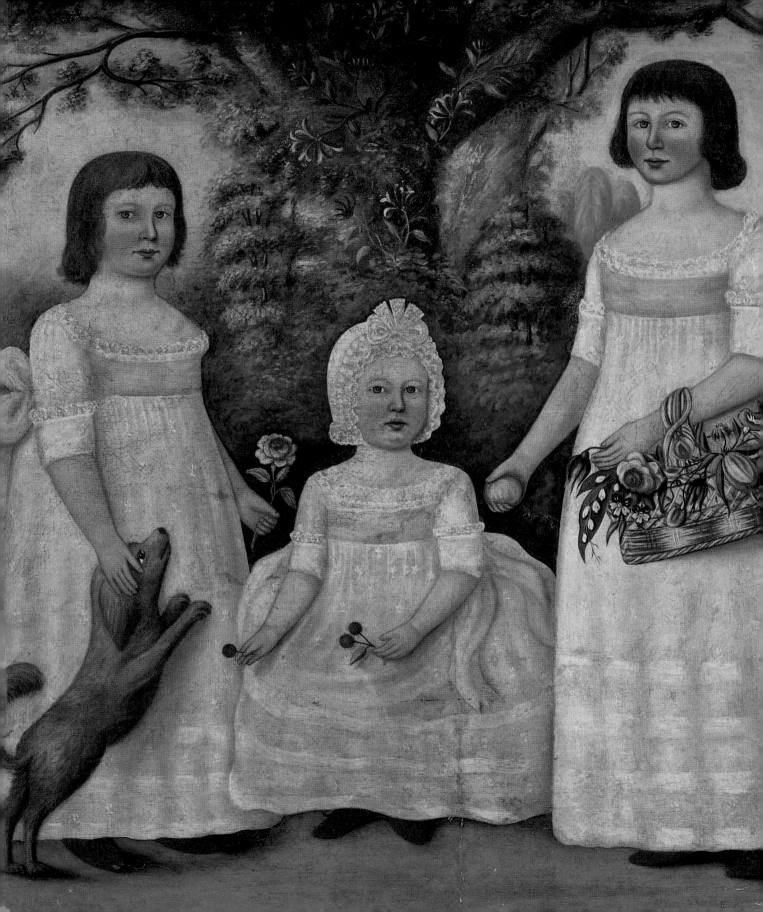

Two Hundred Years of
English Naive Art
1700-1900

JAMES AYRES

ART SERVICES INTERNATIONAL
ALEXANDRIA, VIRGINIA
1996

This volume accompanies an exhibition organized
and circulated by Art Services International,
Alexandria, Virginia.

LIBRARY OF CONGRESS CATALOGING-IN-PUBLICATION DATA
Ayres, James.
 Two hundred years of English naive art 1700-1900 / James Ayres.
 p. cm.
 Includes bibliographical references.
 ISBN 0-88397-120-8 (pbk.)
 1. Outsider art—England—Exhibitions. 2. Art, Modern—
17th-18th centuries—England—Exhibitions. 3. Art, Modern—
19th century—England—Exhibitions. I. Title.
 N6766.A97 1996
 709' .42' 074—dc20 96-18681
 CIP

Editor: Jane Sweeney
Designer: The Watermark Design Office, Alexandria, Virginia
Printer: Balding + Mansell, Peterborough

ISBN 0-88397-120-8
Printed and Bound in England

Cover: Cat. 5, R. Hunt, *Portrait of Alfred Openshaw* (detail),
1847, oil on canvas, The Judkyn/Pratt Collection, Bath

Frontispiece: Cat. 1, Artist unknown, *Portrait of Three Sisters*
(detail), c. 1810, oil on canvas, Private collection.

Photo Credits
Photographs kindly provided by owners of works of art except
as follows: Figs. 9, 20, Trustees of the British Museum; figs. 12,
31, Royal Commission on Historical Monuments; figs. 15, 16,
Derek Parker, Devizes, Wiltshire; fig. 17, National Trust
Photographic Library.

Table of Contents

Participating Museums

Fraunces Tavern Museum
New York

The Society of the Four Arts
Palm Beach

San Diego Museum of Art

Fresno Metropolitan Museum

List of Lenders

Beamish, The North of England Open Air Museum
The Birmingham Museums and Art Gallery
Bristol Museums and Art Gallery
Cheltenham Art Gallery and Museums
The Gall Allan Collection
The Jane and Grierson Gower Collection
Hull Museums, Art Galleries and Archives
Iona Antiques, London
The Judkyn/Pratt Collection, Bath
Kendal Museum
Leicestershire Museums, Arts and Records Service
Malcolm Frazer Antiques, Manchester
Museum of London
National Waterways Museum, Gloucester
Norfolk Museums Service
 Bridewell Museum
 Norfolk Rural Life Museum
 Norwich Castle Museum
 Strangers Hall Museum, Norwich
Northampton Museums, Northamptonshire
Peter Moores Foundation, London
Private Collections
Rochdale Art Gallery
Mr. and Mrs. K. H. Rogers
Salisbury and South Wiltshire Museum
Peter Tillou Collection
Urchfont Manor College (Wiltshire County Council)
Nick Woodbridge

Acknowledgments

The immediate delight of naive art from Britain is its honesty, dignity, simplicity, and humor. The British naive artist of the eighteenth and nineteenth ceturies worked outside the "art for art's sake" philosophy of the academy. This artisan, skilled in the tools, materials, and craftsmanship of his trade, documented everyday subjects related to family, occupation, or community. While producing an object to fulfill a social function or to meet a commercial need, he often created art of unconscious sophistication that retains a timeless, universal freshness and direct appeal. Superb examples remain, in diminishing numbers, as social documents that provide a valuable insight into English daily life of a bygone era. Art Services International is honored to celebrate this singular art form in an effort to expand admiration for the talent and individuality embodied in England's arts of "everyman."

An exhibition of this magnitude and diversity could never take place without the kindnesses and efforts of many individuals and institutions on both sides of the Atlantic. We express heartfelt gratitude first to the lenders who have consented to part with their treasured objects for the duration of the tour and who have provided so much information on the items in their collections. Their generosity will help to ensure for British naive art the recognition and appreciation that have been so long overdue.

The names of the lenders precede these remarks, and we applaud each of them for sharing their works of art with a wider public.

Our curator and enthusiastic partner in the realization of this project has been James Ayres, Director of the John Judkyn Memorial, Bath, and a tireless and enlightened proponent of British naive art. His expertise and dedication continue to elicit our highest respect; his insightful and persuasive prose in these pages is sure to make a willing advocate of every reader; and his good humor has made our collaboration only that much more enjoyable. Special thanks go to Kenneth Rogers, Tony Lewery, Philip French of Leicestershire Museums, John Liffen of the Science Museum, London, Tony Condor of the National Waterways Museum, and Arthur Credland of Hull Museums.

Graciously serving as Honorary Patron of this uniquely British project has been His Excellency Sir John Kerr, British Ambassador to the United States. We are grateful to him for the support and encouragement he provided when first we discussed this groundbreaking project. We are also pleased to recognize the assistance of David Evans, Cultural Counsellor. The consistent level of support we have received from the Embassy for our British projects is for us a constant source of pride.

We are especially eager to acknowledge our

friends and colleagues at the institutions that will be hosts of the tour: Lauren Kaminsky, Director, Fraunces Tavern Museum in New York; Robert W. Safrin, Director, and Nancy Mato, Deputy Director, The Society of the Four Arts, Palm Beach; Steven L. Brezzo, Director, the San Diego Museum of Art; and Kaywin Feldman, Executive Director, the Fresno Metropolitan Museum. We are delighted that the exhibition will be seen over such a broad area of our country. We are most grateful to these institutions, their Directors, and their accomplished staffs.

This catalogue will serve as an ambassador for the expanded recognition of British naive art, and its clear and handsome presentation is the result of the special talents of Jane Sweeney, editor; Lynne and Don Komai of The Watermark Design Office; and Guy Dawson and Michael Wojtowycz of Balding + Mansell Inc., printers.

The staff of Art Services International deserves special recognition for the expertise and dedication they have demonstrated in the creation of such a complicated exhibition. In particular, Ana Maria Lim, Douglas Shawn, Donna Elliott, Betty Kahler, Patty Bruch, Mina Koochekzadeh, and Sally Thomas have once again directed their energies to the successful execution of this project. And finally, we thank Jean Purcell of the John Judkyn Memorial for typing the manuscript.

It is impossible to accurately measure or express our gratitude to these individuals and to the many others who have contributed in making *Two Hundred Years of English Naive Art* a reality. We remain in their debt.

Lynn K. Rogerson
Director

Joseph W. Saunders
Chief Executive Officer

The Vernacular Artist in Context

When the Royal Academy of Arts was founded in London in 1768, a distinction was institutionalized between the visual dialect of the craftsman's art and the more cerebral aspirations of academic painters, sculptors, and architects.[1] Henceforth the *Trade Directories*, issued in regional centers throughout Britain, would list academic if provincial painters as "Artists: Portrait, Landscape, Miniature &c" to distinguish them from those denominated as "Painters: House, Sign &c." Before 1768, and certainly before the middle of the century, it remained possible for house-painters, tradesman-carvers, and builder-architects to ignore this emerging division between their respective trades and professions. In this way a joiner such as John Wood (1704–54), in the guise of architect, was to establish the Palladian idiom of the City of Bath. Similarly, a jobbing silver engraver named William Hogarth (1694–1764) was to become, as a painter and printmaker, one of the great artistic forces of the mid eighteenth century. Hogarth nevertheless retained a respect for the artist's trade notwithstanding his more recondite theories on such subjects as "the line of beauty." In much the same spirit, Wood retained the practicalities of the craftsman despite his more pretentious if parochial opinion that a native pre-Roman culture had anticipated the achievements of the classical Mediterranean.[2] For the generation that followed that of Hogarth and Wood, and especially for Sir Joshua Reynolds (1723–92), the visual arts, though manual in practice, were to be subsumed in a dignified philosophy. Lurking behind Reynolds' *Seven Discourses* (1778) was the intention that painting and sculpture were to become "professions."

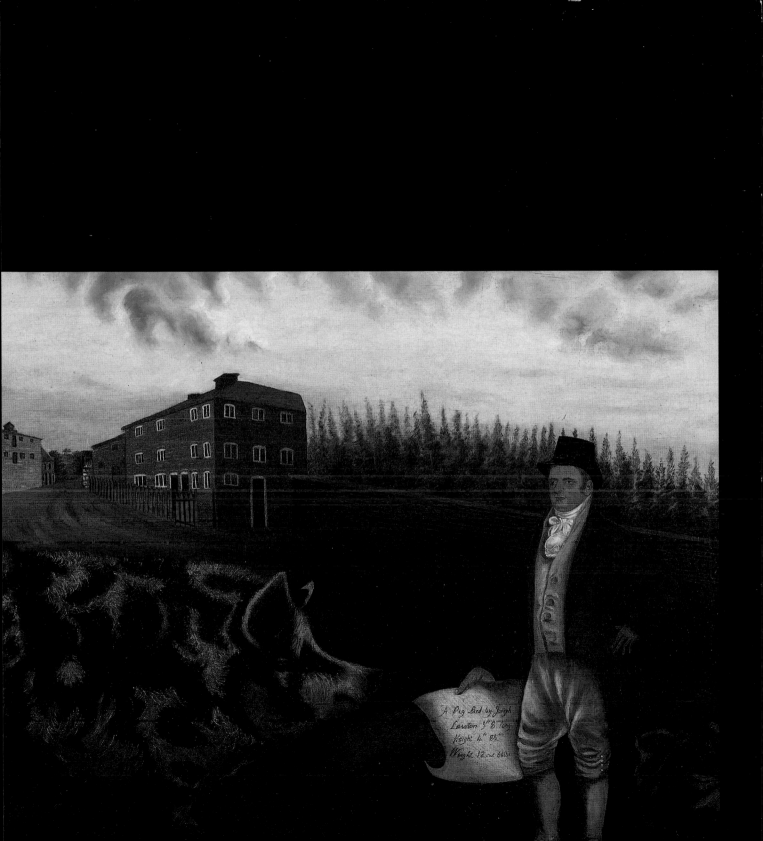

A Pig Bred by Joseph
Lawton 9 ft 8 in long
Height 4 ft 8½ in
Weight 12 cwt 66 lbs

This desire for professional status coincides with, and may even have been inspired by, the archaeological zeal of Neo-classicism. In great contrast, the Renaissance had truly been a rebirth, which fostered a flexibility toward classical precedent that admitted great originality and regional variation. Neo-classicism, however, saw a return to the strict observance of the precepts of antiquity, including the contradictory values of the slave-owning democracies of the ancient world. It was these "democracies" that established the notion of the liberal arts, those intellectual pursuits deemed suitable for freeborn (i.e. liberal) men and the antithesis of the manual activities to which slaves were bound.[3] The social attitudes established by the prejudices of antiquity have proved in the twentieth century to be more persistent than have classically inspired art and architecture. From these centuries-old discriminations stems the contempt for manual labor, a convention that presumes that theoretical thinking must necessarily enjoy higher status than practical doing.

These historical circumstances were evidently the motivating force behind Reynolds' determination to promote the "intellectual dignity . . . that ennobles the Painter's art; that lays the line between him and the mere mechanic."[4] Similar views were later expressed by the painter Prince Hoare (1755–1834), who regretted that "so little have the distinct provinces of Painting" been understood by "the discriminating classes of society [that] a Painter is a term equally expressive of Michaelangelo [and his Sistine Chapel frescoes] as of him who covers the wainscot on the walls of our houses."[5] Hoare, the scion of an aristocratic banking family, was not unaware of the contradictions in his own position. He concluded that while the social mores of his time permitted "Painters to be of a Liberal class [, the age would] not allow men in the liberal classes to be painters."

Primitive art has been defined as "the high art of low cultures."[6] Many of the artists whom one might describe as primitive may well, as the entries in the *Trade Directories* indicate, have accepted such a definition. In their self-appointed subsidiary role, they served a wide public at a localized level. In the classical sense these tradesmen artists are aptly termed vernacular, a word that derives from the Latin *verna*, a home-born slave. Thus most vernacular artists who conformed to this "home-born" or localized definition were usually centered on a town in a particular district and were not born to the "liberal classes,"[7] although in some circumstances they could achieve this status. There were, though, two important exceptions to this localized interpretation of the vernacular. These were the itinerant societies, Gypsies and narrow-boat people, whose traditions were national rather than regional; similarly the mariners were far removed from the parochial concerns of most vernacular traditions, for they drew upon international influences.

The house-painters of preindustrial England were highly trained in "the arts of picture craft,"[8] and the best exponents of the trade became proficient artists in the vernacular, the "artisan painters" as Peter Lord has termed them.[9] For them, sign painting formed an important part of their stock-in-trade (fig. 1). So important was this branch of their business that a contributor to *The Library of Fine Arts* (1831)[10] asserted that for

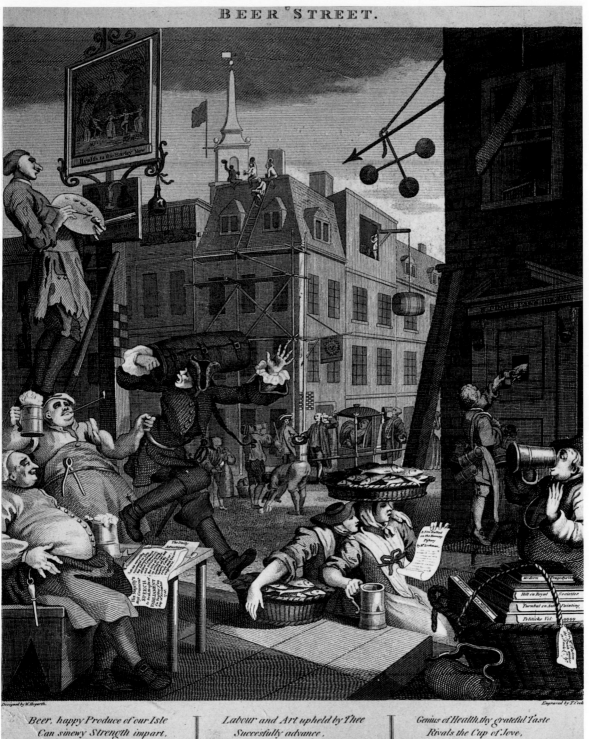

Fig. 1. William Hogarth,
Beer Street, *1751,*
showing a sign painter at
work.

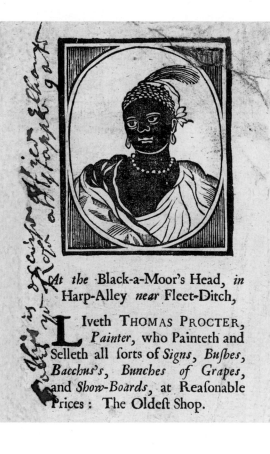

At the ·Black-a-Moor's Head, *in*
Harp-Alley *near* Fleet-Ditch,

Liveth THOMAS PROCTER,
Painter, who Painteth and
Selleth all sorts of *Signs, Bushes,
Bacchus's, Bunches of Grapes,*
and *Show-Boards*, at Reasonable
Prices : The Oldest Shop.

painters in early eighteenth-century London, "the
only encouragement or rather the only means of
employment, to be procured was in sign-painting,
and the place of show and sale was found in Harp
Alley [see fig. 2], Shoe Lane, where, from end to
end of that place, the works of the candidates for
public favor and employ were to be found,—
a sort of Noah's Ark, in which animals of every. . .
kind . . . might be seen."

This account concluded that, while sign
painting "may appear contemptible in the eye of
modern practice[, it] was the stable traffic for the
sale of art and . . . in those days [great sums of
money were] expended on the painted sign,
which with its massive carved frame and
ornamented iron work, cost in many instances a
hundred to a hundred and fifty pounds. It may
also be observed that the style of painting
required for this sort of art, a firm pencil [paint
brush] and a decided touch, together with an
effect which might tell at a distance—no bad
foundation for skilful execution in art."

A passage such as this expresses considerable
prejudice toward "scrubbers and smudgers," as
painters and glaziers were known,[11] but it also
reveals a grudging respect and a recognition of an
art form that obeyed its own conventions,
involved many skills (painting, woodcarving, and
smithing), and evolved procedures for training,
production, promotion, and distribution that were
unknown in Britain until the Royal Academy of
Arts was established with its schools and
exhibitions. In 1762, the work of these sign
painters was celebrated, at William Hogarth's
instigation, in an exhibition by a fictitious Society
of Sign Painters in Bonnell Thornton's rooms in
Bow Street, London (fig. 3). With the benefit of

hindsight, one may regard this venture as possibly the first exhibition of folk art ever to be presented.[12] For Hogarth the signs of London were "specimens of genius emanating from a school which he used emphatically to observe was truly English."[13] In offering such a provocative opinion and in presenting his exhibition of signboard art, Hogarth operated behind a mask of humor. For those who lacked the wit to see with his unblinking eye, a warning phrase was prominently displayed in the exhibition. This was taken from the *Ars Poetica* of Horace: "Spectatum Admissi Risum Teneatis" (you who are let in to look restrain your laughter). It was not perhaps the last art exhibition to require such an admonition.

Folk art, although a well-used term, is so wide in its potential scope as to have defied attempts at a definition.[14] This is probably because it is not one subject but several, ranging from the sophisticated works of the artisan to the unsophisticated crafts of the patrician. Folk art, as with all such labels in the arts, is a relative rather than an absolute term. Furthermore there is a tendency to view a given work of art retrospectively rather than attempting to reconstruct a prospective understanding of the circumstances in which it was created. The prospective approach gives value to the makers of such objects and the methods they used. It is also a means by which consideration may be given to those who commissioned these artists and why. It is a methodology that enables the research to speak for itself, acknowledging the skill of the amateur and giving voice to a series of artisan artists who were self-defined in the *Trade Directories* as operating outside the limitations of academic art,

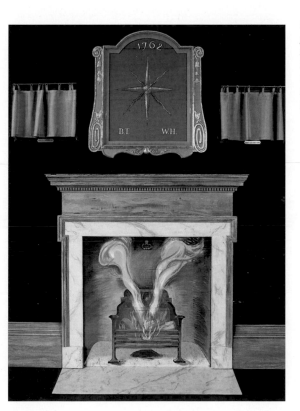

Fig. 3. Reconstruction of part of the exhibition of signboard art organized in London in 1762 by Bonnell Thornton and William Hogarth. Reconstruction by J. Ayres.

limitations of which Hogarth was profoundly aware: "I grew so profane as to admire Nature beyond Pictures and I confess sometimes objected to the divinity of Raphael . . . and Michael Angelo."[15]

In questioning the gospel of art history and the divinity of Renaissance art, Hogarth recognized that such blasphemy might result in persecution, a pardonable exaggeration if a humorous recognition of the courage demanded of originality.

This exhibition examines a visual dialect based on the traditions of those who were trained in a relevant craft rather than educated in the aesthetics of a particular art. These tradesmen with whom this discussion is concerned were not simple hobbyists. They were in the business of their chosen media, and if that medium was paint, the production of pictures was but an extension of their skill. As craftsmen their products were structurally sound and built to last. Their vision was often based upon the known facts rather than the observed truth. A bird's-eye view of a country house in its setting could become a flight of fancy, an isometric projection of what was known rather than seen. Such pictures were not diminished by theoretical perspective or circumscribed by one vantage point. In summary, these works are naive only in the sense that they are innocent of the distorting lens of classicism. Furthermore, in the case of an instinctive artist (is there any other?) working within the vernacular traditions and therefore emancipated from the tyrannies of academic convention, the possibility existed for the creation of works of startling originality. In some instances these artists achieved works that possess formal qualities of great subtlety in which abstract form triumphs over representational content. Despite which, it was the subject that was central for these artists and their clients, which is perhaps how a living creature (a child, a pig, a sailing ship) could so effectively be transmuted into a "thing"—an emblem. This was a metamorphosis from subject to object that resulted in a satisfying unity. A portrait painting remains a painted portrait.

These were values that were first recognized outside their original milieu by early twentieth-century exponents of the modern movement. Even for those academic painters of the past who are known to have painted signs, it was an activity that seems to have remained for them a thing apart, an essay in an alien language. In the nineteenth century, James McNeill Whistler (1834–1903), the London-based American artist, recognized the innate ability of the Thames boatman Walter Greaves (1846–1930) as a painter of pictures. Nevertheless the fastidious American was unable to leave Greaves in his "primitive" condition.[16] Ultimately the Thames boatman and his younger brother Henry were persuaded to eat of the tree of knowledge, a half-knowledge that reduced their qualities as artists to the level of worthy amateurs. Not until the twentieth century did a truly ethnographical respect develop for artists of this instinctive kind who, as a result, remained in their native Eden of innocence. In England in 1928, the avant-garde artists Ben Nicholson and Kit Wood "discovered" the Cornish fisherman painter Alfred Wallis (1855–1942).[17] As with so many vernacular artists, Wallis believed in representing the known facts, facts that could

often best be conveyed by combining a plan and elevation in one painting (as in the plan of a harbor with the boats moored in it shown on elevation). In this way Wallis was unknowingly developing Hogarth's prescription of "retaining in my mind linearly such objects as fitted my purpose best."[18] Wallis summarized his objectives in a highly intelligent and illiterate phrase: "what i do mosley is what use to Bee out of my own memery what we may never see again."[19] With admirable sensitivity, neither Nicholson nor Wood attempted to "improve" Wallis; on the contrary, it was the Cornishman who was to influence these prophets of English modernism—a pivotal point in the history of taste in England. In passing it might be noted that both the Greaves brothers and Wallis were artisan artists in that, as boatmen, paint and the painting of ships' hulls were central to their calling.

In England, the appreciation of the vernacular arts has been extraordinarily uneven. While language, architecture, and music at this level have been enjoyed and studied for many years,[20] the pictorial and sculptural arts have been all but ignored. Part of the reason for this may simply be that less artisan painting and sculpture was created in England than in much of Europe and North America. The cause for such a situation owes much to the way in which the English gentry of the eighteenth century organized their calendar. It was customary for such families to spend part of the social season in an urban setting such as London, York, or Bath. Most of the year was, however, spent at the family's country seat. This kept the English regions and the constituent parts of the United Kingdom in touch with metropolitan standards and fashions. Consequently, provincial art in Britain was generally too knowing to qualify as artisan art. The painter John Opie (1761–1807) exemplifies the point. At an early age he emerged from the distant South West and appeared in London in 1781 as "the Cornish wonder," a fully fledged artist capable of producing portraits that were perfectly acceptable to a fashionable clientele. Only his manners needed polishing.

For the eighteenth-century patrician, the Grand Tour buttressed classicism in England, where its most satisfactory expression manifested itself in the country house. In the following century, an interest in the ethnology of distant peoples became a by-product of colonialism. The English, it would seem, colonized almost everyone but themselves. Accordingly, galleries and museums in Britain are rich in the arts of the Mediterranean and ethnological objects drawn from outposts of empire. Nearer to home, the Irish, Scottish, and Welsh were to use their respective folk traditions as a means of asserting national identity[21]; the English meanwhile were under no such compulsion.[22] Consequently, folk art is, as Andras Kalman has observed, "the endangered species of the English art world."[23] As "an art without pedigree," it is the antithesis of the "polite arts,"[24] while the anonymity of much of this material may also deprive it of nationality. In contrast, works by Reynolds or Gainsborough, Constable or Turner remain British no matter where they may be located. No such passport is available for the generality of English vernacular art. Once beyond their native shores, such works may too easily be appropriated by other cultures for commercial gain. It is a migration that has reduced the critical mass of identifiable works of this kind, and no major permanent public

collections have been formed to redress the balance. The effect (or is it the cause?) of this situation has produced circumstances in which the appreciation of this cultural thread within the British tradition has been, at best, intermittent.

In the years immediately following World War II, there developed a wide and wistful affection for the values that epitomized an England that predated the horrors of industrialized warfare. As early as 1945, Noel Carrington published *Popular English Art*, and the following year Margaret Lambert and Enid Marx brought out *English Popular and Traditional Art*. This groundswell of feeling probably reached its most tangible form in 1951 when the Festival of Britain on London's South Bank included the Lion and Unicorn Pavilion, which celebrated English popular culture. Popular art as interpreted by Lambert and Marx was wide in scope, and today popular culture has come to mean the mass culture first made possible by the printing press. Thus in late nineteenth-century England the most popular picture in the annual exhibition at the Royal Academy, that citadel of received taste, could, by means of steel engravings, become a part of "popular culture."[25]

In general it must be said that, despite Hogarth's venture of 1762 and the somewhat similar Drol-o-phusikan, a "whimsical and original exhibition of sign painting"[26] of a decade later, exhibitions of English vernacular art have been few in number and slow to develop. In the late 1950s, Margaret Lambert and Enid Marx organized *English Popular Art*, an exhibition at the then-newly opened Museum of English Rural Life at Reading. More recently, I have curated two comparative shows of American and British folk art (U.S. Embassy, London, 1976, and the Cornerhouse Arts Centre, Manchester, 1985/1986), and *The Dallas Pratt Collection of English Naive Art* at the Peter Moores Foundation, Bath, 1994–95. Other shows that appeared in the early 1990s included *A Common Tradition: Popular Art of Britain and America,* organized by Andy Durr and Helen Martin (University of Brighton, 1991), *North Country Folk Art* curated by Peter Brears and toured within the region of its title, and in 1995 *Roses and Castles* (on canal boat painting) assembled by the specialist in that field, Tony Lewery, at the National Waterways Museum, Gloucester. The growth in the frequency of these exhibitions in the 1990s points to a late but developing interest in artisan or vernacular art in England.

The first two major collections of British folk art as such were formed by leading art dealers. John Judkyn, English by birth and American by choice, was a convinced folk art enthusiast, bringing a transatlantic eye to the collection he formed in the late 1950s. The second was formed by Andras Kalman, a Hungarian by birth who, in the 1960s, recognized the qualities to be found in the vernacular arts of his adopted country. Both collections are represented in this exhibition.[27] Similarly, Christopher Bibby held regular exhibitions at his Rutland Gallery in London from the 1960s to 1994, while Iona Antiques, who specialize in that peculiarly English genre of farm animal portraits, have included many works by artisan artists in numerous appearances at antiques fairs in the United States and Britain.

It seems that the appreciation of vernacular art follows a somewhat predictable sequence. The connoisseurship begun by practicing artists is

taken up by dealers who establish the financial worth of the oeuvre, which is then made "respectable" by art historians (although social historians may well have participated by including it as part of "material culture"). The early appreciation by practicing artists of the artisan arts of the past was common to many countries including Sweden (for example Carl Larsson in the 1880s), France (Picasso, 1907), and the United States (Robert Laurent, c. 1916). It is this aesthetic response that may account for the relative lack of a theoretical basis for the study of folk art. Does it have a historical reality, or is it simply a taste of the present imposed on the past by an unholy alliance between sentimental artists and cynical dealers?[28] In England, any such retrospective aesthetic arrived late so that folk art, insofar as it may be found in public collections, is very much locked into its sociological context rather than its art historical place. This approach is found in J. W. Y. Higgs' *Folk Life: Collection and Classification* (1963).[29] The logic of this position is in many ways justified by the practical intent behind the creation of much of this work: its function is inescapable, a feature reflected in this catalogue. Despite which, the artists concerned could at times triumph over their craft and over the pedestrian needs of their clients to create pictorial and sculptural objects of lasting aesthetic value.

The tradesmen who turned their hands to painting pictures were drawn from a bewilderingly wide variety of crafts. Furthermore, by no means all pictures were made of paint (figs. 4, 5, and 6), while only some painters of pictures were painters by trade. Nevertheless there remained in Hanoverian England some residual sense that

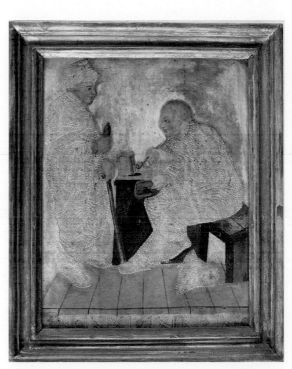

Fig. 4. Pin-prick picture, paper with watercolor, coll. J. Ayres. Paint was but one material among the many that were used for making pictures.

craftsmen should not poach on the preserves of another trade. There were inevitably, in the language of modern trade unionism, some "demarcation disputes." For example, plasterers were, by tradition, permitted to apply distemper to their work.[30] In these circumstances, it was inevitable that some plasterers strayed into using paints based on media other than size and water, working on surfaces other than plaster. Similarly in many regions, and particularly in smaller communities, it was common for the trades of plumber, glazier, and painter to be combined in one firm and sometimes in one individual (fig. 7 and cat. 30). This rather strange repertoire of skills may only be explained in craft terms,

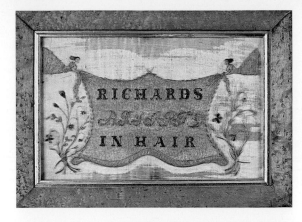

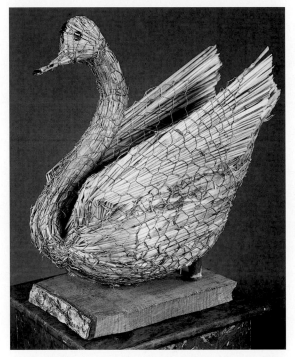

through the materials deployed in these three trades. In this respect plumbing and lead-based paints were clearly related. Furthermore, the "cames" used in leaded windows were ultimately displaced by timber glazing bars in which the glass was held in place by "sprigs" and putty, the latter being painted to preserve its flexibility. Thus the plumber who made leaded windows became, by natural progression, the painter and glazier of sash windows.[31] These activities were creative only in a strictly utilitarian sense, but in the circumstances of this "backward linkage" it was perhaps inevitable that many of these master craftsmen, as masters of their own destiny, should become fully creative "artists in their trades."[32]

This was particularly true in the years before their independence was circumscribed by the emergence of general building contractors.[33] Much the same sequence of events, of cause and effect, may be seen in other aspects of the building trades, for it was the crafts of the construction industry that were dominant: "the mother-craft of building" as Walter Crane termed it in 1910.[34]

Distemper and oil paint were the principal media used by house-painters and related tradesmen. Indeed in the early eighteenth century they ground and prepared pigments, combining them with various sizes and water to make distemper or, alternatively, with oil and "dryers" to make paint. By the 1730s, horse mills were in use among paint manufactures in London, an innovation that seems to have had a deleterious effect on the house-painters' trade.[35] One family of paint manufacturers in the capital, the Emertons, went so far as to issue printed directions for the use of their products so that laborers or household servants could apply the paint and thus deprive those who were painters by trade of part of their livelihood.[36] There is some evidence to suggest that tradesmen painters responded by diversifying. Thomas Bardwell advertised his numerous services as a painter in the Norwich Gazette (June 10, 1738), and these included "History, Landskips, Signs, Shew-Boards, Window Blinds, Flower-Pots for Chimneys and House Painting."[37] The reference to the painting of "Flower-Pots for Chimneys" probably refers to chimney boards. Commissions to paint these boards were to decline rapidly with the burgeoning use of narrow-throated chimneys associated with coal-burning grates.

Bardwell was by no means exceptional in the

diversity of his undertakings. The ledgers of one such craftsman have survived. They show the accounts of Michael Edkins of Bristol from 1764 to 1789.[38] At this time Bristol was the second city in the kingdom, at the center of international trade with a highly developed cultural milieu. Despite this it is evident that Edkins' work was remarkably diverse in its nature, a feature more often associated with small communities in which there is insufficient patronage to provide employment for highly specialized services. Among the activities listed by Edkins in his ledger are the painting of furniture, shop fronts, shop signs, and carriages, the decoration of tinware, the painting of political banners and of scenery and props for the Theatre Royal, Bristol, a theater that remains in use to this day. For the *Merchant of Venice,* Edkins' work included "Gilding and Silvering, Painting Lead Colour the Caskets" (July 11, 1768). He even ornamented steel gun barrels for "blueing," presumably with a resist. His carriage painting was sometimes carried out in startlingly stimulating colors. Long before Chevreul developed his "laws of simultaneous contrast" (1839),[39] this Bristol artisan painted "4 Post Chaises Patent Yellow Stripeing them Green and Red Gilded," for which he charged £8.18s.0d each on July 23, 1784. In the 1760s Edkins painted numerous signs, but a couple of decades later it is noticeable that this type of work became largely confined to inns, some of which also required his services for painting their hire vehicles and for maintaining the paint work on mail coaches. Other work included lettering: "Druggists bottles with labels" (1768). In 1775 Edkins was "Writing 1542 Black Letters on Lord Bottetourt's Monuments @ 3s/6d Hund." This was

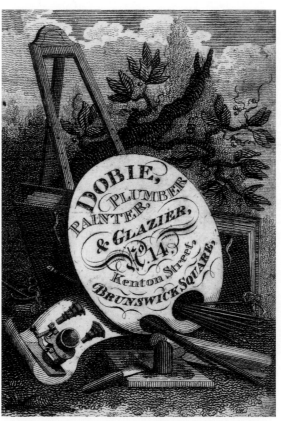

Fig. 7. Dobie, Plumber, Painter, and Glazier, *trade label, early 19th century, British Museum. These trades were often combined in one individual, some of whom also produced easel paintings, as the easel shown in this label indicates.*

evidently not for the 1773 statue of the colonial governor that stands in Williamsburg, Virginia. The colonial marble figure was by Richard Hayward of London (1728–1800), whereas Edkins was working for a "Mr. Pattey," presumably Thomas Paty (1713–89), the Bristol ornament carver and architect.[40] Other centers, in addition to London, Norwich, and Bristol, provided similarly wide employment for these craftsmen artists. For example, a mid-eighteenth-century York painter advertised not only his

services but also his retail goods as follows: "Thomas Chapman: Painter at Cambden's Head in Spurriergate; York. Paints Houses, Coaches, Signs, Heraldry, Landscapes, Atchievements, Escutcheons, Banners &c. &c. Also Japans, Bronzes & Gilds in the Genteelest manner, & at the most Reasonable Rates. N.B. Of whom may be had all Sorts of Colours, Paints & Oils, Water Colours in Shell, Starches, Blues, &c., and other Implements for Drawing."[41]

Shells, especially mussel shells, were the traditional vessels used to contain pigments before the advent of "convenience paints," a custom perpetuated in such terms as shell gold (powdered gold) and shell-lac (shellac).[42] The reference to "Water Colours in Shell" antedates the development of watercolor cakes by the Reeves brothers, who went public with their innovation in 1780.[43] Before then, the use of polychrome watercolor on paper or vellum required a level of technical training sufficient to render it a specialized activity largely confined to limners (a word derived from the illuminated manuscripts of medieval Europe). Although the term has been somewhat abused since the late eighteenth century (as by Oliver Goldsmith in *The Vicar of Wakefield* of 1766), William Salmon (1672) had categorically defined limning as "an Art whereby in water Colours we strive to resemble Nature in everything to the Life."[44] The true limner used opaque watercolor, and the use of transparent washes was first applied to the tinting of maps so that the underlying printed information was not masked. So new was the use of transparent watercolor that Prince Hoare ascribed its introduction for the painting of pictures to Paul Sandby (1725/26–1809).[45]

In the years before the wide availability of the Reeves' watercolor cakes in 1780, architects and many professional topographical artists were confined within the possibilities of monochromatic washes of bister or Chinese ink for tonal effect. Much the same was true for amateurs, but for those who wished to introduce color a means other than paint was often sought. For example, in the second quarter of the eighteenth century, Mrs. Delany worked in colored papers to produce vivid collage flower pictures.[46] Polychrome watercolor painting having for long remained the exclusive preserve of the limners, it was perhaps inevitable that they should have maintained the age-old traditions of working in opaque color on paper or vellum, sometimes even introducing gilded details. Limners such as Thomas Robins, Sr. (1716–70) persisted in the ancient traditions of their craft and produced representations of landscaped gardens for all the world like an eighteenth-century version of the Duc de Berry's *Book of Hours* (c. 1407–09).[47] While these techniques rapidly fell into disfavor among "polite artists" and their clients, they persisted at the popular level into the early Victorian age of "penny plain and tuppence coloured" prints, in which the gilded details were applied in embossed metal foil.

In the late eighteenth and early nineteenth centuries, painted window blinds, known as transparencies, became a popular means of protecting carpets and furniture from fading in sunlight. Nathaniel Whittock gives instructions and illustrates patterns for making these in his *Painters' and Glaziers' Guide* (London, 1827). Translucent pigments suspended in a medium of isinglass and water were applied to "Scotch cambric" for this purpose and represent a return to the working methods of the stainers of the

seventeenth century. As a technique it was unlike that of the painters whose vehicle was water and whose use of size-based distemper involved opaque color comparable to the small-scale work of the traditional limners. In all these forms of watercolor, size of various types provided the binding agent and water was the vehicle.

Sculpture, like painting in the vernacular idiom, maintained historic methods where, at the artisan level, conservative attitudes preserved traditions that went back, through a continuous sequence of many generations, to before the Reformation. Nowhere was this more explicit than in woodcarving and the continuing use of polychrome decoration and gilding. These traditions were learned through apprenticeship rather than taught in schools of art. Further keys to the survival and continuity of this tradition may be found in the nature of the patronage and the adaptability of craftsmen. For example, as the use of timber in building declined in the course of the seventeenth century to be replaced by brick and stone, so the demand for architectural woodcarving dwindled. It was, though, at about this same time that the use of carved decoration on ships burgeoned, so that the shipyards became the natural haven for this tradition. And so they remained until the transition from sail to steam, from wooden hulls to "ironsides." Mercifully, the age of steam gradually brought about the decline of one habitat for the craft as it created another, and this shipyard tradition reemerged on steam-driven fairground rides for the amusement of landlubbers. So dramatic were these transitions and innovations that they could have destroyed a less vital craft, a less accomplished art.

While artisan letter cutters and carvers were kept fully engaged carving, in the words of the poet, "uncouth rhymes and shapeless sculpture,"[48] architectural sculpture in the vernacular was, in post-Baroque England, thought to "incumber rather than adorn" the facades on which it appeared.[49] For the current generation and presumably for those who commissioned them, these works have an irresistible, if provincial, vigor (fig. 8).

In the preceding paragraphs, terms such as craftsman and tradesman have appeared with some regularity. This is a historical assessment rather than a sociopolitical position. At this juncture very few female artisan artists seem to have emerged from the historical record in England, perhaps because their contribution was so often cloaked in anonymity.[50] One reasonably consistent exception to this was the painting of portraits in watercolor in the first decades of the nineteenth century. This is amusingly characterized in the person of Miss La Creevy in Charles Dickens' 1839 novel *Nicholas Nickleby*. The portrait *James Ayres 18th Hussars* by Isabella Avis (cat. 8) is a remarkably good example of the genre, having a fine sense of flourish that is often lacking in these generally rather static watercolors.

The artisan artists of the past may have been a clearly identifiable (indeed self-identified) group, but they were far from homogeneous. Even more to the point, they were not necessarily locked permanently within their caste, for a number are known to have joined the ranks of academic respectability. Among these was Charles Catton, R.A. (1728–98), "in early life a coach and sign painter."[51] Others with a similar background included John Baker, R.A. (1731–71), Richard Dalton (1715–91), William Kent (1684–1758), Ralph Kirby, Peter Monamy (c. 1670–1749), and

Robert Smirke, R.A. (1752–1845). In great contrast to the work of the artisans were those confections made by members of the leisured classes. These were often contrived by women to the extent that such activities are now generally known as "ladies' amusements."[52] Works of this kind were by amateurs, in both the exact and the inexact meaning of the word. In particular, the gentry were fond of making "pictures without paint," the very items that the Royal Academy was, in 1769, determined to exclude from its annual exhibitions: "No needlework, artificial flowers, cut paper, shell work, or any such baubles should be admitted."[53] In this context it should not be presumed that textiles were the exclusive preserve of leisured women, for, at the vernacular level, tailors and sailors made significant contributions. John Munro of Paisley or David Robertson of Falkirk were, as tailors, technically capable of producing impressively pictorial mosaic coverlets.[54] Perhaps the finest such work ever achieved by a tailor/artist was the commemorative coverlet made by James Williams of Wrexham between 1842 and 1852. In this truly great work of art, Williams (like Munro and Robertson) used the off-cuts from the military uniforms in which he (and they) specialized to create what we may now see as an unconscious precursor of Cubism.

In the endeavors of these highly trained artisan artists may be found a system of values that formed part of a dialect of art distinct from the received pronunciation of academic standards and polite taste. These standards and this taste were little more than conventions, institutionalized by academies of art and formulated on the basis of classical precepts. The earlier traditions of medieval Europe were the product of an integrated society in which art of differing qualities remained part of a common school that addressed all classes.

In great contrast, patronage was confined to a tightly knit elite. In England the great redistribution of wealth resulting from the Reformation brought in its train the division of cultural traditions. Even so, as Peter Borsay has pointed out, by the early seventeenth century "a significant number of the traditional gentry continued to patronize popular recreations . . . [while] puritan elements . . . felt little sympathy with either of the two major cultures."[55] This duality and neutrality of "the upper classes and the 'little tradition'" has also been examined by Peter Burke.[56] A good example of this phenomenon would be a goldsmith's sign. Clearly such an emblem would serve to beckon a monied elite but, as the work of a carver and gilder, it was dependent upon the artisan culture that generated such signs. On the other hand, the ironwork from which it was hung was in a category all of its own, since blacksmiths seem to have worked in a consistent idiom for most levels of society.[57]

In a number of respects, vernacular art, almost by definition, went back to pre-Reformation England, a feature unconsciously recognized by Daniel Defoe on his visit to Salisbury cathedral. In the journal of his travels written in the early eighteenth century, Defoe described "The painting in the choir [as] mean, and more like the ordinary method of common drawing-room or tavern painting than that of a church."[58] All these issues give to the vernacular tradition an importance that extends far beyond its protagonists and raises fundamental questions concerning the nature of art and its place in society.

While vernacular art may have been popular, it did not conform to the tenets of taste observed by the elite, the minority culture. Consequently

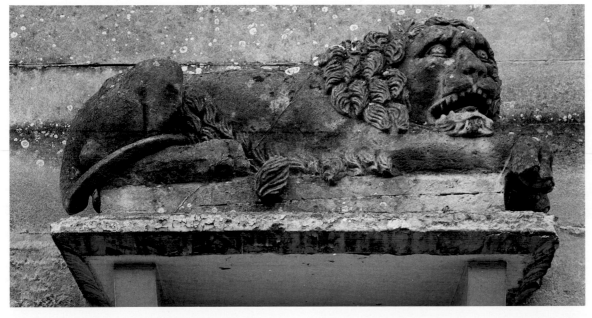

Fig. 8. Lion Couchant, *carved Bath stone, length 5 ft., Freshford High Street, near Bath. Apart from some monumental sculpture, stone or marble carving in the vernacular is rare in England.*

the conventional methods of description and analysis devised for the "polite arts" in the service of the patrician are largely irrelevant to those arts that were of and for the people. Only when viewed as an aspect of the history of taste do the traditional systems of analysis apply, which may well account for the numerous essays of that kind.[59]

Ultimately, the vernacular arts are easier to enjoy than to explain, less difficult to describe than to define, simpler to write around than write about. It is a conundrum that has produced a proliferation of labels to describe folk art, itself a term that is usefully wide rather than helpfully precise.[60] The terms appended to this illusive theme are neither synonymous nor adequate. Consequently these labels have been used promiscuously throughout this catalogue in a way that, it is hoped, conforms precisely to the context of a particular sentence but not necessarily to the publication as a whole. All of which underlines the complexity and breadth of the theme. While various arts may be grouped within the overlapping orbits of "primitive," "amateur," "nonacademic," or "popular," the primitive and the nonacademic may be technically advanced while academic painters and sculptors are often extraordinarily deficient in their craft.[61] Out of this complex morphology, the vernacular arts emerge as a relatively definable species based upon the presumption of training in a relevant craft skill. Naive art may thus be seen as a highly sophisticated aspect of the visual arts, no matter how immediate one's enjoyment of it may be.[62]

NOTES

1. *Earlier attempts at founding an academy in London (such as The Great Queen Street Academy founded in 1711 or The St. Martin's Lane Academy founded in 1720) were doomed to failure and do not represent a significant watershed.*

2. *Tim Mowl and Brian Earnshaw,* John Wood: Architect of Obsession *(Bath: Millstream Books, 1988), 25. It might be added that this convenient belief in the importance of pre-Roman Britain excused Wood the joiner from an understanding of Latin and Greek.*

3. *By Roman times, music making, though manual, was to become, in effect, an honorary liberal art. In the 1786 edition of Abraham Rees'* Encyclopaedia, *it was stated that historically "much of the artificers' business was done by slaves and foreigners."*

4. *Joshua Reynolds,* Seven Discourses *(London, 1778), 72.*

5. *Prince Hoare,* Epochs of the Arts *(London, 1813), 148.*

6. *Douglas Fraser,* Primitive Art *(London and New York: Thames and Hudson, 1962), 13.*

7. *See Richard Campbell,* The London Tradesman *(London, 1747), 105: "Mr. Kateing . . . deals in all Colours for the House Painter; but his chief Business consists in furnishing the Liberal Painters."*

8. *Horace Walpole,* Anecdotes of Painting in England *(London, 1762–71), 2:207, quoting the "Graphice" on Laniere.*

9. *Peter Lord,* Artisan Painters/Arlunwyr Gwlad *(Aberystwyth: National Library of Wales, 1993).*

10. *"Paul Sandby and His Times,"* The Library of Fine Arts *2, no. 11 (1831).*

11. *J. T. Smith,* Nollekens and His Times *(1828; reprint, London: Turnstile Press, 1949), 99.*

12. *For a full account of the Hogarth/Thornton exhibition of signboard art, see Jacob Larwood and John C. Hotten,* History of Signboards, *Appendix (London: Chatto and Windus, 1866).*

13. *John Nichols and George Steevens,* Genuine Works of William Hogarth *(London, 1808), 1:416–19, quoting Hogarth's pupil Philip Dawes and cited by Ronald Paulson,* Popular and Polite Art in the Age of Hogarth and Fielding *(South Bend, Ind.: University of Notre Dame Press, 1979), 35.*

14. *See Kenneth Ames, Introduction,* Beyond Necessity: Art in the Folk Tradition *(exh. cat. Chadds Ford, Pa.: H. F. du Pont Museum/Brandywine River Museum, 1977); "Folk Art, A Symposium" (with six contributors),* The Magazine Antiques *(January 1989); "What is American Folk Art: A Symposium" (with thirteen contributors),* The Magazine Antiques *(May 1950). While some of the contributors to these two symposia agreed, many were contradictory and even self-contradictory.*

15. *Ronald Paulson,* Hogarth, *vol. 1,* The Modern Moral Subject 1697–1732 *(New Brunswick, N. J.: Rutgers University Press, 1991), 44.*

16. *Tom Pocock,* Chelsea Reach: The Brutal Friendship of Whistler and Walter Greaves *(London: Hodder and Stoughton, 1970); Michael Parkin,* Eight Views of Old Chelsea by Henry and Walter Greaves *(London: W. H. Newson Holding Ltd., 1975).*

17. *Edwin Mullins,* Alfred Wallis: Cornish Primitive Painter *(London: Macdonald, 1967), 107.*

18. *Paulson,* Hogarth, *46.*

19. *Mullins,* Wallis, *37, reproduces the manuscript letter dated "Ap 6 1935."*

20. *John Collier published a number of books of and in the Lancashire dialect in the late eighteenth century. Vernacular building as a serious study in England may be seen to date back to 1898, when S. O. Addy first published* The Evolution of the English House. *This important book went into second and third impressions in 1905 and 1910, with a revised and enlarged edition being published by George Allen and Unwin, Ltd., London, in 1933. The Folklore Society was founded in London in 1878 and the Folk Song Society in 1898.*

21. *Peter Burke,* Popular Culture in Early Modern Europe *(1978; revised reprint, Cambridge: Scolar Press, 1994), 11, 12.*

22. *The Museum of English Rural Life at the University of Reading, founded in 1956, is largely concerned with the history of agriculture.*

23. *See Andras Kalman, Preface, in James Ayres,* English Naive Painting 1750–1900 *(London and New York: Thames and Hudson, 1980).*

24. *While "vulgar" in its exact sense (vulgaris: common people) is the antithesis of "polite" (politus: polish), it would perhaps be misleading to describe this exhibition as being about "the vulgar arts."*

25. *Sidney C. Hutchinson,* The History of the Royal Academy 1768–1968 *(London: Chapman Hall, 1968), 140, lists examples.*

26. *Richard D. Altick,* The Shows of London *(Cambridge: Belknap Press, Harvard University, 1978), n. on 151.*

27. *Most of the Judkyn collection was dispersed by auction at Christie's South Kensington, London, 8 November 1995, while the Kalman collection is now part of the Peter Moores Foundation.*

28. *For a questioning polemic along these lines, see Kenneth Ames, Introduction,* Beyond Necessity.

29. *J. W. Y. Higgs,* Folk Life: Collection and Classification *(London: Museums Association, 1963). This publication includes folk art within folklife and gives a useful overview of the history of British folklife collections, 23–24. These include those assembled by Dr. J. L. Kink, a physician whose collection formed the basis of the Castle Museum at York, and Miss Lavinia Smith, an American, who lived in Berkshire and bequeathed her collection (formed during World War II) to the County Council, which permitted it to deteriorate, passing the residue on to the Museum of English Rural Life at Reading.*

30. *See Abraham Rees, editor,* Encyclopaedia of Arts and Sciences *(London, 1786), "Plastering."*

31. *James Ayres,* The Artist's Craft *(Oxford: Phaidon, 1985), 18. See also James Ayres,* The Shell Book of the Home in Britain *(London: Faber, 1981), 98 and chapter on "Paint and Painting."*

32. *For "Artists in Their Trades," see Abbot Lowell Cummings,* The Framed Houses of Massachusetts Bay 1620–1720 *(Cambridge: Belknap Press, Harvard University Press, 1979), 40; also William Salmon,* Palladio Londinensis *(London, 1755), 63.*

33. *See, for example, Hermione Hobhouse,* Thomas Cubitt: Master Builder.

34. *See W.Cr. (Walter Crane), "Arts and Crafts,"* Encyclopaedia Britannica, *eleventh edition (Cambridge University Press, 1910–11).*

35. *Richard Campbell,* The London Tradesmen *(1747), 103, gives reference to "horse-mills to grind the Colours."*

36. *Ayres,* Artist's Craft, *126–29.*

37. *John Harris,* The Artist and the Country House *(London: Sotheby Parke Bernet, 1979), 307.*

38. *Ledgers of Michael Edkins, Bristol Reference Library B20196 (Strong Room).*

39. *M. E. Chevreul,* The Principles of Harmony and Contrast of Colors *(1839 and later editions translated into English, London: George Bell and Sons, 1876).*

40. *For both Hayward and Paty, see Rupert Gunnis,* Dictionary of British Sculpture 1660–1851 *(London: The Abbey Library, 1951). It should be noted that the inscription on the pedestal of the Williamsburg figure does not have 1,542 letters.*

41. *Ibid. Significantly, Thomas Chapman is not mentioned by John Ingamells, "Art in 18th Century York I,"* Country Life *(June 10, 1971).*

42. *Ayres,* Artist's Craft, *115.*

43. *Ibid., 130–31.*

44. *William Salmon,* Polygraphice *(London, 1672), 1:90. By the nineteenth century, the American educationalist Mrs. A. H. L. Phelps (1793–1884) of Troy Female Seminary, New York, was less than constant in her definition: "Painting in Watercolors is often called limning";* The Female Student *(London, 1836).*

45. *Hoare,* Epochs, *168.*

46. *Ruth Hayden,* Mrs. Delany and Her Flower Collages *(1980; new edition, London: British Museum Press, 1986).*

47. *The elder Robins used washes for monochromatic sketches but not for his chief works. His son, also Thomas Robins, continued his father's working methods but specialized in flower painting rather than landscape painting in which, by his time, the prevailing fashion was for translucent watercolor.*

48. *Thomas Gray (1716–71), "Elegy: Written in a Country Churchyard."*

49. *John Wood,* Towards a Description of Bath *(1742; 1765 edition), 2:318. Wood was here condemning his fellow joiner-architect William Killigrew and (possibly) the Bath sculptor and mason Thomas Greenway (fl. 1707–20).*

50. *Mirra Bank,* Anonymous Was a Woman *(New York: St. Martin's Press, 1979).*

51. *Smith,* Nollekens.

52. *Robert Sayer,* The Ladies' Amusements *(London, 1763), quoted in John Fowler and John Cornforth, ch. 9, "Ladies' Amusement,"* English Decoration in the 18th Century *(1974; reprint, London: Barrie and Jenkins, 1978), 248.*

53. *Quoted by Robert C. Alberts,* Benjamin West: A Biography *(Boston: Houghton Mifflin, 1978), 96.*

54. *Emmanuel Cooper,* People's Art *(London and Edinburgh: Mainstream Publishing, 1994), 74–76.*

55. *Peter Borsay,* The English Urban Renaissance . . . 1660–1770 *(1989; reprint, Oxford: Clarendon Press, 1991), ch. 11, "Cultural Differentiation," 284, 300.*

56. *Peter Burke,* Popular Culture in Early Modern Europe *(1978; revised and reprinted, Cambridge: Scolar Press, 1994), ch. 2, "Unity and Variety in Popular Culture," 23. Burke has even more to say about the withdrawal of the elite from the values of popular culture; see 270–86.*

57. *While blacksmiths were not included in the ranks of the Royal Academy, it is worth recalling that a founder-member, George Michael Moser (1704–83), was by trade a "chaser" (as well as being the R.A.'s first Keeper).*

58. *Daniel Defoe,* A Tour Through the Whole Island of Great Britain *(1724; new edition, New Haven and London: Yale University Press, 1991), 78.*

59. *For example, Tom Armstrong, "The Innocent Eye: American Folk Sculpture,"* 200 Years of American Sculpture *(exh. cat. New York: Whitney Museum of American Art and David R. Godine, 1976), 74–111.*

60. *For a longer theoretical discussion of these issues, see James Ayres, "Folk Art" and "Vernacular Art," in* The Dictionary of Art *(London: Macmillan, 1996), 34 volumes.*

61. *For example, Joshua Reynolds' disastrous use of bitumen or Benjamin West's involvement in "the Venetian Secret," a varnish that, it was thought, would offer the elixir of everlasting Titian; see Robert C. Alberts,* Benjamin West: A Biography *(Boston: Houghton Mifflin, 1978), 225–32 and 450. As for academic sculptors, they became evermore dependent upon carvers who would translate their clay models (or plaster casts of them) into fashionable marble.*

62. *The Concise Oxford Dictionary defines "naive" as "artlessness," which as measured against academic art is reasonable as far as it goes!*

The People

The values reflected in vernacular portraiture go back to premodern times. Historically, portraiture was both feared and venerated. As such it has proved to be one of the great human yet mystic achievements. In medieval Europe, the representation of a personage was little more than a device for deploying the emblems of authority or social distinction. The development of portraiture as an objective study of reality coincided with, and was largely the product of, the Renaissance, not to mention the introduction of glass for mirrors. In contrast to these innovations, the vernacular artist maintained into the postmedieval world the traditions of the "image maker." Indeed, if we are to take the eighteenth-century aesthete Horace Walpole at face value, the portraits in most Oxford colleges were little more than "proxies—so totally unlike they are to the persons they pretend to represent."[1] Certainly it was this notion of the official portrait as emblem that persisted in the court of Queen Elizabeth I: secular icons offered up to the sumptuary laws as collaborators in governance. With the faltering belief in the divine right of kings, Stuart artists adopted a less hieratic approach in which the old subservience was emancipated into the life and light of humanity.

Paradoxically, these trends toward a more "democratic" and consequently a more objectively observed portraiture were largely confined to the upper echelons of society, "warts and everything" as in Oliver Cromwell's immortal instruction to Sir Peter Lely.[2]

For the vernacular artist, rooted in the tradition of the craft, and for his client, ever-cautious and suspicious of new or alien ideas, earlier objectives and their resulting idioms persisted. Portraits by such tradesmen-artists, made for such customers, record the personage rather than the person, his or her age and place in a county or town rather than the idiosyncrasies of the particular human being. This attitude to portraiture is touched on by Charles Dickens in *Nicholas Nickleby*. In this novel Miss La Creevy, a painter of miniatures, displayed examples of her work gathered together in a velvet-lined frame that was screwed to the street door of her workshop. These sample portraits included two of "naval dress coats with faces looking out of them, and telescopes attached; one of a young gentleman in a very vermilion uniform flourishing a sabre; and one of a literary character with a high forehead, a pen, ink, six books and a curtain."

Miss La Creevy evidently regarded the patronage of the professional classes as important; and judging by this account, the class of her sitters was more evident than the verisimilitude of the likenesses. Dickens goes on to describe another important aspect of this type of work, her portraits of children. These included "a touching representation of a young lady reading a manuscript in an unfathomable forest, and a charming whole length of a large headed little boy, sitting on a stool with his legs fore-shortened to the size of salt spoons."

Mortality was the inspiration behind much portraiture. Images of this kind were an important source of employment for artists when parents sought the permanence of the painted portrait, especially in an age when the death of an infant or child was an ever-present threat. In a premature obituary to the artisan artist William Roos (1808–78) written in 1850, the poet Ellis Owen included the following lines:

He painted life so well that Death
Envied his art;—withdrew his breath:
Although with mortals here he lives
His fame both Time and Death defies.[3]

While many statistics could be quoted to substantiate the high death rate in the nineteenth century, the personal experience of bereavement (and its cost) is perhaps more striking and certainly more poignant. One such was that of James Dawson Burn, a peddler turned felt-hat maker who recorded in his auto-biography that "During my married life I have had eighteen births and thirteen deaths to provide for."[4]

In such circumstances, portraiture was very much a matter of life and death, which is what gives these vernacular examples their vitality. It was in this practical spirit, and for these emotional reasons, that soldiers about to go overseas took the precaution of having their portraits "taken." An example of this is the early nineteenth-century watercolor of George Blakely of the 51st Kings Own Light Infantry, which was painted when the subject was "under orders for India." In keeping with tradition, such pictures with their gilded details were the work of limners who, like their medieval predecessors, produced likenesses that represent little more than the relevant uniform and rank accompanied by an inscription. At least two identical images inscribed as being of Sergeant Dolley of the 34th Cumberland Regiment, his wife, and son seem to have been part of a mass-produced run with the names of the sitters and the intended recipients ("Aunt" or "Parents") added as afterthoughts. It is noticeable that many of these keepsakes have been folded, presumably so as to be posted with a letter. These small frail watercolors were probably once very common but, as the generations passed, their intrinsic worth declined before their extrinsic financial value developed. Few have survived and none seem to date from later than the 1850s, although some engraved versions of these,[5] with the "penny plain, tuppence coloured" look of juvenile drama prints, extended this tradition well into the age of photography. While many of these early nineteenth-century representations are rendered in watercolor in a translucent wash, others are in opaque color in the manner of gouache, thus maintaining the traditional techniques of the limners of previous centuries. There was, though, one innovation that these limners seem to have adopted with some enthusiasm, the physiognotrace, a device invented in 1786 for drawing profiles with photographic accuracy. This and similar gadgets were also employed by silhouette artists. The use of these mechanisms is often evident in the precision of the profile, which may be noticeably at variance with the

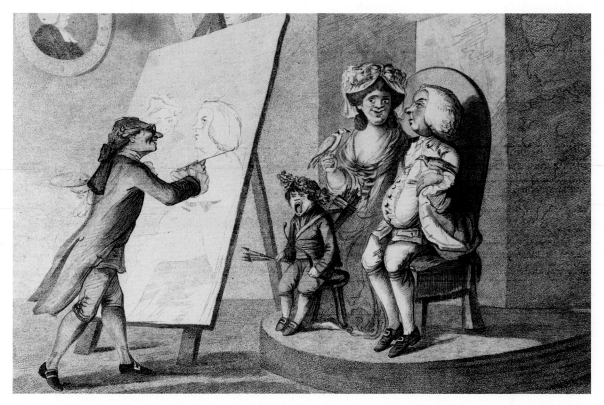

Fig. 9. A Family Piece, 1781, engraved by W. Dickinson from a drawing by H. Bunbury. This scene from Oliver Goldsmith's Vicar of Wakefield *(1766) shows an itinerant artist at work.*

naivety of the internal drawing.[6] Since the second half of the eighteenth century, the word limner has often been used inaccurately to describe vernacular painters in general rather than those whose medium was watercolor used in the manner of gouache. Oliver Goldsmith's *Vicar of Wakefield* (1766) includes a description of a "limner" who worked on a stretched canvas and, by implication, used oil paint. In this description Goldsmith gives a vivid word-picture of a vernacular painting with all its color, charms, and inconsistencies (fig. 9). The vicar commissioned a group portrait of his family in emulation of his neighbors who "had lately got their picture drawn by a limner, who travelled the country and took likenesses for fifteen shillings a head."[7] The neighbor's family, all seven of them, "were drawn with seven oranges—a thing quite out of taste, no variety in life, no composition in the world. We desired to have something in a brighter style; and, after many debates, at length came to a unanimous resolution of being drawn together in one large historical piece. This would be cheaper, since one frame would serve for all, and it would be infinitely more genteel; for all families of any taste were now drawn in the same manner. As we did not immediately recollect an historical subject to hit us,

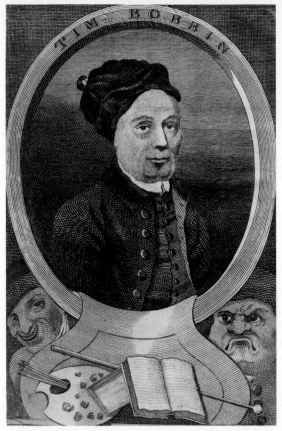

we were contented each with being drawn as independent historical figures. My wife desired to be represented as Venus, and the painter was desired not to be too frugal of his diamonds on her stomacher and hair. Her little ones were to be as Cupids by her side; while I, in my gown and band, was to present her with my books on the Whistonian controversy. Olivia would be drawn as an Amazon, sitting upon a bank of flowers dressed in a green joseph, richly laced in gold, and a whip in her hand. Sophia was to be a shepherdess, with as many sheep as the painter could put in for nothing; and Moses was to be dressed out with a hat and a white feather. Our taste so much pleased the 'Squire, that he insisted on being put in as one of the family, in the character of Alexander the Great, at Olivia's feet. This was considered by us all as an indication of his desire to be introduced into the family, nor could we refuse his request. The painter was therefore set to work, and, as he wrought with assiduity and expedition, in less than four days the whole was completed. The piece was large, and, it must be owned, he did not spare his colours; for which my wife gave him great

encomiums. We were all perfectly satisfied with his performance; but an unfortunate circumstance had not occurred till the picture was finished, which now struck us with dismay. It was so very large, that we had no place in the house to fix it. . . . The picture therefore instead of gratifying our vanity, as we hoped, leaned, in a most mortifying manner against the kitchen wall, where the canvas was stretched and painted, much too large to be got through any of the doors, and the jest of all our neighbours."

At a somewhat earlier period, in the late seventeenth century, the itinerant artist could be a "respectable" figure. Walpole cites the Anglo/Spanish Sir John Medina who is said to have traveled around Scotland "carrying a large number of bodies and postures" prepainted on canvas "to which he painted heads."[8]

Itinerant artists of the vernacular kind described by Goldsmith continued to be important well into the nineteenth century. The travels of the Wales-based artisan painter William Roos have been well documented by Peter Lord. In 1834 Roos was working in Caernarfon and before 1836 he was in London. By 1841 the painter appears in the *Liverpool Trade Directory*, but for the remainder of that decade he was traveling in Wales. Possible visits to London occurred in 1850 and 1851, and he was certainly in the capital in 1856. His travels concluded with Aberystwyth (1862), London (1870), Cardigan (1873), and Carmarthen (1875).[9]

Vernacular portraits in oil paint on canvas, panel, pasteboard, or metal plate were produced by house and sign painters as one of their many activities, an extension of their skill, a part of their livelihood. For example, Edward Edwards (1808) described George Evans as "a house painter but [he] frequently painted portraits. . . . Much cannot be

said of his powers as an artist, nor will his portraits be much in request with posterity."[10] In addition to such references and the listings in *Trade Directories,* artists of this kind are also identifiable by the internal evidence offered by their surviving works. An example of this is the group "portrait" *Three "Sober" Preachers* (cat. 11). At the center of this composition is a table, the top of which is quite arbitrarily rendered as a sample of wood graining, doubtless just the sort of job that formed part of the stock-in-trade of this particular painter. The iconography of such works may also provide clues. Take, for example, *Portrait of Alfred Openshaw,* painted by R. Hunt in 1847 (cat. 5). In view of the known use and importance of emblems in such canvases, the hen fostering a group of ducklings in the portrait may imply that Openshaw was adopted. Perhaps the best recorded example of the deliberate use of symbolism in a postmedieval portrait is to be found in colonial America. Samuel King's *Ezra Stiles* (painted 1770–71) includes a series of devices and books that refer to the sitter's learning, all of which were summarized by Stiles with a resounding and memorable phrase: "These Emblems are more descriptive of my Mind than the Effigies of my Face."[11] It was in colonial America that the painter John Singleton Copley lamented that only the desire to perpetuate features in "likenesses" saved painting from extinction in the colonies.[12] Not that eighteenth-century Massachusetts was alone in this respect. Richard Campbell made disparaging remarks about "Trading Connoisseurs," concluding that "Picture Mongers" were so interested in dealing in Italian history paintings that "Portrait or Face-painting" was almost the only outlet to offer some "small encouragement" to English artists.[13]

The patronage of house-painters as painters of portraits may now seem alien, but it was once a sufficiently common reality for the young Charles Dickens to have alluded to the phenomenon in his *American Notes* (1842), and he may well have been familiar with the versatility of house-painters in England. When visiting the then-frontier regions of the United States near St. Louis, the English novelist noted that the wooden houses near Belleville "had singularly bright doors of red and yellow, for the place had lately been visited by a travelling painter who 'got along' as I was told by 'eating his way'." That night Dickens and his companions stayed in an inn at the nearby village of Lebanon. The best room of the hostelry was adorned with "two oil portraits of the kit-cat size [36 x 28 in.] representing the landlord and his infant son; both looking as bold as lions, and staring out of the canvas with an intensity that would have been cheap at any price. They were painted, I think, by the artist who had touched up the Belleville doors with red and gold paint; for I seemed to recognise his style immediately."

The problems associated with using oil paints in an age when they were not prepprepared and packaged were sufficiently complex to inhibit amateurs from venturing into this field. There were, though, some semiprofessional yet vernacular artists whose contributions could be significant. In England John Collier, alias Tim Bobbin, was probably one of the most important of these; he is certainly the best known (see cats. 9 and 10). In early life he was apprenticed to a Dutch loom weaver (i.e. tape loom), but later became a schoolmaster in his native Rochdale. In addition he was an accomplished musician and the earliest known student of the Lancashire dialect, publishing a number of books on and in that vernacular form of speech. As a painter he was known as the "Lancashire Hogarth," a sobriquet that, judging by his engraved self-portrait (fig. 10), he by no means discouraged; it evidently derives from

the Londoner's *Portrait of the Painter and His Pug* (1745) in the Tate Gallery, London. Bobbin is a remarkable example of the autodidact, his paintings and engravings being exaples of self-plagiarism and self-promotion. His illustrated book of verse entitled *The Human Passions Delineated* (1773) includes a title page with the following advertisement: "N.B. Gentlemen &c. may have any Plate or Plates, Painted on Canvas or Pasteboard as large as the life, from 5s to 15s a Head by sending their Orders to the Author, near Rochdale. Whole Books or any single Print may be had of the Booksellers or the Publishers."[14]

With the invention of collapsible metal tubes for oil paint in 1841 and the rising use of paints produced on an industrial scale, the vernacular painter was deprived of the craft basis of his trade. His role as an artist would increasingly be taken over by the "Sunday painter." Joseph Sheppard (1834–1928) was a typical example. The son of a farmer, Sheppard was born at Worl near Weston super Mare in Somerset. Unlike the vernacular painters of the past who were apprenticed in their craft, Sheppard was schooled in his art at evening classes run by James A. Davis. In 1866 and again in 1867 Sheppard won prizes for watercolor drawing and for "success in Freehand or Model Drawing." The best of his surviving works, such as *Miss Bisdee* (c. 1866–70),[15] owe much of their quality to an unknowing surrealism that derives more from his failures than his successes.

"Convenience paints" and evening classes were only part of the problem. Photography was to become the most significant cause for the demise of vernacular portraiture. Its effect, though, was gradual. Nevertheless, by 1873, the artisan portrait painter William Roos reported that he had "taken to Animal and Landscape painting for the last few years, this is the only thing in art Photography can't do" since "Prize Cattle and Hunters" would not stand still for the long exposures needed for the photographic plates then in use. By 1875 Roos, in an acrimonious court case with the photographer Henry Howell, was accused of using a photographic portrait supplied by Howell as the basis over which Roos painted his full-length *Alderman Thomas*.[16] With photography, the vernacular portrait became a thing of the past.

NOTES

1. W. S. Lewis, ed., Selected Letters of Horace Walpole (New Haven and London: Yale University Press, 1973), 52.

2. The whole phrase ran as follows: "Remark all these roughnesses, pimples, warts, and everything as you see me, otherwise I will never pay a farthing for it [the portrait]."

3. Peter Lord, Artisan Painters/Arlunwyn Gwlad (Aberystwyth: National Library of Wales, 1993), 35.

4. James Dawson Burn, The Autobiography of a Beggar Boy (1855), quoted by J. F. C. Harrison, The Common People (1984; reprint, Glasgow: Fontana Press, 1989), 298.

5. A version of the Sergeant Dollery portrait is in Cumberland Castle, Carlisle, the regimental museum of the Border Regiment and the King's Own Border Regiment. A print of Corporal Gilham Stanes, 62 Regiment of Foot, engraved by "I. Bruce, 1820" is in the Regimental Headquarters of the Duke of Edinburgh's Royal Regiment (Berkshire and Wiltshire), The Wardrobe, 58 the Close, Salisbury, Wiltshire SP1 2EX.

6. For a discussion of the physiognotrace, see James Ayres, The Artist's Craft (Oxford: Phaidon, 1985), 65. For an example of the accuracy of silhouette in contrast to the naivety of internal drawing, see James Ayres, English Naive Painting 1750–1900 (London and New York: Thames and Hudson, 1980), pls. 22–25.

7. Oliver Goldsmith, The Vicar of Wakefield (1766; Everyman edition, London: Dent, 1917), 84–86. John Penrose in his Letters from Bath 1766–67, ed. Brigitte Mitchell and Hubert Penrose (Gloucester: Alan Sutton, 1983 and 1990), 41, seems to have used the word "limner" with similar freedom, stating that in Bath in April 1766 such an artist charged £20 for a quarter length, £40 for a half length, and £60 for a whole length, prices that almost certainly reflect the use of oil paint.

8. Horace Walpole, Anecdotes of Painting in England (1786), 3:237–38. For naive miniature painters using "stock" bodies, see Beatrix T. Rumford, ed., American Folk Portraits (Boston: New York Graphic Society/Colonial Williamsburg, 1981), 29.

9. Lord, Artisan Painters, 28–35.

10. Edward Edwards, Anecdotes of Painters (London, 1808), 31.

11. Charles F. Montgomery and Patricia E. Kane, American Art 1750–1800: Towards Independence (New Haven and London, Yale University Press/Victoria and Albert Museum, 1976), 90.

12. William L. Sachse, The Colonial American in Britain (Madison: University of Wisconsin Press, 1956), 171.

13. Richard Campbell, The London Tradesman (London, 1747), 96–97. The importance of portraiture in England was also touched on by Walpole in Anecdotes 4 (1786):129–31; with reference to Giacomo Amiconi, Walpole mentions "Portraiture as the one thing necessary to a painter in this country [England]," and when giving an account of Joseph Vanaken, he states that "in England almost everybody's picture is painted" (4:136).

14. Antonia Roberts, Enter Tim Bobbin (exh. cat. Rochdale: Rochdale Art Gallery, 1980).

15. Portrait of Miss Bisdee in Woodspring Museum, Weston super Mare, in Ayres, English Naive Painting, pl. 28.

16. Lord, Artisan Painters, 53, 56, 57.

1

Portrait of Three Sisters

Artist unknown
c. 1810
Oil on canvas
102.5 x 125 cm (41 x 50 in.)
Malcolm Frazer Antiques, Manchester

The high-waisted dresses suggest a
Regency period for this memorable group
portrait found in Lancashire. The idyllic,
sylvan setting effortlessly implies a landed
family, while the unusually pale palette is
in keeping with the youth of the sitters.

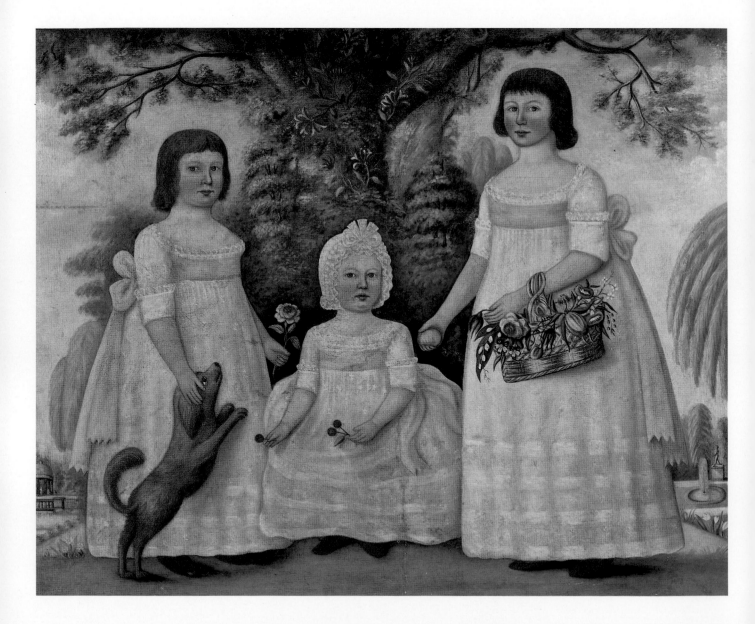

2

Portrait of Four Children

Artist unknown
c. 1840
Oil on canvas
22.5 x 30 cm (9 x 12 in.)
Malcolm Frazer Antiques, Manchester

This portrait was found in the
north of England.

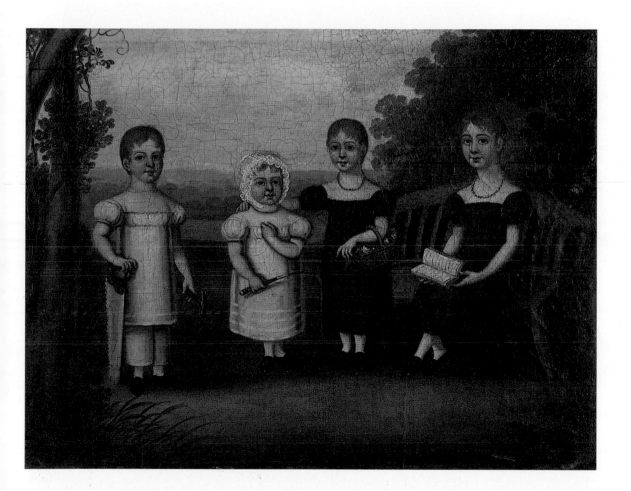

*Profile Portrait of a
Small Boy*

Artist unknown
c. 1820–30
Oil on canvas
15.5 x 11.3 cm (6 1/8 x 4 1/2 in.)
Beamish, The North of England
 Open Air Museum

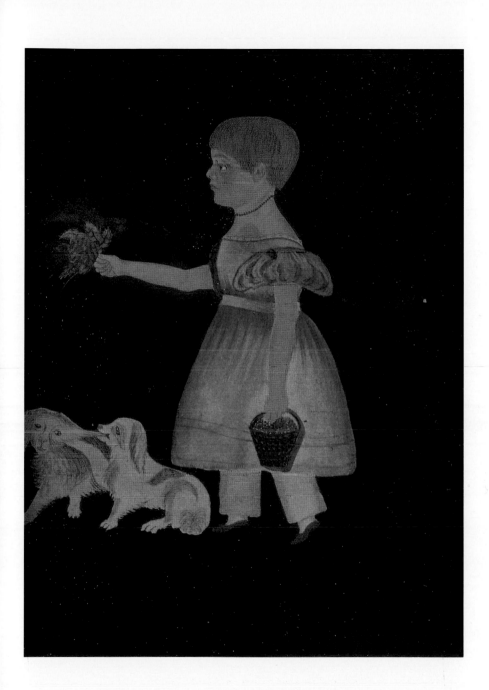

4

*Profile Portrait of a
Small Girl*

Artist unknown
c. 1820–30
Oil on canvas
15.8 x 11.5 cm (6 1/4 x 4 1/2 in.)
Beamish, The North of England
 Open Air Museum

5

Portrait of Alfred Openshaw

R. Hunt (signed and dated)
1847
Oil on canvas
85.09 x 65.58 cm (33 1/2 x 27 in.)
The Judkyn/Pratt Collection

Openshaw is a Lancastrian name, which may suggest that this painting originated in the palatinate. The picture is inscribed on the back with the subject's name in large calligraphic letters. The child is clothed in the gown typical for small boys until the age of four years (fig. 11). His necklace relates to a superstition, dating back to classical antiquity, that coral warded off evil spirits. The hen fostering ducklings prompts the possibility that the sitter was adopted. The somewhat Claudian landscape and the bright red of the dress cannot quite distract from the dislocation in the drawing of the chair which, nevertheless, conveys a great sense of depth.

In the late 1950s, John Judkyn (1913–63) formed what was to become the first significant collection of British folk art. British by birth, Judkyn was a naturalized American, and it was in the United States that he formed his eye for folk art, a vision that did much to enhance his contribution as the co-founder, with Dr. Dallas Pratt (1914–94), of the American Museum in Britain at Bath.

Illustrated: J. Ayres, English Naive Painting *(1981), pl. 21;* J. Ayres, British Folk Art *(1977), 104.*

Exhibited: America and British Folk Art, *U.S. Embassy, London, 1976;* The Art of the People, *Cornerhouse Arts Centre, Manchester, 1985–86;* A Common Tradition, *University of Brighton, 1991;* Judkyn/Pratt Collection British Folk Art Collection, *Peter Moores Foundation, 1994–95.*

Fig. 11. Portrait of a Small Boy, *mid 19th century, oil on canvas, The Judkyn/Pratt Collection. Until the breeching ceremony, which took place at four years, small boys wore dresses. However, they were often portrayed carrying some toy, emblem, or implement that asserted their masculinity.*

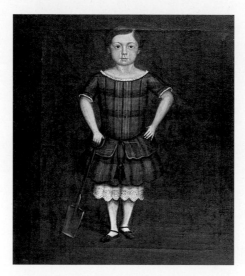

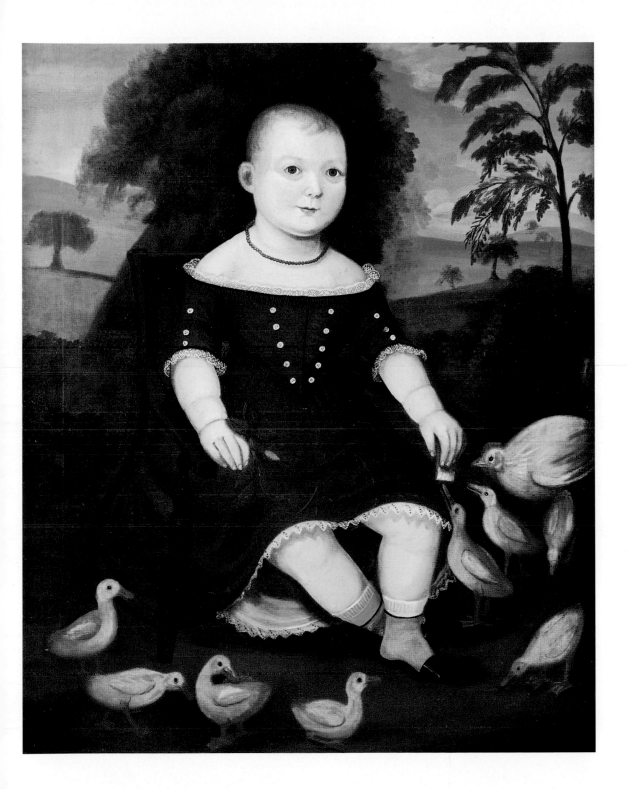

6

Mary Alice Oliver with
Her Dog

Artist unknown
c. 1856
Oil on canvas
91.4 x 71 cm (36 x 28 in.)
Beamish, The North of England
 Open Air Museum

The date of this portrait is established
by its nine-year-old sitter Mary Alice
Oliver, who was born on August 31,
1847.

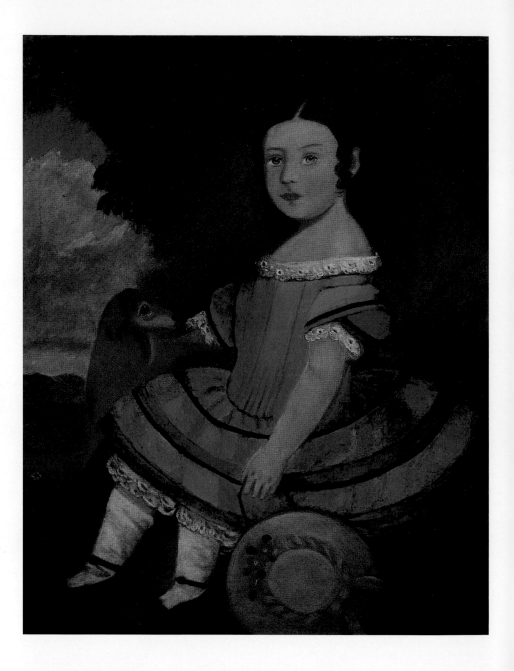

7

The Benevolent School, Bristol

Artist unknown
c. 1795
Watercolor on paper
37.5 x 57.5 cm (15 x 23 in.)
Bristol City Art Gallery

The great Atlantic port of Bristol boasted three grammar schools, three or four schools for those who were destined to be indentured or apprenticed, and numerous charity schools. Shiercliff's *Bristol and Hotwell Guide* (c. 1808) describes these and concludes with "no less than nine Benevolent Schools . . . in which 250 Boys and Girls are daily taught reading, sewing &c. and conducted by their mistresses every Sunday to church. They are new clothed once a year when they all walk in procession . . . to attend Divine worship."

Exhibited: Samplers, *Bristol Museum and Art Gallery, 1983;* The Subversive Stitch, *Whitworth Art Gallery, Manchester, 1988.*

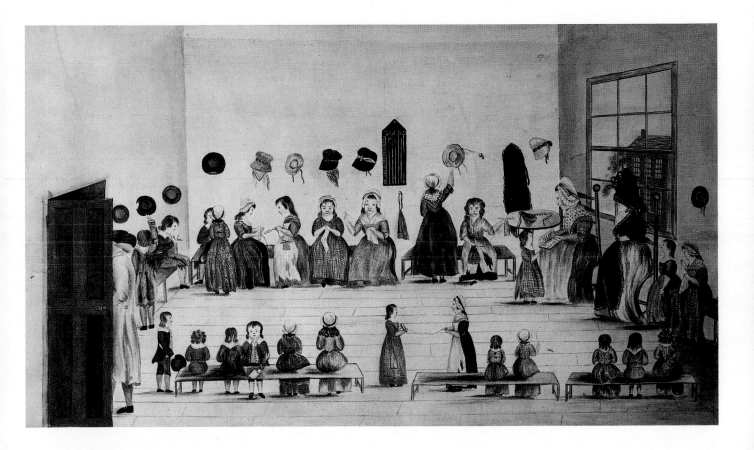

8

James Ayres 18th Hussars

Isabella Avis of Twickenham
c. 1820
Watercolor on paper
23.12 x 27.5 cm (9 1/4 x 11 in.)
Mr. and Mrs. K. H. Rogers

Generalized military "portraits," in which the name of the sitter was often added after the picture was finished, were probably quite common in the first half of the nineteenth century, even though few have survived. As "portraits," their representation of uniforms is generally quite accurate.

James Ayres was born at Westbury, Wiltshire, about 1786. He joined the 18th Hussars when they had a recruiting party at the nearby town of Trowbridge in April 1811.

At that time the regiment was stationed in Kent on the Revenue (anti-smuggling) service, but in May 1811 it marched to Hounslow, Middlesex, where it remained until August 1812. It had during that time a detachment at Twickenham, so the date of the picture is certainly 1811-12. In 1813 the regiment joined the army of Lord Wellington in Portugal and fought in the various engagements in Spain and Portugal until the first defeat of Napoleon in 1814.

James Ayres received medals for being present at the Battles of Vittoria and Toulouse and also fought at and received the medal for the Battle of Waterloo in 1815, when Napoleon was finally defeated. He continued to serve until the regiment was disbanded in 1821, when he was discharged at Dublin. His military records in the Public Record Office show that he was a laborer at enlistment, had a sallow complexion, blue eyes, and fair hair.

He remained a private throughout his service and his conduct was good.[1]

The 18th Hussars was raised as a Light Dragoon regiment in 1759 and adopted the Hussar uniform in 1805. Until 1830, Hussars were the only troops in the British army allowed to wear mustaches.

Although a girl named Isabella Avis was baptized at Twickenham in 1798, it is by no means certain that she was the artist, who may have been an older relative.

The picture has been in the hands of the same family since it was painted.

NOTE
1. *The information on the sitter was kindly supplied by Kenneth Rogers.*

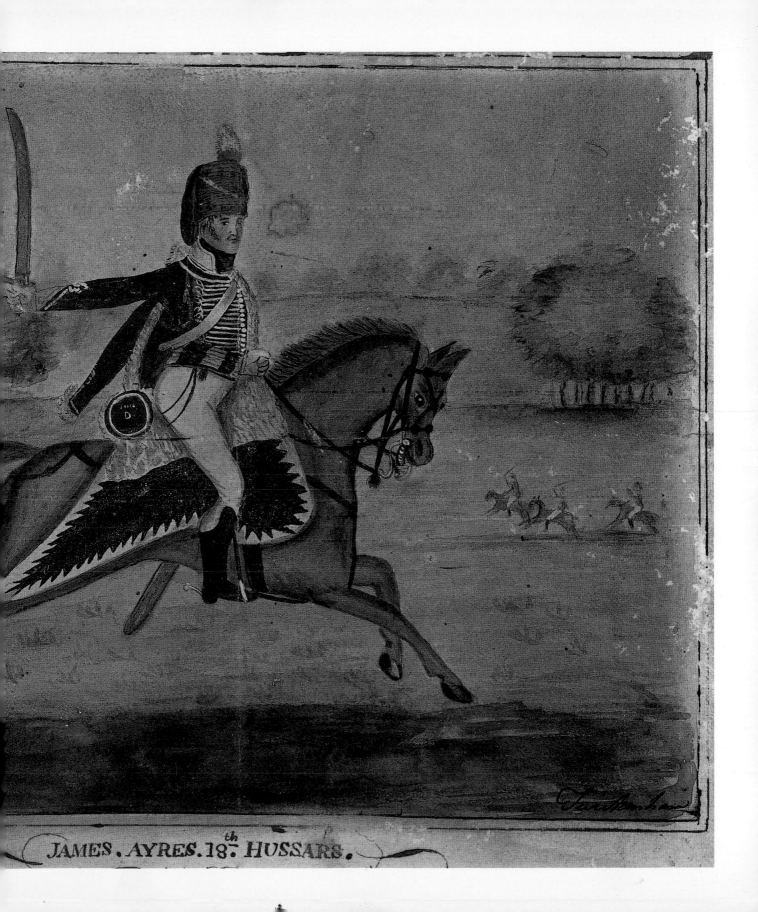

JAMES. AYRES. 18th HUSSARS.

9

The Parson and the Devil

John Collier, alias Tim Bobbin
 (1708–86)
c. 1773–80
Oil on canvas
65 x 101.87 cm (26 x 40 3/4 in.)
Rochdale Art Gallery

Collier's radical political opinions were fired by his father's position as a lowly curate carrying most of the responsibilities of his parish. In contrast, the often-absent parson received a generous stipend.

Many of Collier's paintings are closely related to the illustrations in his *Human Passions Delineated* (1773). It is not now possible to establish in which direction this self-plagiarism took place. In the book, the illustration that related to this picture was accompanied by the following verse:

This hypocrite, whose holy look and dress
Seem Heav'n-born, whose heart is nothing less;
He preaches, prays and sings for worldly wealth,
Till old sly mammon takes it all by stealth.

John Collier's pseudonym "Tim Bobbin" seems to have been a widely used sobriquet among textile workers and reflected, with its reference to "the birchen sceptre," Collier's brief apprenticeship to a weaver. Following the cancellation of his indentures, Collier, as the son of a reasonably well-educated curate, spent some years as a peripatetic schoolteacher. In 1729 he was appointed as usher of Milnrow School near Rochdale, where he became acting headmaster in 1739 and headmaster in 1742. With this background Collier was quite unlike the great mass of artisan artists, for he was not by trade a painter, although one of his sons became a successful coach and heraldic painter in Newcastle.

Collier's posthumous reputation, as reflected in Britain's *Dictionary of National Biography*, is as one of the earliest students of the vernacular, in language rather than in art. His *View of the Lancashire Dialect* was published under his alias around 1746. To his contemporaries he was possibly better known for his musicianship and his enjoyment of ale and punch.[1]

PUBLICATIONS BY TIM BOBBIN

A View of the Lancashire Dialect (c. 1746)

The Quack Doctor: a Poem in three Parts; to which is added a Humorous Dialogue betwixt the Quack Doctor and his Wife (1750)

Truth in a Mask or SHUDE-HILL FIGHT, being a short Manchestrian Chronicle of the Present Times (1757)

Tim Bobbin's Toy Shop Open'd; or his Whimsical Amusements (1763)

The Miscellaneous Works of Tim Bobbin (1770)

The Fortune Teller or the Court Itch at Littleborough (1771)

Curious Remarks on the History of Manchester (1771)

The Human Passions Delineated (1773)

More Fruits from the same Pannier, or Additional Remarks on the History of Manchester (1773)

NOTE
1. Antonia Roberts, Enter Tim Bobbin . . . (exh. cat. Rochdale: Rochdale Art Gallery/Greater Manchester Council, 1980).

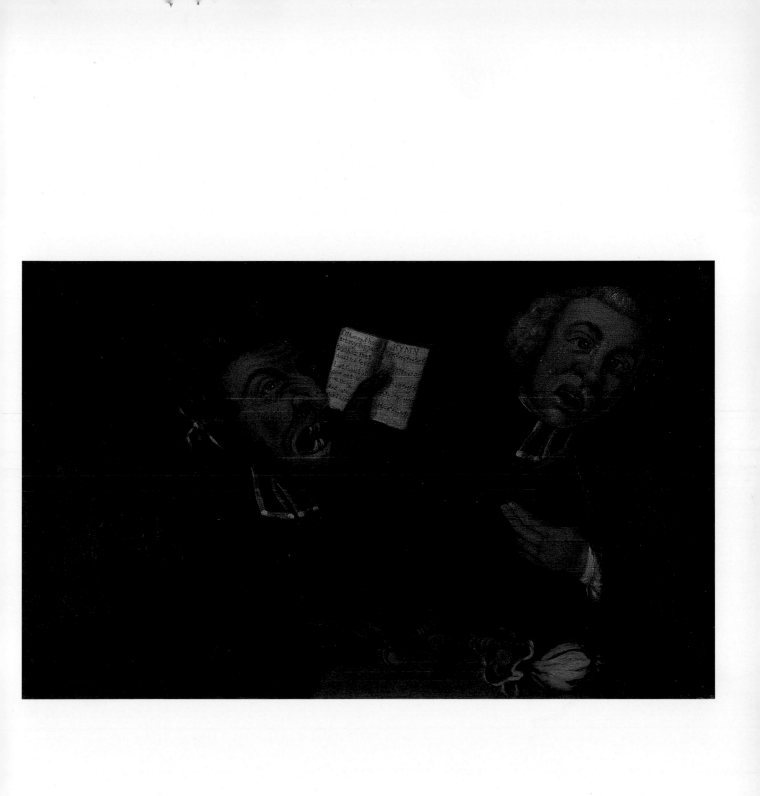

10

Two Drunkards

John Collier, alias Tim Bobbin
 (1708–86)
c.1772–80
Oil on canvas
66.66 x 95.25 cm (26 1/4 x 37 1/2 in.)
Rochdale Art Gallery

This painting is associated with Collier's verse of 1766:

See here, ye wordlings, whence contentment
 springs;
Now from full Bags, or being great as kings;
A single Bottle sets our minds at rest
And, true contentment is the noblest Feast.

Collier later published *Human Passions Delineated* in Manchester in 1773. Plate 2 in the publication is closely related to this composition and is in turn accompanied by verse:

Four statesmen here, all plac'd and pension'd sit,
Have drown'd all care, and murder'd patriot wit;
Their bellies fill'd with wine, their chests
 with gold,
Squeez'd from a nation which they've bought
 and sold.
No conscience pricks;—no dread of public
 wrath;—
Thy rob like Orford, or an Earl of Bath!
A groaning nation breaks no silken ease,
And only study how l-d B-te [Lord Bute] please,
Thus warm'd within the down or regal wing,
Whilst England mourns, her statesmen laugh
 and sing.
O Britain's guardian, when wilt thou awake,
And on such vipers deadly vengeance take.

The "statesmen" were a yeoman class of farmers secure in their land tenure. In northwest England, the years between about 1600 and 1750 have been termed the Age of the Statesmen. By Collier's day, the statesmen were in sharp decline, suggesting that the author of these lines was attacking a target more appropriate to an earlier generation.[1]

NOTE

1. Susan Denyer, Traditional Buildings and Life in the Lake District (London: Victor Gollancz/National Trust, 1991), 17 and 192. Rochdale was in Lancashire, the southernmost county of the Lake District.

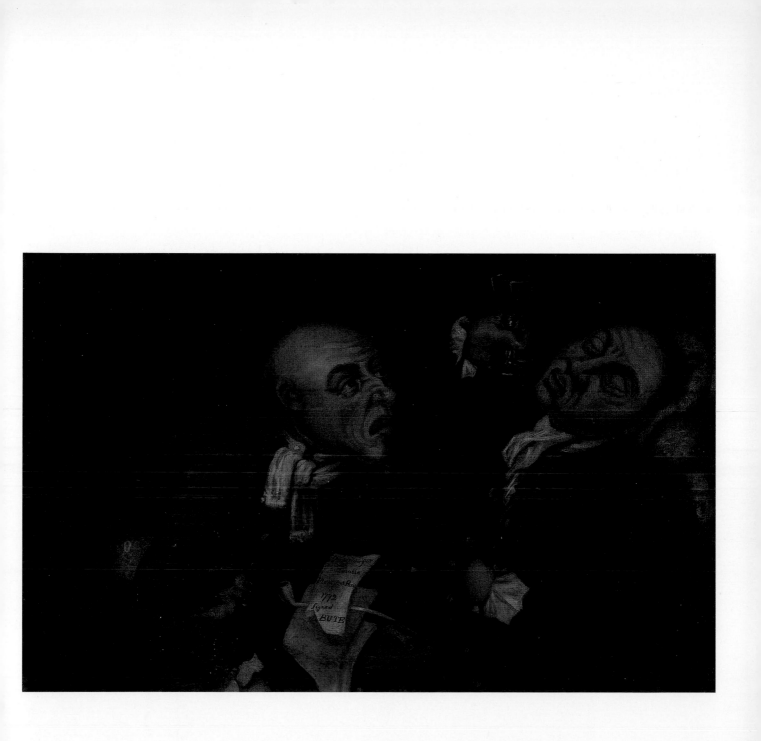

11

Three "Sober" Preachers

Artist unknown
Early 19th century
Oil on canvas
87.63 x 86.9 cm (34 1/2 x 34 1/4 in.)
Peter Moores Foundation

The three texts hanging on the wall behind the three clerics strike an amusing contrast to the more usual biblical quotations. The treatment of these texts and the somewhat arbitrary sample of graining on the tabletop suggest that the artist was primarily a sign writer and house painter.

This painting was once in the collection of Mr. and Mrs. Andras Kalman, who formed one of the most important collections of English naive art. Thanks to the Peter Moores Foundation, the Kalman Collection is one of the few to remain intact.

Illustrated: J. Ayres, English Naive Painting *(1980), pl. 12.*

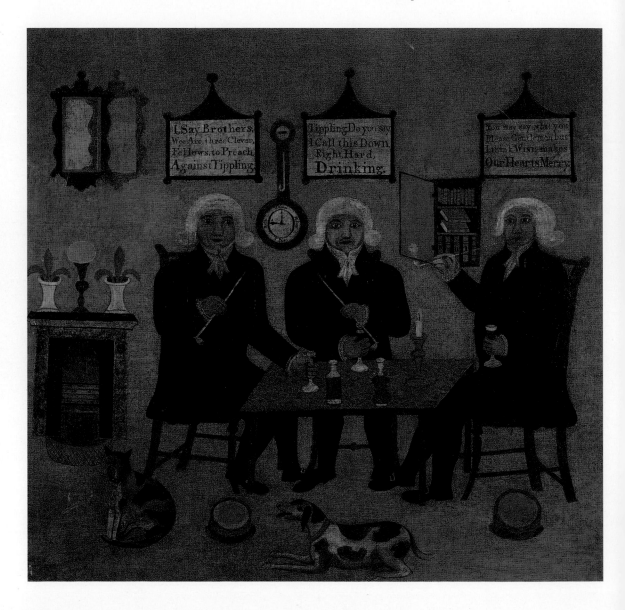

12

The Engineer

Artist unknown
Dated 1839
Oil on canvas
91.44 x 68.58 cm (36 x 27 in.)
Peter Tillou Collection

The medieval tradition for symbolism was maintained by vernacular portrait painters well into the age of steam. It was an idiom in which status, as measured by clothes, and avocation, as indicated by emblems, were more important than the frailty of the human condition, as reflected in the physiognomy of an individual. Here, the engineer's scale ruler and model steam locomotive reflect great glory on a young man who stands at the frontiers of a rising technology, with the opulence of the past, expressed in the classical column and lavish drapery, behind him.

According to John Liffen of the Science Museum in London, the locomotive shown here closely resembles the Stephenson Company's patent design, which was manufactured by several companies under license. This design originated in 1835 and continued in production into the 1840s.

The making of a home has been described as "a craft cultivated by all its members."[1] It was and remains a collective art form. As the achievement of its occupants, the traditional home involved the deployment of homemade elements or bought-in plenishings that were, ideally, composed into a convenient and satisfying whole. For the elite few, "style" might be provided through the services of an upholder (upholsterer), but for the majority the home was "of the people" and "for the people." As such it reflected both the standards and traditions of a particular district as well as the specific needs of those it served, insofar as they could afford the basic essentials for life. In England there was one further inhibiting factor, namely the enthusiasm for gardening in a country with such an equable climate. It was and remains a preoccupation for all social classes. Whereas the landed and wealthy developed parks with vistas, greensward, and woodland, the middle classes grew flowers and the poor concentrated on survival by combining their flower gardens with the cultivation of vegetables. In humble households, personal skills such as carpentry could lift families above the basic levels of subsistence. Whatever the social level, the ability to raise the fundamentals of practicality into something more spiritually satisfying has never been easy. The lares and penates are not easily propitiated.

The basic requirements of a house were defined in 1734 as "a building wherein to shelter a man's person and goods from the inclemencies of the weather and the injuries of ill disposed persons."[2] These "goods" have become known as "material culture" and in the home could include the tools of a trade or occupation, which often strayed indoors from the field or workshop. This was particularly true before the full effects of industrialization were felt in England. A Lancashire weaver described his uncle's modest home: "like all the others [it] consisted of one principal room called 'the house'; on the same floor with this was a loom-shop capable of containing four looms." Industrialization would eventually draw a great distinction between living and working, home and factory.[3]

The often arbitrary division of numerous objects between the decorative and fine arts is more useful than real. The more basic the way of life, the more irrelevant such distinctions became. Thus an implement for hunting or fighting (often the same tool) offered an appropriate surface for decoration. Likewise, in the domestic context, a knitting sheath (cats. 18 and 19) would be similarly embellished. Accordingly, the tools of survival were celebrated long before they were adopted as symbols of power: the evolution of the mace from an implement of war to an emblem of authority is a good example. It is in this type

of context that the origins and purpose of vernacular art may be viewed. A family's portraits and painted representations of their means of livelihood, a sailor's ship, a farmer's prize bull are examples of an art that existed on the premise of function. It would, though, be a mistake to assume that "art for art's sake" did not exist at this level. Few art forms can be more without function than the still life, and yet these were painted at the vernacular level and, one may conclude, found willing purchasers (cat. 26). Who, then, were the artists who served the aesthetic needs of the "common people"? What type of craftsman assisted in the decoration of the vernacular home?

The contributions of the house-painters could be both considerable and wide in scope, from the painting of walls with a flat color to the production of an easel painting. Indeed, in various parts of the country there was scarcely a surface within a room that did not provide scope for decoration in some way. In some regions, stone or slate floors would be decorated with chalk, pipe clay, or sand, while mud floors would be whitewashed.[4] In addition to being employed to apply flat color underfoot, house-painters were commissioned to decorate floorboards, walls, and even ceilings[5] with pattern or paint and to treat other surfaces of many kinds in such a way as to resemble exotic woods or marbles. These craftsmen were not known as "painters and decorators" for nothing.

Twentieth-century interior decorators, like eighteenth-century upholders, have been inclined to see textiles (carpets and curtains) as the principal vehicle for color and pattern, but it was not always so. For traditional societies, the weaving of cloth, and especially the spinning of yarn,[6] were such labor-intensive activities that textiles were reserved primarily for clothing. The use of curtains, carpets, and upholstery in the preindustrial past was an opulence available to only a small, privileged minority. Paint was therefore the principal means through which color and interest were introduced into the homes of the masses.

In Britain as in colonial America, the tax on printed paper (1712–1861) made patterned wallpaper too expensive for all but the most affluent. In response, the house-painters of the late eighteenth and early nineteenth centuries produced stenciled designs to counterfeit the prestigious printed wall coverings. Within this subspecies of decoration a clearly evident pecking order is discernible, with the principal rooms of a house being graced with the most elaborate patterns (more complicated designs with more colors and therefore more stencils). Patterned surfaces of this kind, with their slightly blurred outlines, provided the perfect foil and background upon which to hang vernacular paintings with their customarily hard-edged treatment. Elizabeth Gaskell gives a vivid word picture of such an ensemble in a Manchester millworker's living room: "The room was tolerably large, and possessed many conveniences. . . . On the opposite side to the door and window was the staircase. . . . The other door, which was considerably lower, opened into the coal-hole—the slanting closet under the stairs; from which, to the fireplace, there was a gay-coloured piece of oil cloth laid. The place seemed almost crammed with furniture (sure sign of good times among the mills), beneath the window was a dresser with three deep drawers. Opposite the fireplace was a table, which I should call a Pembroke, only that it was made of deal, and I cannot tell how far such a name may be applied to such a humble material. On it, resting against the

wall, was a bright green japanned tea-tray having a couple of scarlet lovers embracing in the middle. The fire-light danced merrily on this and really . . . it gave a richness of colouring to that side of the room. It was in some measure propped up by a crimson tea-caddy, also of japan ware. A round table on one branching leg rarely for use, stood in the corresponding corner to the cupboard; and if you can picture all this with a washy but clean stencilled pattern on the walls, you can form some idea of John Barton's home."[7]

John Claudius Loudon in his *Cottage Farm and Villa Architecture* (1836) confirms the status of this form of decoration as "not unsuitable for cottages of the humblest description, on account of its cheapness; and because in remote places or in new countries it might be done by the cottager himself or by a local plasterer." Despite the labor-intensive nature of stenciling, it was a cheap alternative because of the tax on printed paper. Once this tax was reduced in 1847 and abolished in 1861, patterned wallpapers became available to all, and stenciling reverted to its medieval status as a means of decorating prestigious interiors.

An alternative to the repeat patterns of stenciling was the landscape mural produced in imitation of that luxurious French import of the early nineteenth century, the scenic wallpaper. Painted murals of this kind can be found in the homes of the yeoman class; an example is that of the reasonably prosperous farmer James Shutter Williams who, in the 1830s, commissioned a member of the Walters family of Bristol to decorate his farmhouse at Butcombe, Somerset. These murals are to be seen in the dining room and principal bedroom, with stencil painting decorating walls elsewhere in the house. The omission of a mural scheme from the drawing room

Fig. 12. Overmantel painting in situ in a second-floor bedroom of the White House, Fen Ditton, Cambridgeshire.

is probably explained by the presence there of family pictures.

In general, surviving post-Stuart, pre-Victorian mural schemes of a vernacular kind are now excessively rare in Britain, although they were probably once quite common as they certainly were in North America.[8] Writing in the early nineteenth century, Edward Pugh noted that in Welshpool it was "general . . . to paint the walls of the rooms of public houses in size, with decorations of festoons, and in panels ornamented with various devices strongly mimicking the present mode, so prevalent among the fashionable world." Pugh lamented[9] that these were only "executed by sign painters" and that they reflected "a want of taste." These murals by house-painters were invariable created in distemper on plaster, although in one possibly exceptional case an overmantel landscape was worked in true fresco.[10]

The fashion for wallpaper and stenciling grew as the use of paneling declined in the second half of the eighteenth century. The earlier custom for lining a room with panels held within stiles and rails had

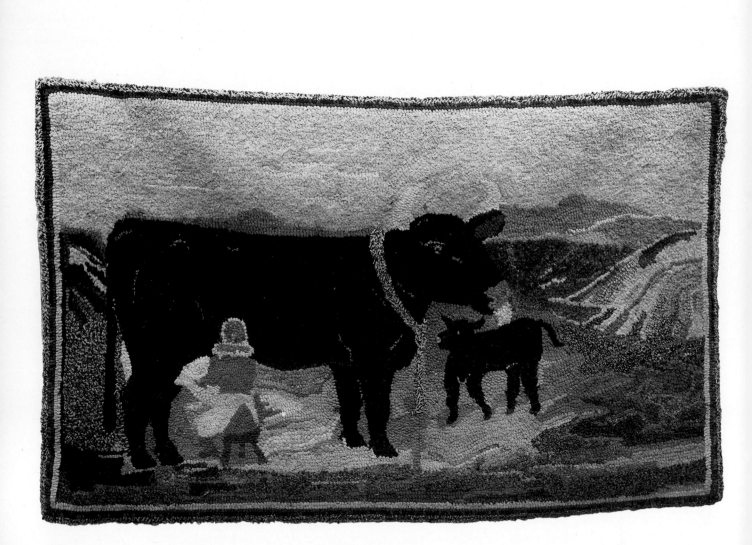

Fig. 13. Hooked rug, late 19th–early 20th century, Museum of Lakeland Life, Kendal, Cumbria.

provided the ideal surface for marbling, graining, and even japanning. Sometimes the panels were given a painted pictorial treatment, and occasionally whole rooms were adorned in this way. Most commonly this embellishment was confined to the panel over the fireplace (the overmantel, see fig. 12) and those over the doors (the overdoor). These locations were considered as secondary, since the heat of the

fireplace would constitute a hazard to a "real" work of art, while the position over the door in a high-status, high-ceilinged house[11] rendered overdoor pictures all but invisible. Chimney boards similarly occupied a lowly status in the hierarchy of art. For these reasons, "furnishing pictures" by artisan artists may be found in houses of the gentry. Urchfont Manor in Wiltshire retains a series of overmantel

paintings that show this fine William and Mary house as it appeared around 1700 surrounded by its "Dutch garden" (cat. 13). Celia Fiennes describes "the very good pictures" at Durdens, Surrey, which were "in all the roomes over chimneys and doors all fix'd into the wainscoate." This remarkable account may well refer to the surviving late seventeenth-century paintings of the house that are now at Berkeley Castle in Gloucestershire.[12] Horace Walpole refers to several ornamental painters including John Stephens (d. 1722), who was "mostly employed for pieces over doors and chimneys,"[13] and Luke Cradock, "who died early in the reign of George I." Cradock was born in Somerton, Somerset, and apprenticed to a house painter in London. His paintings of birds in particular were "strongly and richly coloured, and were much sought as ornaments over doors and chimney pieces." As a journeyman house painter he worked "by the day for dealers who retailed his works," at a profit to themselves, although Walpole generously suggests that this enabled Cradock to maintain a certain distance from patrons of "birth and fortune" who might otherwise have been expected to have "confined his fancy and restrained his freedom."[14]

With such an abundant flowering of the art of the house painter, it is remarkable how relatively little vernacular furniture was decoratively painted in Hanoverian and Victorian England. In contrast, the Classical Revival saw a reintroduction in patrician circles of the polychrome decoration of antiquity. Not that color was absent from the movable items in the home. The spandrels of enameled metal clock faces were painted with colorful and flowery motifs as was the lunette, which often displayed the sun and moon on a revolving disk or a ship rolling in a rough but painted sea. This was the sort of work that, in the decades around 1800, became the specialty of such craftsmen as James Bunk. Edward Edwards dismissed Bunk as one of those "professional artists . . . who have contributed their feeble efforts toward supporting a spirit of enrichment and decoration among the inferior virtuosi a painter of no great powers. He was chiefly employed by those who required subjects for mechanical movements, such as clocks for the East Indies, in which figures are represented, that are put in motion by the machine which they decorate."[16] In contrast to this sort of embellishment, the clock case was left unpainted unless it was of humble pine, when it was generally grained and stained to resemble the more prestigious mahogany, but in general nothing more adventurous or flamboyant was attempted. Similarly, while Windsor chairs may have been painted an allover dark green for the garden as for the home, they were not given decorative lining or florid curlicues of the type that may be connected with the associated craft of the wheelwright.

Pictorial art has been in the ascendant for so long, with paint as the dominant material, that the "canvas" has become a synonym for the "picture." In contrast, the vernacular arts are innocent of this narrow diet, this perniciously unconscious prejudice. Indeed, in one aspect, the visual achievement of one non-paint-based vernacular art has eroded the frontiers of convention: the patchwork coverlet. Be it pieced or appliquéd, quilted or unquilted, it has effortlessly migrated from the bed to the wall, from the home to the gallery and back.

In England and indeed throughout the British Isles, the patchwork coverlet ranges in quality from the true vernacular, based on the frugal use of fabrics and made as an extension of the housewife's skills, to the "ladies' amusement," sometimes designed by professionals and constructed out of fashionable materials. They were even made by injured soldiers in

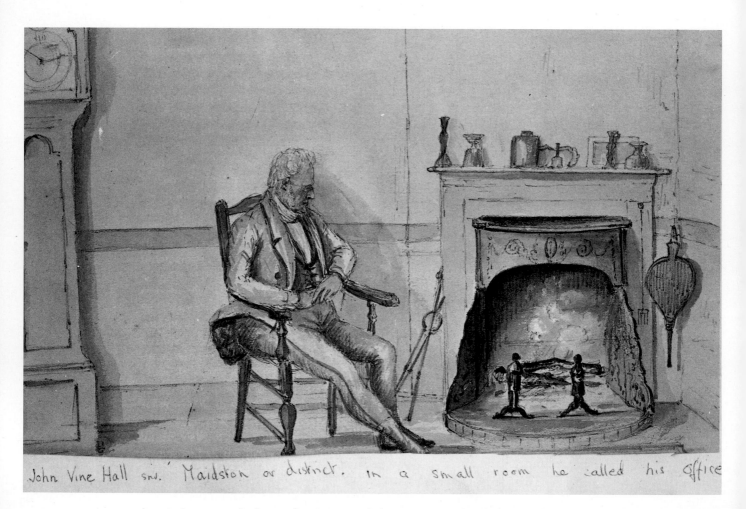

John Vine Hall snr. Maidston or district. in a small room he called his office

hospital as an early form of occupational therapy. Most of these were made in a highly characteristic mosaic technique using uniform fabrics, which gives a certain heraldic simplicity to their color range (see cat. 21). A related version of these was made by professional tailors who specialized in military uniforms (cat. 20). This tradition does something to place George Smart of Frant in context. A tailor by trade, Smart established a reputation for making "cloth and velvet pictures" that he sold to the fashionable visitors who came to nearby Tunbridge Wells to take the waters.

Among amateurs the making of embroidered pictures was popular, and in the mid eighteenth century the wife of the miniature painter Thomas Worlidge gained some reputation for this type of

needlework. The *Public Advertiser* published a verse describing her at work on one of her embroidered landscapes. The verse somewhat resembles the rhymes that were later used by George Smart to promote his work.

> At Worlidge's as late I saw
> A female artist sketch and draw,
> Now take a crayon, now a pencil,
> Now thread a needle, strange utensil!
> I hardly could believe my eyes
> To see hills, house, steeples rise
> While crewel o'er the canvas
> Became a river or a lawn.

Walpole, who quotes these lines, did so not only to "do justice to the lady celebrated," but also "to take notice that the female art it records, has of late placed itself with dignity by the side of painting and actually maintains a rank among works of genius." This is clearly an exaggeration in view of the strictures placed on embroidery by the Royal Academy; furthermore, the extent to which this was a "female art" may also be questioned. Even in the same paragraph, Walpole goes on to mention that a "Miss Gray [who] was the first to distinguish herself by so bold an emulation of painting [was] taught by Mr. Taylor, but greatly excelled him."[17] At times the attitudes engendered by "the ladies' amusements" seem to have been extended to other classes through the agency of a "lady bountiful"; in one of his letters Horace Walpole makes reference to a "home for reformed prostitutes in which the inmates "made linen and did bead-work."[18]

Before the industrial revolution, rugs on the floor were something of a luxury, the conspicuous consumption of their time. For more practical purposes, the rug on the bed rather than the floor was widely used, for even "the poorest creature in a workhouse had a rug on his bed."[19] In the late nineteenth century, rag rugs were a source of homespun comfort on the floor, where they provided both color and pattern, but very few examples survive from before around 1900 (fig. 13). Flora Thompson's description of the homes in her native village at the end of the nineteenth century indicate their place in the scheme of things. "In nearly all the cottages there was but one room downstairs, and many of these were poor and bare, with only a table and a few chairs and stools for furniture, and a superannuated potato sack thrown down by way of a hearth rug. Other rooms were bright and cosy, with dressers of crockery, cushioned chairs, pictures on the walls and brightly coloured hand-made rag-rugs on the floor."[20]

So various were the items used in the home that it is not easy to summarize the miscellaneous objects of concern to this essay. Many of these items may have been supplied by a type of shopkeeper known in the eighteenth century as a "toy man." These traders were not particularly concerned with the toys of childhood, but their range of small-scale quality goods was truly extraordinary and might include turnery, Tunbridge ware, oilcloths and other floor coverings, draft boards, japanned tea trays, and many other items.

A traveling exhibition is necessarily confined to movable examples of carved wood or painted decoration, especially easel paintings. Although, woodcuts had been widely available from the sixteenth century, it was the nineteenth century that saw the rapid increase in the use of such mass-produced imagery in the home. Prints had also for long been the exemplars that transmitted the visual language of the elite into a medium to which vernacular artists responded, not that this

Fig. 14. Arthur Vine Hall (1824–1919), John Vine Hall, Snr., Maidstone or District, in a Small Room He Called His Office, *watercolor and pencil on paper, coll. Mrs. Polly Rogers. "American" or Franklin stoves are described by J. C. Loudon (1836) as having been "lately introduced into farmhouses in Kent" with some success. The manufacture and distribution of consumer durables marks the start of the decline of traditional and regional design in England.*

transmission was by any means in one direction. In 1804, Edmund Bartell acknowledged that "Prints, or pictures, though certainly articles of luxury, are such pleasing ornaments, that we should be doing great violence to our feelings not to admit them among the furniture of the ornamented cottage. . . . That they should be neatly framed, is all that is required. . . . The love of pictures is not confined to persons in the higher situations of life. Do we not see in almost every, the meanest, cottage, ordinary pictures and prints, and, . . . even ballads, pasted on the wall with good effect? Why, then, exclude those of a better sort from a place in the ornamented cottage?"[21]

By the 1830s this view had become part of conventional wisdom, for there was then thought to be "scarcely a cottage where its inmates do not look with pride and pleasure upon some humble effort of art, that adorns the walls of their home, and from the artisan to the titled nobility of our land, the work of the artist and engraver is admired and valued."[22] Prints also appeared outside the home, in the schoolroom, described in the 1830s by Charles Shaw, a working potter: "There were a few pictures on the walls of the usual garish sort, blazing with colour, and all the figures upon them in strikingly dramatic attitudes."[23] Shaw would have been familiar with the "flat-back" figures from the Staffordshire potteries and other mass-produced items that were no less colorful, their attitudes no less striking, together with other commercially manufactured things such as those described by M. K. Ashby: "On the mantelpiece were china figures of old-fashioned policemen, pale blue and white, and small white lions with crinkled manes. On the wall above were hung long hollow glass "walking sticks,"

twisted like barley sugar, one of them filled with tiny coloured balls like the confectioner's "hundreds and thousands." But her basic furniture was ancient—rough oak stools with splayed-out legs."[24]

The consumer society (fig. 14), which had begun to displace the client economy in the eighteenth century, had, by the late nineteenth century, extended to all classes.[25]

NOTES

1. *Mihaly Csikszentmihalyi and Eugene Rochberg-Halton,* The Meaning of Things: Domestic Symbols and the Self *(Cambridge University Press, 1981), quoted by Philip Pacey,* Family Art *(Cambridge: Polity Press, 1989).*

2. *Anonymous,* Building Dictionary *(1734), attributed by contemporaries to James Ralph.*

3. *Samuel Bamford's autobiography* Early Days *(1849), quoted by J. F. C. Harrison,* The Common People *(Glasgow: Fontana/Flamingo, 1984; reprint, 1989), 215 and 300.*

4. *Harold Hughes and Herbert L. North,* The Old Cottages of Snowdonia *(1908; new edition, Gwynedd, Capel Curig: National Park Society, 1979), 65.*

5. *James Ayres,* The Shell Book of the Home in Britain *(London: Faber, 1981), 112–15, 140, 162–80.*

6. *It is generally estimated that it took ten spinsters to keep one weaver supplied with yarn.*

7. *Elizabeth Gaskell,* Mary Barton *(1848).*

8. *Nina Fletcher Little,* American Decorative Wall Painting 1700–1850 *(1952; reprint, New York: E. P. Dutton, 1972).*

9. *Peter Lord,* Artisan Painters/Arlunwyn Gwlad *(Aberystwyth: National Library of Wales, 1993), 13. The reference to painted panels brings to mind a paneled room painted in the early nineteenth century by Robert Hughes that was embellished with a tropical paradise; see page 17.*

10. *This c. 1760 mural is at Sundial House, Corton, near Warminster, Wiltshire.*

11. *The relationship between ceiling height and status is well recognized; see, for example, Linda J. Hall,* The Rural Houses of North Avon and South Gloucestershire 1400–1720 *(Bristol: City Museum and Art Gallery, 1983).*

12. *Christopher Morris, ed.,* The Journeys of Celia Fiennes 1685–c. 1712 *(London, Sydney, Exeter: Macdonald/Webb and Bower, 1982), 236–37. For illustrations of the paintings of Durdans see John Harris,* The Artist and the Country House *(London and New York: Sotheby Parke Bernet, 1979), 61, pl. 54, view by Jacob Knyff, 1673, and pl. 55, by Jacob Scmits (Smits), 1689.*

13. *Horace Walpole, ed.,* Anecdotes of Painting in England: Collected by the late Mrs. George Virtue 4th *(1787 ed.), 4:59.*

14. *Ibid., 4:19–20.*

15. *J. T. Smith,* Nollekens and His Times *(1828; reprint, London: Turnstile Press, 1949), 134–35.*

16. *Edward Edwards,* Anecdotes of Painters *(London, 1808), 32.*

17. *Walpole,* Anecdotes, *4:143–45. The book also cites "Caroline Countess of Aylesbury . . . who works with such rapidity and intelligence, that it is almost more curious to see her pictures in the progress, than after they are finished." George Smart's rhyme, which seems to derive from the verses about Mrs. Worlidge, is quoted by J. Ayres in* British Folk Art *(1977), 88.*

18. *W. S. Lewis,* Selected letters of Horace Walpole *(New Haven and London: Yale University Press, 1973), 235.*

19. *Smith,* Nollekens, *210.*

20. *Flora Thompson,* Lark Rise to Candleford *(1939; reprint, London: Penguin, 1973), 19.*

21. *Edmund Bartell,* Hints for Picturesque Improvements in Ornamented Cottages *(London, 1804), 50–51.*

22. *J. C. Loudon,* Cottage Farm and Villa Architecture *(1836; new edition, London, 1842), 165.*

23. *Charles Shaw,* When I Was a Child *(1903; reprint, 1980), 1–4, quoted by Harrison,* Common People, *289–90.*

24. *M. K. Ashby,* Joseph Ashby of Tysoe 1859–1919 *(1961; new edition, London: Merlin Press, 1974), 172.*

25. *Neil McKendrick, John Brewer, and J. H. Plumb,* The Birth of a Consumer Society: the Commercialisation of Eighteenth-Century England *(London: Hutchinson and Co. Ltd., 1983).*

Urchfont Manor

Artist unknown
c. 1688–1700
Oil on panel
120 x 120 cm (48 x 48 in.)
Urchfont Manor College
(Wiltshire County Council)

Overmantel paintings, in both England and New England, were frequently painted with a representation of the houses that they adorned.[1] In this case, the painting is a very accurate portrait of the east front of Urchfont Manor, near Devizes, Wiltshire, as it survives to this day (fig. 15). The house was built at a time of great change in English domestic architecture; note the newly fashionable sash windows that are flanked by less up-to-date mullions and transoms. The name of William Talman has been associated with the design of this house, which was built between 1678 and 1688. Urchfont was spelled "Erchfont" until about 1940. The manor is now used for residential educational courses.

The house was probably originally set in a "Dutch garden," although this representation may well illustrate an objective rather than the realized truth. The footings of the summer house, visible on the right, were located in the early twentieth century, and one cypress tree, felled in the mid nineteenth century, may have been a survivor from the avenue.

Urchfont Manor boasts no fewer than six overmantel paintings, three on each of the two principal floors (fig. 16). Four of these are English renditions of Italianate landscapes, one is of an English winter scene, with this view of the house being the sixth and most important in the series.

Publication: J. Harris, The Artist and the Country House *(1979).*

NOTE
1. See Nina Fletcher Little, Early American Decorative Wall Painting, 1700–1850 (1972).

Fig. 15. The east front of Urchfont Manor, late 17th century, Wiltshire.

Fig. 16. Overmantel painting, late 17th century, in a bedroom at Urchfont Manor. These paintings were originally built into a scheme of paneling as here. Paintings of this kind were regarded as "furnishing pictures" and as such were often the work of artisan artists.

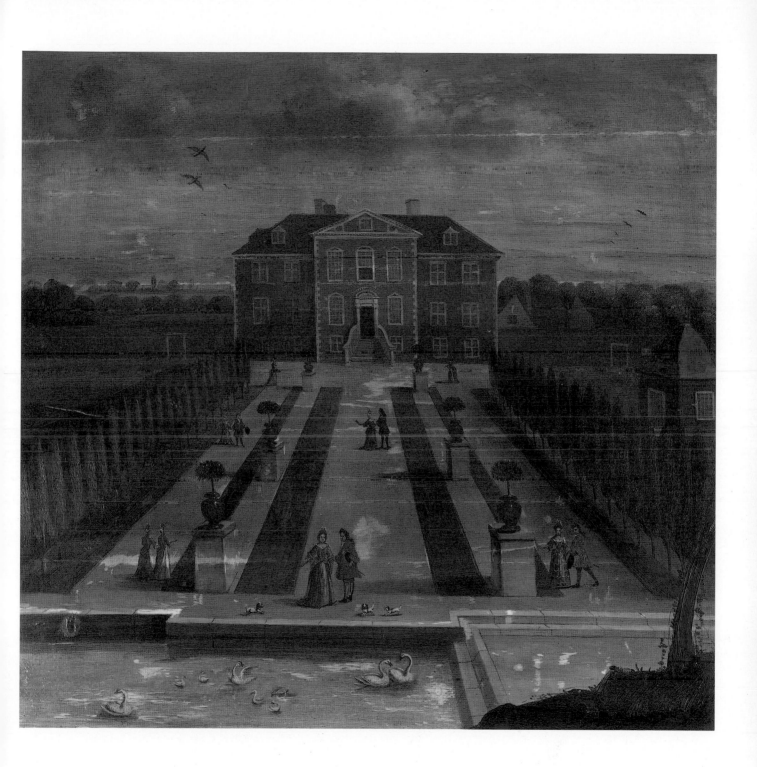

14

The Royal Rat Catcher

J. Clark (signed)
Mid 19th century
Oil on canvas
34.2 x 62.2 cm (12 1/2 x 24 1/2 in.)
Peter Moores Foundation

Clark was from Hoxton, East London, and sometimes described himself as "Animal Painter to the Queen."

The scene is evidently set in the boiler house of one of the royal palaces. The rat catcher himself is shown left of center, proudly wearing a sash bearing the Royal Arms as evidence of his royal appointment.

This painting was formerly part of the collection of Mr. and Mrs. Andras Kalman.

Illustrated: J. Ayres, English Naive Painting *(1980), pl. 32.*

15

Toby Jug

Artist unknown
c. 1800
Carved and painted pine
36.2 x 24 x 16.5 cm
 (14 1/4 x 9 1/2 x 6 1/2 in.)
The Birmingham Museums and
 Art Gallery

The Toby Jug was an invention of the
Staffordshire potters of whom Ralph
Wood was a most distinguished example.
While a carved and painted wood version
of one of these pottery jugs is unusual,
Pinto[1] refers to two related examples.

NOTE
1. Edward H. Pinto, Treen (London: G. Bell and
 Sons, 1969), 43, fig. 41.

16

Newlands

W. Roberts
1860
Inlaid panel in teak and bone
57.15 x 69.85 cm (22 1/2 x 27 1/2 in.)
The Judkyn/Pratt Collection

As a porter at Ruthin Castle, it is possible that Roberts used an old draining board and broken knife handles to construct this remarkably alien-looking object. He inscribed it on the back "Done by W. Roberts, Porter, Ruthin Castle, 1860."

At least one other example of Roberts' work is known, his *Chirk Castle, Denbighshire, North Wales.*

Exhibited: America and British Folk Art, *U.S. Embassy, London, 1976;* The Art of the People, *Cornerhouse Arts Centre, Manchester, 1985–86;* A Common Tradition, *University of Brighton, 1991;* Judkyn/Pratt Collection British Folk Art Collection, *Peter Moores Foundation, 1994–95.*

17

Carved Wooden Spoon

Maker unknown
19th century
Sycamore
34.8 x 7.3 x 3.7 cm
 (13 3/4x 2 3/4 x 1 1/2 in.)
The Birmingham Museums and
 Art Gallery

All manner of small domestic objects were carved in wood and given as love tokens. In England and Wales, knitting sheaths were particularly popular vehicles for such demonstrations of affection. In the Principality (Wales), spoons were also made for this romantic purpose. Carving from the solid a chain or, as here, a captive ball has always been seen as a virtuoso performance on the part of the whittler in wood (a word that probably derives from "whittle," a large knife). In practice, most of these objects seem to have been made using conventional wood-carving tools. The production of these highly decorated yet utilitarian objects seems to relate closely to the mass-production of edged tools in centers such as Sheffield and Newcastle.

Fig. 17. W. Roberts, Chirk Castle, Denbigshire, 1735.

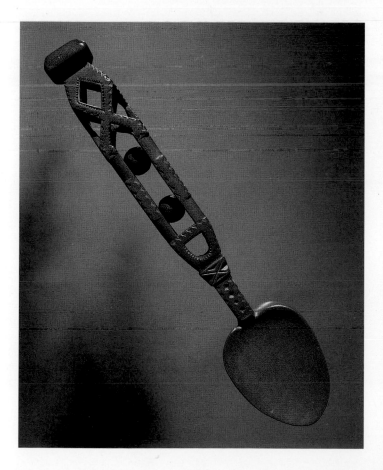

Knitting Sheaths

In William Howitt's invaluable book *The Rural Life of England*, first published in 1838, knitting is described as "the most characteristic custom of the Dales [Yorkshire valleys]"[1] for both men and women. It was a cottage industry of great commercial value. In the 1820s, knitting from Wensleydale and Swaledale alone was worth some £40,000 a year.[2]

The knitting produced in the north of England and South Wales was made in an Anglo-Scandinavian technique. It involved the use of long flexible steel needles, one of which was inserted into the knitting sheath and held between the upper arm and torso.

Howitt describes knitting parties in the Dales when groups of neighbors would gather in a house at night and, in near darkness by the light of the fire, would "sit and knit, sing knitting-songs, and tell knitting-stories . . . all this time the knitting goes on with unremitting speed. They sit rocking to and fro like so many weird wizards. . . . And this rocking motion is . . . called swaving," a movement that was evidently a by-product of this particular method of working. Howitt continues, "the knitting produced is just the same as by the ordinary method. They knit with crooked pins called pricks; and use a knitting-sheath consisting commonly of a hollow piece of wood, as large as the sheath of a dagger, curved to the side [of the body], and fixed in a belt called a cowband. The women of the north, in fact, often sport very curious knitting sheaths. We have seen a wisp of straw tied up pretty tightly, into which they stick their needles; and sometimes a bunch of quills of at least half-a-hundred in number. These sheaths and cowbands are often presents from their lovers to the young women. Upon the band there is a hook, upon which the long end of the knitting is suspended that it may not dangle. In this manner they knit for the Kendal market, stockings, jackets, nightcaps, and a kind of cap worn by the negroes called bump-caps. These are made of very coarse worsted, and knit a yard in length, one half of which is turned into the other, before it has the appearance of a cap."[3]

The messages inscribed on many knitting sheaths confirm Howitt's account of their being given as love tokens. In this respect they are comparable to other such items as stay-busks (corset stays). Peter Brears has identified regional characteristics for sheaths from Durham, Weardale, Cumbria, South Wales, Cornwall, and Warwickshire, with regional variations within Yorkshire including Airedale, Clapham, and Eskdale.[4]

Knitting sheaths, in deference to hard wear, were made of close-grained woods such as holly, yew, and fruitwood and also metal and whale ivory. A few of these miniature works of art are known to have been made by professional or semi-professional woodworkers and turners. From the 1780s, Thomas Tarn of Middleton in Teesdale was producing particularly fine examples, a tradition maintained into the twentieth century by his descendant Timothy Tarn (see cat. 19c). Brears notes that a similar continuity occurred with the Scott family of Walker Hill Farm in the same village.

NOTES

1. W. Howitt, The Rural Life of England (*London, 1838; reprint of the 1844 edition, Shannon: Irish University Press, 1971*), 237.
2. Peter C. D. Brears, North Country Folk Art (*Edinburgh: John Donald, 1989*), 47.
3. Howitt, Rural Life, 238.
4. Peter C. D. Brears, "The Knitting Sheath," Folk Life: Journal of Ethnological Studies 20 (1981–82), 16–40.

18a

Knitting Sheath

Maker unknown
1800–1850
Carved sycamore
Length 21.4 cm (8 3/8 in.)
The Birmingham Museums and Art Gallery

Exotic imported hardwoods were
sometimes used in place of native fruit or
shrub woods.

18b

Knitting Sheath

Maker unknown
1700–1900
Carved sycamore
Length 31.4 cm (12 1/4 in.)
The Birmingham Museums and Art Gallery

Knitting sheaths often provided the
opportunity for a display of technical
proficiency as here in the chain that is
carved out of solid wood. For such work
the small scantlings and close grain of
sycamore were ideal.

18c

Knitting Sheath

Maker unknown
1750–1850
Carved sycamore
Length 24 cm (9 1/2 in.)
The Birmingham Museums and Art Gallery

This knitting sheath is relatively utilitarian, despite which it is composed of a pleasing combination of geometric forms.

18d

Knitting Sheath

Maker unknown
1805
Boxwood
Length 21.9 cm (8 5/8 in.)
The Birmingham Museums and Art Gallery

The initials "MG" probably stand for the recipient rather than the maker. Boxwood was often chosen for making objects of this kind, being close in texture.

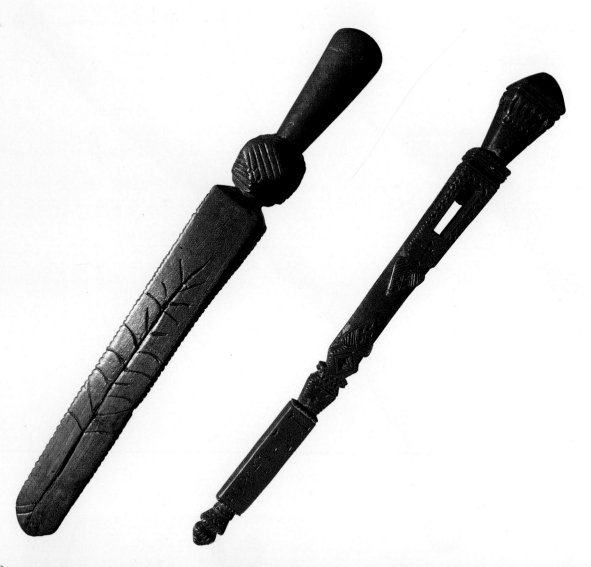

18e

Knitting Sheath

Maker unknown
1800–1850
Mahogany, boxwood, glass
Length 24.3 cm (9 1/2 in.)
The Birmingham Museums and Art Gallery

The heart motifs and the name of the
recipient Mary Armstrong, inscribed
under glass in the recessed panel, indicate
that knitting sheaths were regularly made
as love tokens.

18f

Knitting Sheath

Maker unknown
19th century
Mahogany, ivory, bone
Length 30.9 cm (12 1/8 in.)
The Birmingham Museums and Art Gallery

Knitting sheaths of this form are known as
"goose wings." It was a shape particularly
suitable for its function. These sheaths
were placed under the armpit (the curve
following the line of the knitter's body),
leaving the tubular section exposed to
receive the end of the knitting needle. In
this system of knitting, the needle held
under the arm in the sheath was kept
relatively static while the other needle (or
needles) held in the right hand did most
of the work. Today knitting is seldom
performed in this traditional way in
Britain, but the technique survives in
Scandinavia.

19a

Knitting Sheath

Maker unknown
Late 18th to early 20th century
Hardwood
Length 15 cm (6 1/4 in.)
Beamish, The North of England
 Open Air Museum

This straight knitting sheath has a
diagonal slot and inlay. It is inscribed:
"When this you see, Remember me."

19b

Knitting Sheath

Maker unknown
1851
Hardwood
Length 20 cm (7 7/8 in.)
Beamish, The North of England
 Open Air Museum

This straight chip-carved knitting sheath
has a diagonal slot, typical of County
Durham. It is inscribed "A. Harrison
1852."

19c

Knitting Sheath

Probably Timothy Tarn
1905
Hardwood
Length 22.5 cm (8 7/8 in.)
Beamish, The North of England
 Open Air Museum

This knitting sheath is in the form of a
shoe, the heel of which is inscribed
"J. B. 1905." This example was probably
made by Timothy Tarn of Forest in
Teesdale for Jane Beadle.

19d

Knitting Sheath

Maker unknown
Late 18th to early 20th century
Hardwood, brass, glass
Length 19.9 cm (7 7/8 in.)
Beamish, The North of England
 Open Air Museum

This knitting sheath with brass-inlaid studded initials "MAC" is in the form of a fish with an inlaid glass eye. It is from Northumberland.

19e

Knitting Sheath

Maker unknown
Early 20th century
Hardwood, metal
Length 29 cm (11 1/2 in.)
Beamish, The North of England
 Open Air Museum

This goose-wing knitting sheath has metal inlay including First World War badge, figure of peace, heart, open book, sheaf of wheat, diamond, spade, and sword. It is from Wensleydale, Yorkshire.

19f

Knitting Sheath

Maker unknown
Late 18th to early 20th century
Hardwood
Length 23.2 cm (9 1/8 in.)
Beamish, The North of England
 Open Air Museum

This goose-wing knitting sheath, carved on its face, is probably from County Durham.

Military Patchwork

Artist unknown
Mid 19th century
Coverlet made probably from materials
 used for military uniforms
208 x 258 cm (81 3/8 x 101 1/2 in.)
Peter Moores Foundation

Coverlets such as this are known to have been made by tailors specializing in military uniforms or by soldiers recuperating in hospital following injury in battle.

The colors (flags) shown here may represent those presented at Newcastle upon Tyne to the 98th Regiment on May 10, 1841, by Major General Sir Charles Napier K.C.B., which were carried until 1856 when new colors were presented. The Queen's Color carries the battle honor "China" (1840) the Punjab (1848–49); the device below the wreath is a China Dragon. A fragment of the 1841 colors survives in the museum of the Staffordshire Regiment in Litchfield, and the 1856 colors hang in the Garrison Church of St. George in Lichfield.[1]

The symbols that surround the colors include, for England, the red cross on a white field of St. George, the Scottish cross of St. Andrew, the Irish harp, and the red, white, and blue of the Union flag. The British Union Jack symbolizes the Acts of Union with Scotland (1707) and with Ireland (1801) by combining the crosses of sts. George, Andrew, and Patrick.

The quilt was formerly in the collection of Mr. and Mrs. Andras Kalman.

NOTE
1. *Information kindly supplied by the Regimental Headquarters of the Staffordshire Regiment, Lichfield, Staffordshire.*

21

Patchwork Quilt

Artist unknown
Second quarter 19th century
Various textiles
250 x 270 cm (98 1/2 x 106 1/4 in.)
Beamish, The North of England
 Open Air Museum

The maker of this quilt was probably from
Weardale, County Durham, in the
northeast of England.

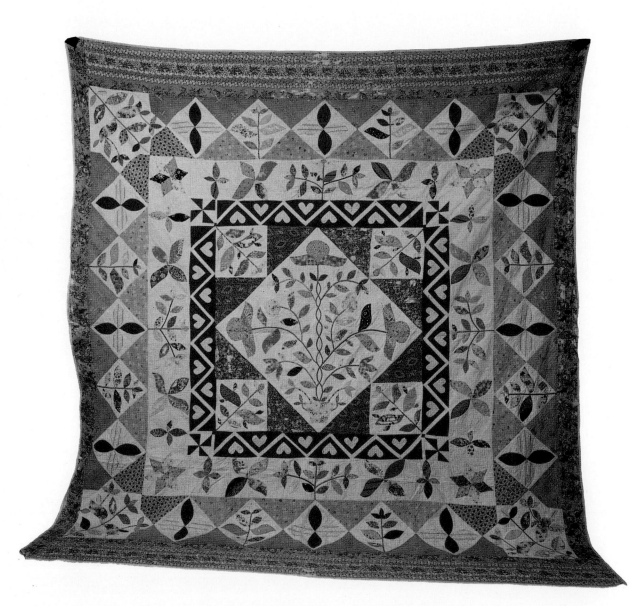

22

Patchwork Quilt: Eight-Pointed Star

Artist unknown
c. 1870–80
Various textiles
254 x 257 cm (100 x 101 in.)
Beamish, The North of England
 Open Air Museum

Although resembling some quilts made in the United States, this example is typical of the north of England. The turkey red in some of the pieces of cloth was a fast dye that was developed at the mills in New Lanark in Scotland, the Utopian settlement so closely associated with the social reformer Robert Owen (1771–1858). The quilting is stitched in a pattern of small flowers and large feathers with diamond infill. The maker of this

quilt was probably from Weardale, County Durham, in the northeast of England.

See Rosemary E. Allan, North Country Quilts *(Beamish, n.d.); Freda Parker,* Victorian Patchwork *(1991).*

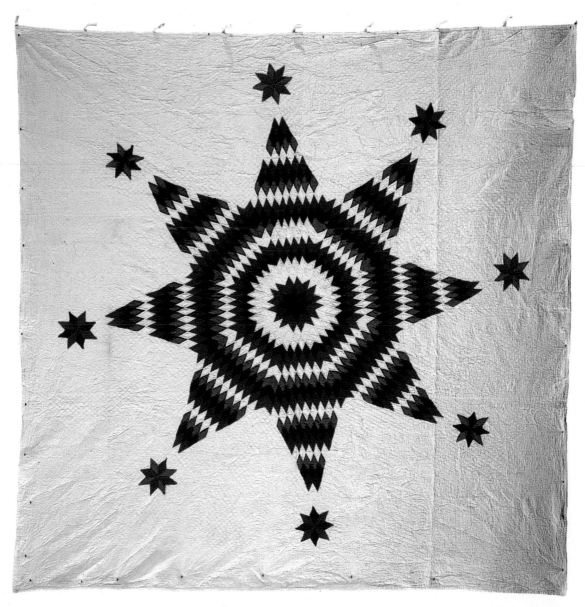

Sampler

Elizabeth Brown
1844
Embroidered in yarn on canvas
82 x 75 cm (32 5/8 x 30 in.)
Beamish, The North of England
 Open Air Museum

Elizabeth Brown included in her design
the legend "Worked this in the 17th year
of her Age." She later married into a
branch of the Hindmarsh family of
Newcastle upon Tyne.

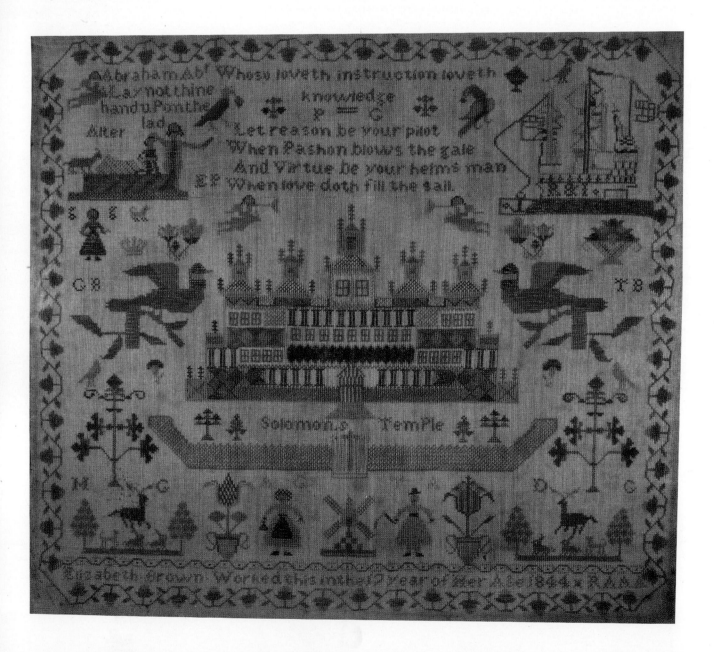

24

The Lord's Prayer

Charles Brown
1849
Ink on paper
51.44 x 39.37 cm (20 1/4 x 15 1/2 in.)
Leicestershire Museums Arts and
 Records Service

Calligraphy, as a functional necessity, has always been an important part of education. Numerous instruction manuals were published on the subject. Enoch Noyes' *An Analytical Guide to the Art of Penmanship* (Boston, 1832) advises that "Good quills and a sharp knife are the first things necessary. Quills that grow on the left wing will better conform to the hand than those on the opposite," a silent acknowledgment of an age when it was compulsory to be right-handed. In the United States, calligraphic drawings of this date are well known, but in England they are much rarer, perhaps because the fashion for this work occurred there in the late seventeenth century. This may have been in response to the development of steel-nibbed pens. As early as 1680, the writing master John Ayres of St. Paul's Church Yard, London, advertised "steel pens" in his book on calligraphy.[1]

NOTE
1. *Ambrose Heal,* The English Writing-Masters and Their Copy-Books 1570–1800 *(Cambridge University Press, 1931).*

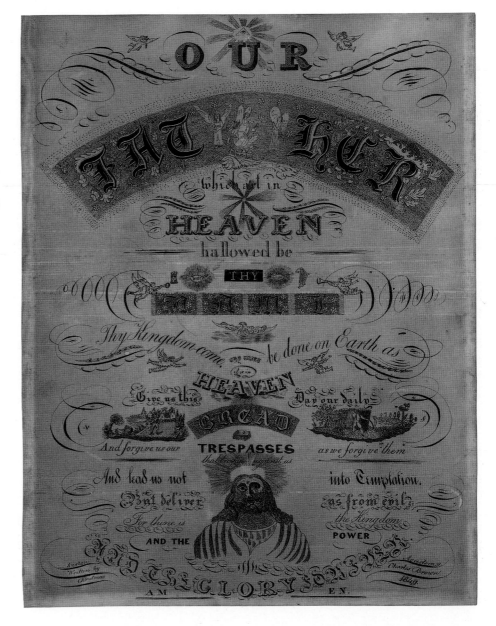

Tray: Adam Naming the Animals

Artist unknown
Second quarter 19th century
Oil on tin
52.5 x 73.75 cm (21 x 29 1/2 in.)
The Judkyn/Pratt Collection

Fig. 18. Artist unknown, Adam Naming the Animals, c. 1840, painted tin tray, ex coll. Ruth Troiani, New York. This is another version by the same hand as cat. 25.

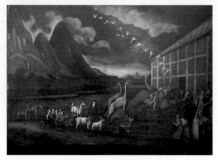

Fig. 19. Artist unknown, Noah's Ark, painted tin tray, private collection. Although the artist is not known, the tray appears to be by the same hand as the person who painted Adam Naming the Animals, possibly a trade-painter in the Birmingham area.

Painted tin trays (actually made of tin-plated sheet iron) were an important product in Birmingham and Pontypool. Most examples have a "sub-polite" appearance, which makes this example somewhat unusual. However, other painted trays from the same hand are known, including at least one other version of this subject (fig. 18) and *Noah's Ark* (fig. 19).

The subject of this painting is biblical: "And Adam gave names to all cattle, and to the fowl of the air, and to every beast of the field" (Genesis 2.20). Themes that included numerous animals, such as Animals Entering Noah's Ark, Orpheus Charming the Birds and Beasts, and The Peaceable Kingdom, could result in compositions with a similar character. The Peaceable Kingdom was a subject that was painted on numerous occasions by the American Edward Hicks (1780–1849) who, as a coach painter, was a typical vernacular artist.

Illustrated: J. Ayres, English Naive Painting (1980), pl. 94; J. Ayres, British Folk Art (1977), 97.

Exhibited: America and British Folk Art, *U.S. Embassy, London, 1976;* The Art of the People, *Cornerhouse Arts Centre, Manchester, 1985–86;* A Common Tradition, *University of Brighton, 1991;* Judkyn/Pratt Collection British Folk Art Collection, *Peter Moores Foundation, 1994–95.*

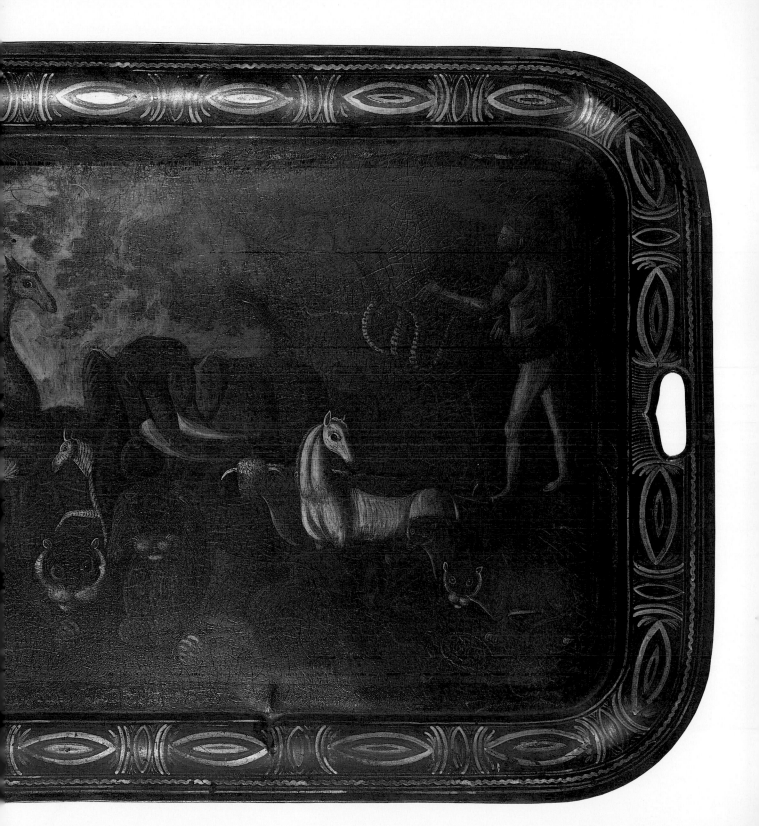

Still Life with a Cheese in a Cradle

J. B. Higginson (signed and dated)
1869
Oil on canvas
62.86 x 76.2 cm (24 3/4 x 30 in.)
The Judkyn/Pratt Collection

John Booth Higginson, like his father before him, is listed in the *Trade Directories* for Staffordshire as a "house painter and decorator." He signed the painting in very faint pencil, on the reverse: "J. B. Higginson, Madeley, Staffs. 1869."

Illustrated: J. Ayres, English Naive Painting *(1980), pl. 72; J. Ayres,* British Folk Art *(1977), 103.*

Exhibited: America and British Folk Art, *U.S. Embassy, London, 1976;* The Art of the People, *Cornerhouse Arts Centre, Manchester, 1985–86;* A Common Tradition, *University of Brighton, 1991;* Judkyn/Pratt Collection British Folk Art Collection, *Peter Moores Foundation, 1994–95.*

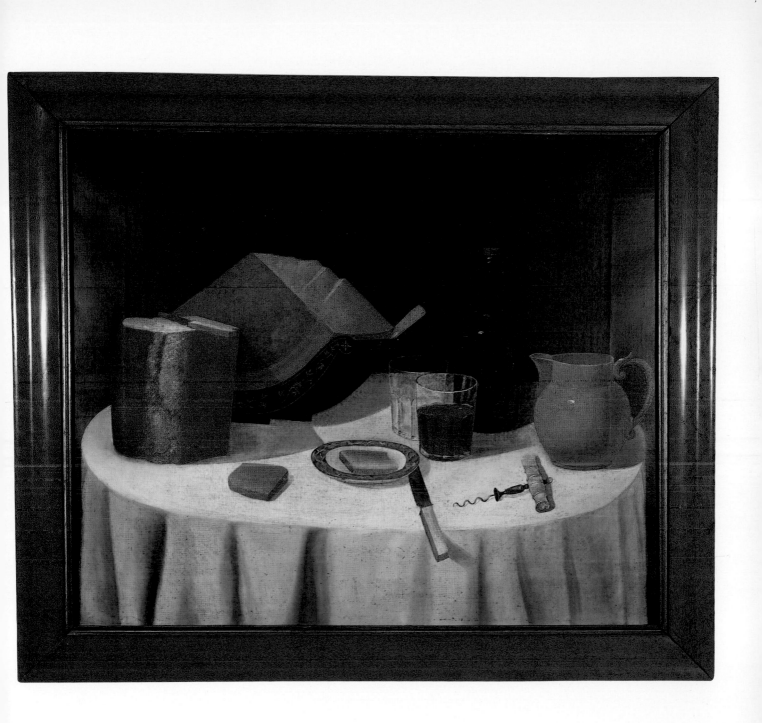

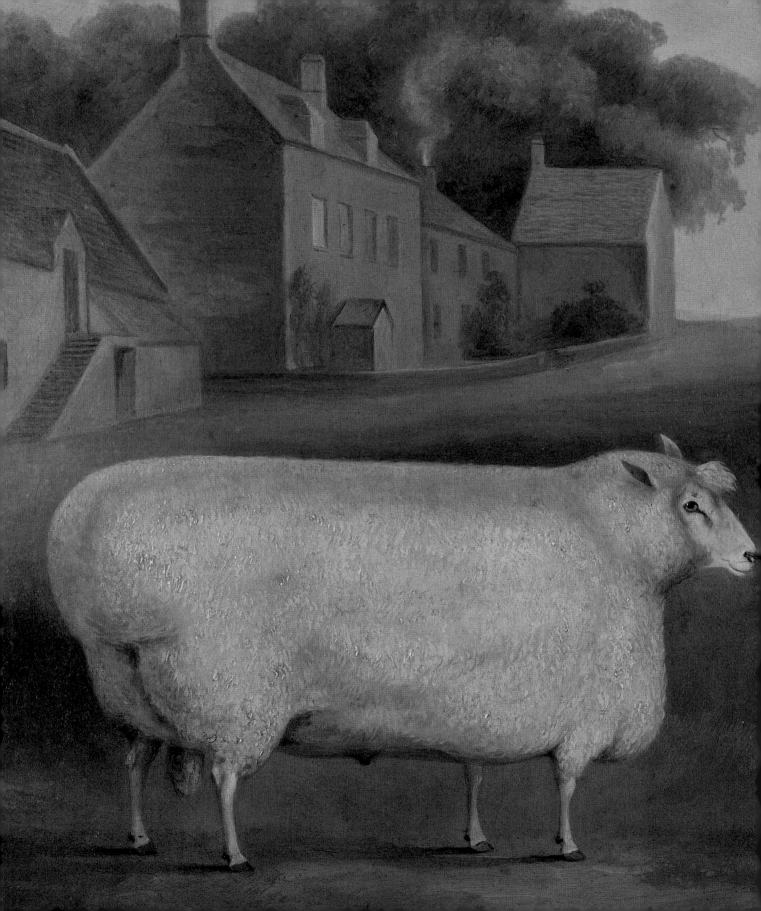

Farms and Farming

The dramatic improvement in agriculture that took place in Britain in the second half of the eighteenth century was recorded in paintings by artists of all levels of ability and background (fig. 20). Their work ranged from the generally predictable efficiency of an academician to the sometimes heraldic splendors of an artisan painter. It was a diversity that may be explained as much by the great variety of clients who commissioned such works as by the artists who created them. In addition to such magnates as Coke of Holkham, there were numerous prosperous farmers who were keen to have their fat cattle, sheep, and pigs recorded pictorially for posterity. This was no art for art's sake; rather, it was painting in the service of agriculture. Even so, in many instances these portraits of farm animals triumphed over the utilitarian needs that both disciplined and inspired their production.

The horse has long been a serious subject for animal portraiture. Indeed, the sporting world in general had every reason to provide a visual record for an animal with special qualities or record-breaking characteristics. Similar motives were to give pictorial expression to the achievements of animal husbandry. In 1697, Celia Fiennes described in her journals the pantry at Newby Hall, the Yorkshire seat of Sir Edward Blacket, where there hung "a picture of the dimensions of a large ox that was fed in these grounds with the account of its weight."[1] A couple of decades later, Defoe visited Sir Edward, whom he described as "a grazier," adding that Blacket bred the best and largest oxen and large black cattle: "He had, two or three times, an oxen out of his park led about the country for a sight, and shewed as far as Newcastle and even to Scotland for the biggest bullock in England."[2] The tradition for breeding and exhibiting these monstrous farm animals has a long history in England. In April 1766 the Reverend John Penrose, on a visit to Bath, alluded to "a remarkably large ox" that could be viewed in the city for three pence a head. This animal had been "fattened on Hay alone" and stood seventeen and a half hands high (5 ft. 10 in.). This ox had cost its owner £40, but he made £4 for exhibiting it, and when slaughtered the meat would be sold for not less than an exorbitant six pence a pound.[3] Pictures of such beasts were to become a significant feature of the agricultural revolution in the closing decades of the eighteenth century and on into the nineteenth. These paintings generated numerous prints that were issued in large editions and, like the Newby

Detail, cat. 36

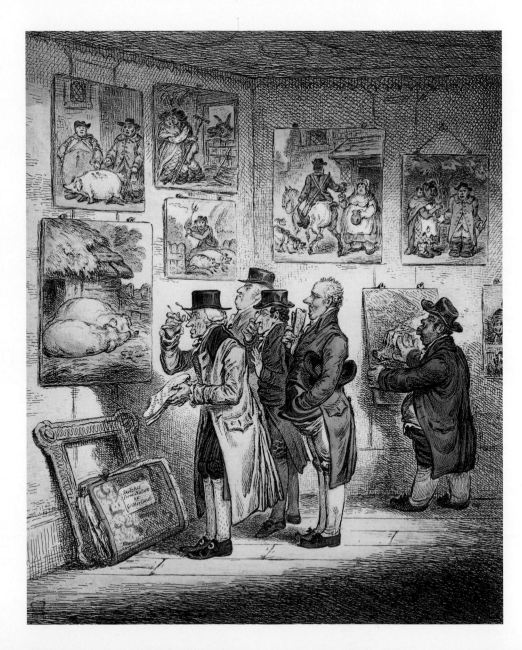

Fig. 20. James Gillray,
Connoisseurs
Examining a
Collection of George
Morland's, *1807.*
Copyright British
Museum.

TWO HUNDRED YEARS OF ENGLISH NAIVE ART

Hall Ox, give very full documentary information concerning the weight and dimensions of the animals portrayed. The famous Yorkshire Hog was both drawn and painted by R. Pollard. It was described as "this stupendous creature [that] for height and length far exceeds any of this species ever yet seen measuring 9'10" long 8' round the body, stands 12 1/2 hands high [4 ft. 2 in.], 4 years old and weighs 1344 lbs." Animals such as this could produce a considerable income for their owners. In addition to stud fees (where appropriate), the sale of prints and the "gate money" resulting from exhibiting such creatures was impressive. In a three-year period to 1809, the Yorkshire Hog made a total of £3,000. Even this beast was exceeded by Joseph Lawton's prize *Midland Plum Pudding Pig*, which weighed 1,410 lbs. (cat. 31). These prize animals were sources not only of income, but also of prestige. As with race horses, all concerned were given "credits," and most prints and some paintings list, in addition to the animals' vital statistics, the names of their owners, breeders, and feeders.

In projecting back into a predominantly agrarian past, sentiment may too easily persuade one that vernacular art was confined to the rural situation where change was gradual. The historical reality was one in which the dynamic change in agriculture was in many ways the precursor, the precondition, for the revolution in manufacturing industry. By 1851, the British census established that, for the first time in history, more people lived in urban centers than in the countryside.[4] This huge urban population had to be fed. The industrial revolution triumphed on the back of a remarkable series of agrarian innovations.

Among the founding fathers of this revolution on the land were Jethro Tull (1674–1744) and his seed drill, Charles Townshend (four-crop rotation in the 1730s), and Thomas Coke of Holkham whose innovations resulted in an increase in the value of his annual rent roll on his Norfolk estate from £2,200 in 1776 to £20,000 in 1816.[5] Of all these developments in husbandry, none would be more important than the improvement of livestock by selective breeding. This had long been recognized as the best way of improving thoroughbred horses (with equine portraits being an important aspect of this process). So far as farm animals were concerned, the regional nature of early agriculture resulted in breeds that were associated with particular places. Indeed, such breeds of cattle as Guernsey, Jersey, and Frisian were once confined to those small islands whose names they bear. The consistent isolation, geographical or otherwise, of a particular breed was known to contemporaries of the wood engraver and writer Thomas Bewick (1724–1806) as breeding "in-and-in," with the vitality of the herd being maintained by hiring "Bulls by the Season."[6] This systematic improvement of existing stock was pioneered with sheep and cattle by Robert Bakewell (d. 1795) of Dishley Grange, Leicestershire.[7] In addition, other breeds of cattle were imported into England, particularly the so-called Holstein or Dutch breed. Edward Hall of Northumberland owned an ox of this breed on his land at Whitley, which at the age of seven years measured 9 ft., 8 1/2 in. from head to rump, and stood 5 ft., 10 in. at the shoulder.[8]

Associated with the development of these breeds was the necessity to provide visual documentation of a particular animal. This was especially relevant at a time when printed stock and flock books had yet to be published. The farmer needed some record of his achievement, some indication of the quality and ancestry of his stock, and some means of advertising his product. This explains the presence of animal paintings and prints in the collections of old-established farming families; such images were also

to be seen in butchers' shops.[9] It was in answer to this highly practical demand that a whole group of painters responded. Inevitably the quality of their work ranges from the objective to the improbable, from George Stubbs (1724–1806) to the ideograph whose authorship is shrouded in anonymity. Between these two extremes were the highly proficient works of such artists as Thomas Weaver of Chester (1774–1843) or the less consistent but often stimulating work of John Boultbee (1747–1812). Some, such as W. H. Davis (cat. 36), could approach Weaver's level of sophistication, even though in this instance the drawing of the buildings in the middle distance conveys a sense of great depth, due in large measure to a dislocated sense of perspective.

The emblematic nature of these paintings could be utilized to represent the aspirations rather than the achievements of the breeder. Thomas Bewick has left a graphic description of the conflict that these artists were expected to resolve between the requirements of the farmer and the actual appearance of the prize animal to be portrayed: "After I had made my drawings from the fat sheep, I soon saw that they were not approved, but that they were to be made like certain paintings shown to me. I observed to my employer that the paintings bore no resemblance to the animals whose figures I had made my drawings from; and that I would not alter mine to suit the paintings that were shown to me. . . . My journey, as far as concerned these fat cattle makers, ended in nothing. I objected to put lumps of fat here and there where I could not see it, at least not in so exaggerated a way as on the painting before me; so "I got my labour for my trouble." Many of the animals were[,] during this rage for fat cattle, fed up to as great a weight and bulk as it was possible for feeding to make them; but this was not enough; they were to be figured monstrously fat before the owners of

them could be pleased. Painters were found who were quite subservient to this guidance, and nothing else would satisfy. Many of these paintings will mark the times, and, by the exaggerated productions of the artists, serve to be laughed at when the folly and the self-interested motives which gave them birth are done away."

Despite his reservations about commissions to paint farm animals, Bewick nevertheless produced a magisterial woodcut of the Chillingham Wild Bull (1789).[10] Payment for this sort of work could be lavish. George Stubbs received £64 12s 6d for *The Lincolnshire Ox* (1790), his son a hundred guineas (£105) for engraving it (in 1791), with a specialist subcontractor receiving £1 11s 6d for engraving the inscription. Prints of this kind could be purchased for three guineas plain or four guineas colored (such as Ward's mezzotint after Weaver's *Thomas Coke with the Holkham Shepherds*[11]), although the cheapest, such as Garrard's prints, could be bought for a modest 2s 6d.

The degree to which painters specialized in animal portraiture varied considerably. The work evidently required some knowledge of animal husbandry, since it was the values of agriculture rather than the aesthetics of painting that prevailed. Indeed some of these artists were drawn from the farming community itself. Perhaps the most significant among them was John Bailey of Chillingham (1750–1819) who, in addition to drawing and engraving (*The Howick Mottled Ox*, 1788) was the author of *An Essay on the Construction of the Plough* (1795), *A General View of the Agriculture of the County of Northumberland* (1797), and a similar volume on Durham (1810).

The decline of this important tradition for animal portraiture closely mirrors the first books devoted to the breeding of particular farm animals. The first was devoted to the shorthorn breed of cattle: *Coate's Herd*

Book of 1822. In contrast, the first stud books for many heavy horses did not appear until 1878–80, the first herd books for pigs (Berkshire) in 1884, while flock books for sheep did not come out until 1910. As these various publications for particular breeds became available, so the demand for portraits of these animals dwindled. It had once been a tradition so closely associated with the agrarian revolution in Britain that it was all but confined to these islands. Exceptions in the United States of America include Thomas H. Hinckley (1813–96), and in Canada Joseph Swift of Toronto (d. 1889), who specialized in painting livestock.[12] It was an artistic idiom born of practical necessity.

NOTES

1. *Christopher Morris, ed.,* The Journeys of Celia Fiennes 1685–c. 1712 *(London, Sydney, Exeter: Macdonald/Webb and Bower, 1982), 97.*

2. *Daniel Defoe,* A Tour Through the Whole Island of Great Britain *(1724; new edition abridged and edited by P. N. Furbank, W. R. Owens, and A. J. Coulson, New Haven: Yale University Press, 1991), 267.*

3. *Brigitte Mitchell and Hubert Penrose, eds.,* Letters from Bath 1766–1767 by the Reverend John Penrose *(Gloucester: Alan Sutton, 1983; reprint, 1990), 46.*

4. *J. F. C. Harrison,* The Common People *(Glasgow: Fontana Press/Collins, 1984; reprint, 1989), 226–27.*

5. *These events are well summarized in Demelza Spago, ed.,* This Land Is Our Land: Aspects of Agriculture in English Art *(exh. cat. London: The Royal Agriculture Society of England, Mall Galleries, 1989), 39.*

6. *Thomas Bewick,* A General History of Quadrupeds *(1790; Newcastle upon Tyne, 1824), 32.*

7. *Ibid., 34, for the Longhorn Cattle or Lancashire breed.*

8. *Bewick,* Quadrupeds, *29–30.*

9. *W. Gurney Benham, "John Vine of Colchester,"* Essex County Standard *(Dec. 26, 1931).*

10. *Bewick gives a good account of these wild cattle in* Quadrupeds, *38–41.*

11. *W. S. Sparrow,* A Book of Sporting Painters *(New York: Scribner's, 1931; London: John Lane, 1938), 24.*

12. *See, for example, Swift's* Flock of Imported Cotswold Sheep, *1887, watercolor and pencil, 17 5/8 x 33 1/2 in., Royal Ontario Museum, Toronto. Another such artist was the farmer Ebenezer Birrel (Good Friends, oil, 23 x 28 in., Hamilton Art Gallery, Ontario). See* A People's Art: Primitive, Naive, Provincial and Folk Painting in Canada *(Toronto: University of Toronto Press, 1974), pls. 45 and 47. For further information, see R. John Dawes,* The Art of American Livestock Breeding *(exh. cat. Pittsboro, N.C.: The American Minor Breeds Conservancy, 1991).*

Allegorical Figure: Spring

Artist unknown
Third quarter 18th century
Carved and painted wood
136.6 x 32.5 x 32.5 cm
 (53 3/4 x 13 x 13 in.)
Nick Woodbridge

This and its accompanying figure *Autumn* are numbered "1" and "3," indicating that they are two of a series of the four seasons. They are said to have come from a Free Trade Hall or Corn Exchange in northern Wales, a possibility reinforced by the subject matter. The artist was possibly a ship or sign carver.

28

Allegorical Figure: Autumn

Artist unknown
Third quarter 18th century
Carved and painted wood
136 x 32.5 x 32.5 cm
 (53 1/2 x 13 x 13 in.)
Nick Woodbridge

Shorthorn Cow

Artist unknown
c. 1830
Oil on canvas
41.25 x 50 cm (16 1/2 x 20 in.)
Iona Antiques, London

The picture is inscribed at the bottom "Joseph Hutchinson's Old Cow." More often such pictures show animals in their prime.

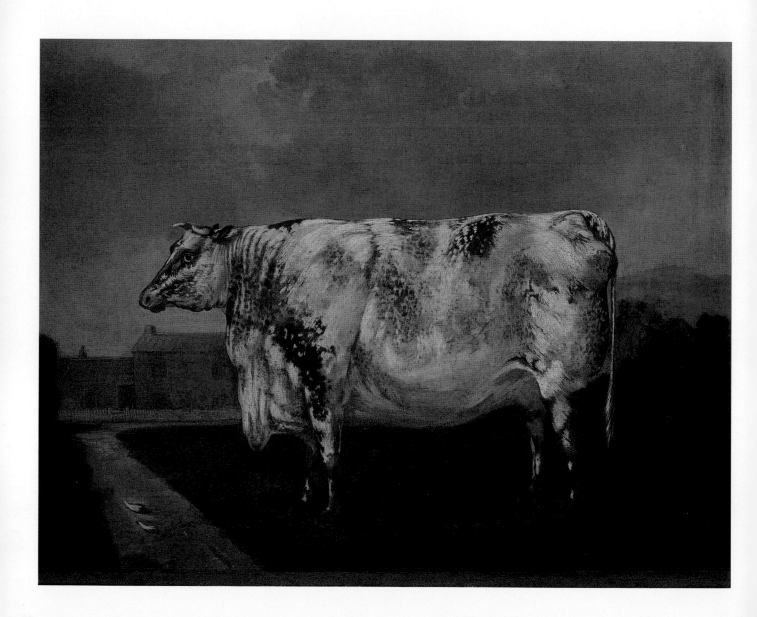

Sign: *Jack Onions, Rat Catcher*

Attributed to William Hatton
c. 1840–1850
Oil on panel
59.69 x 110.49 cm (23 1/2 x 43 1/2 in.)
Leicestershire Museums Arts and
 Records Service

This sign reveals in its lettering all the confident flourish of the professional sign writer in contrast to the more tentative yet charming pictorial treatment in the lunette.

It is known, from the relevant *Trade Directory* for 1861-63, that Jack Onions was based in the village of Belton near Loughborough. With a population of only 781 in 1861, Belton was unable to support specialist painters. The directory does, however, list "Hatton John, plumber, &c." The "&c" traditionally comprised glazing and painting, which makes Hatton the most likely author of this panel. An alternative if less likely attribution would be William Shaw, who is listed in the directory as a carpenter.[1]

The sign was formerly in the collection of the Loughborough Museum.

Exhibited: Focus on Folk Art (Leicester, 1989).

NOTE
1. *Information kindly supplied by Philip French of Leicestershire Museums.*

Joseph Lawton's Midland Plum Pudding Pig

Attributed to Thomas Peploe Wood
 (1817–45)
Early 19th century
Oil on canvas
67.31 x 106.68 cm (26 1/2 x 42 in.)
Private Collection

The painting was probably commissioned by Joseph Bradbury of Little Hayward, Staffordshire. The village is shown in the background of the picture, which also includes the Lichfield Arms, an inn now called the Lamb and Flag, on the left, with local malt houses, now demolished, on the right. As the inscription on the painting states, this animal was bred by Joseph Lawton, with a length of 9 ft., a height of 4 ft. 8 1/2 in., and a weight of 12 cwt 66 lbs., which, translating each "long" hundredweight as 112 lbs., is 1,410 lbs., possibly the largest pig ever reared in the British Isles.

Exhibited: A Neglected Heritage . . . 1760–1900, *Rutland Gallery, London, 1987.*

32

A Prize Hereford Cow

J. Miles (signed and dated)
Dec. 13, 1842
Oil on canvas
64.14 x 76.83 cm (25 1/4 x 30 1/4 in.)
Cheltenham Art Gallery and Museums

John Miles was one of the most prolific of the vernacular animal painters of the second quarter of the nineteenth century. Based in Northleach, Gloucestershire, his surviving works are inevitably of Cotswold subjects.

Late autumn and early winter were the busiest months for these painters, as portraits of livestock were often commissioned just prior to slaughter.

33

Farm Scene in Winter

W. Clifton (signed and dated)
1883
Oil on canvas
40 x 55 cm (16 x 22 in.)
Private Collection, England

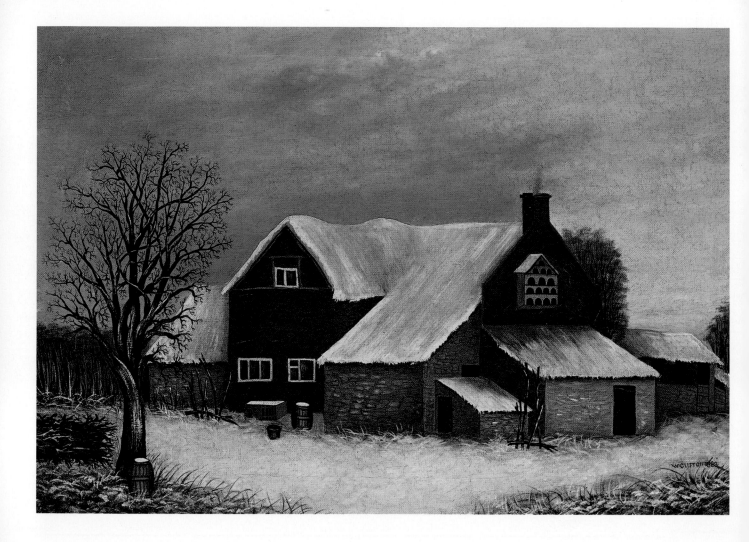

34

Farm Scene in Summer

W. Clifton (signed and dated)
1883
Oil on canvas
40 x 55 cm (16 x 22 in.)
Private Collection, England

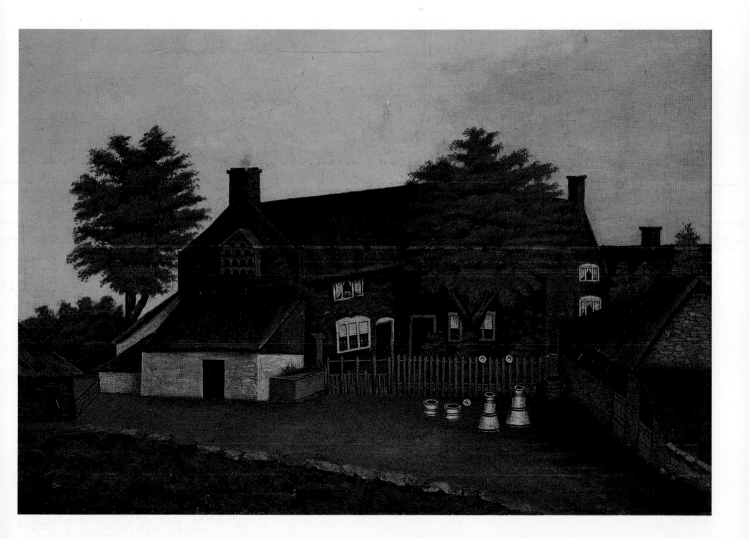

35

A Prize Sow Outside a Sty

Artist unknown
c. 1840
Oil on canvas
37.35 x 50.62 cm (15 x 20 1/4 in.)
Iona Antiques, London

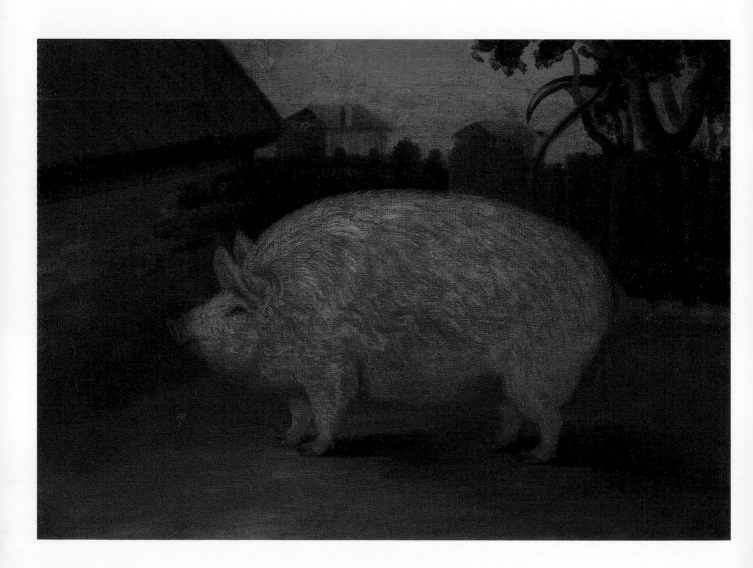

Richard Lane's Cotswold Rams

William Henry Davis (1783–1864)
 (signed and dated)
1850
Oil on canvas
55 x 76.25 cm (22 x 30 1/2 in.)
Iona Antiques, London

Richard Lane was one of the more prominent sheep breeders in the Cotswolds. In the days before the publication of flock and stock books, there arose a great demand for the pictorial representation of prize farm animals, as if the paintings provided a form of pedigree. Consequently, many pictures of this kind are inscribed with statistics, as here: "2nd Prize Old Ram at the R.A.S. [Royal Agricultural Show] meeting held at Exeter, Devon, July 1850."

William Henry Davis was born in Chelsea, London, and spent much of his life there. His animal portraits are invariably efficient. For some twenty-nine years, from 1835, he published steel engravings (engraved by Henry Beckwith) in *The Farmer's Magazine*, a total of 160

animal portraits. Furthermore, in the mid 1830s, some of his prints and exhibition entries assert that he was "Animal Painter to Her Majesty," and even after William IV's death he restyled himself "Animal Painter to the Queen Dowager." There is no record that Davis ever held such a warrant.

If his animal portraits place Davis at the threshold of "polite" art, his handling of perspective (as here) places him within the vernacular tradition.

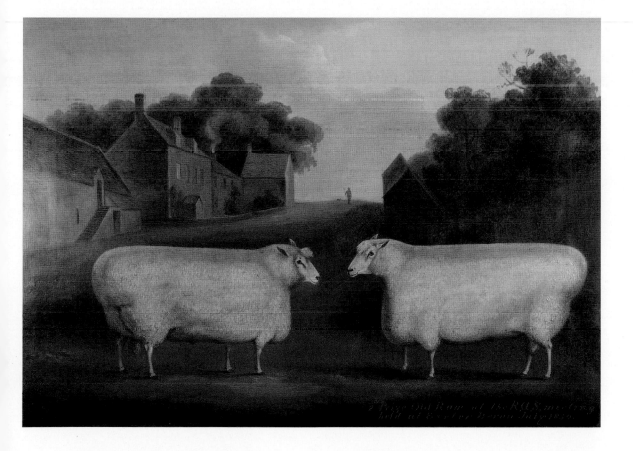

The Prince Consort with His Suffolk and Bedfordshire Pigs

Artist unknown
c. 1844
Oil on canvas
22.5 x 29.37 cm (9 x 11 3/4 in.)
Iona Antiques, London

Prince Albert is shown carrying a pitchfork load of hay or straw, with Windsor Castle in the background. These three twenty-five-week-old pigs gained second prize of £5 at the Smithfield Show of 1844, having been fed on milk, barley meal, and pea meal.

King George III, as "Farmer George," had established the royal tradition for such a hands-on involvement in agriculture.

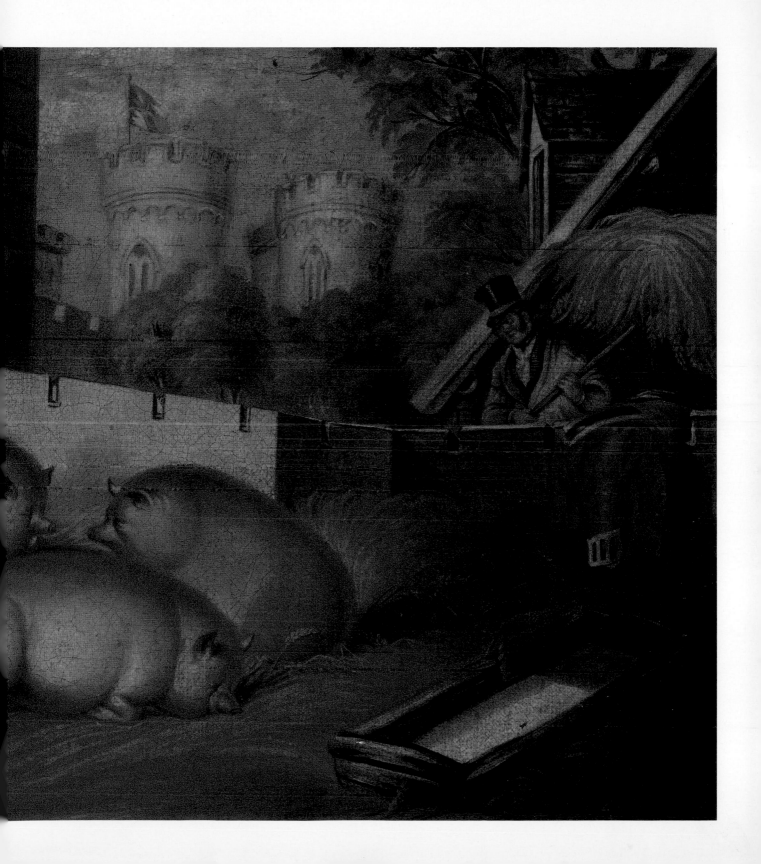

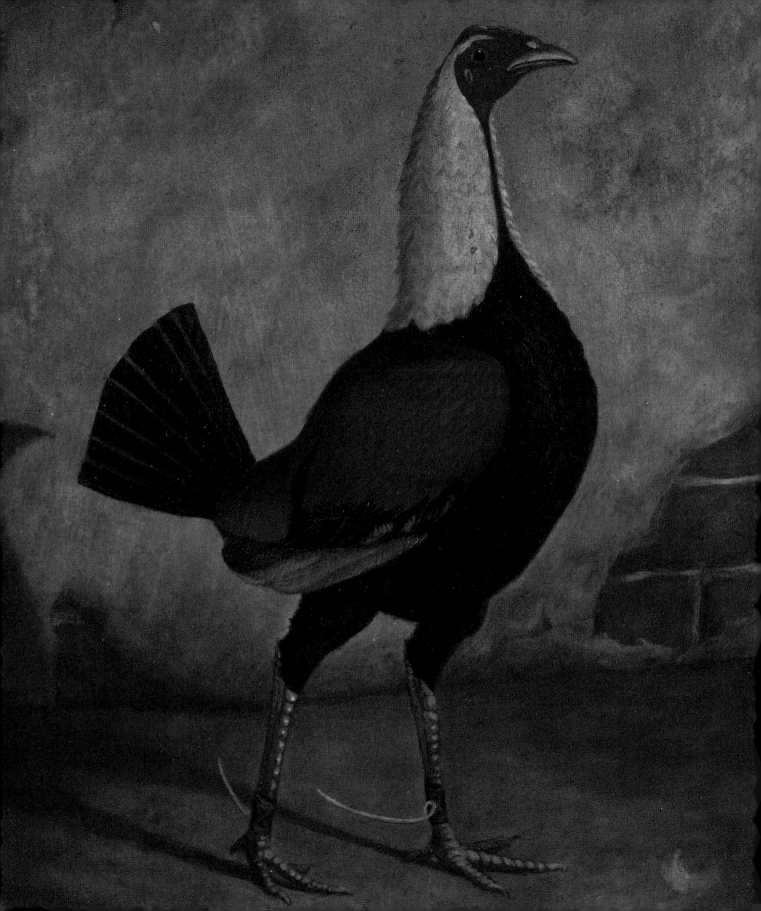

Sports and Pastimes

With the rise of the yeoman class in post-medieval England, many sports and pastimes, which had once been the preserve of prince and prelate, became available to a wider segment of society. The residual prestige associated with many field sports is reflected in paintings that combine a curious and conflicting blend of a primitive aesthetic in the service of a monied class. In some ways these portraits of horses and dogs began as a vernacular idiom and only gradually, in the work of an artist such as George Stubbs, responded to an emerging sophistication. In this respect, Stubbs' book, *The Anatomy of the Horse* (1766), was seminal. Racing may have been the sport of kings: but equine paintings, more often than not, betray a wooden look resembling the rocking horse of the nursery rather than the thoroughbred of the turf. As a result, these images have a charm that removes them from the particulars of portraiture to the wider concerns of painting. Part of the explanation for this look is that the artists concerned often received virtually no academic training,[1] among them James Seymour (1702–52), David Morier (1705?–70), Thomas Butler (fl. 1750–55), Francis Sartorious (1735–1804), and John Van Nost Sartorious (1759–1824). For some art historians, painters of this kind present certain problems, for they served mainstream clients in an idiom that is regarded as an academic backwater. In Oliver Millar's words, "the art historian is faced, for the first time, with genuinely primitive painters whose work reveals almost nothing of the usual influences to which he can peg a thesis."[2] Whatever view may be taken regarding these paintings as "art," the artists concerned were, as Horace Walpole remarked in connection with John Wootton (d. 1765), "peculiarly qualified to please this country [England]."[3]

In the eighteenth and nineteenth centuries, a great variety of artists of all kinds specialized in paintings of this type. As for the paintings themselves, their whole raison d'être is well summarized in Henry and James Roberts' *The Sportsman's Pocket Companion* (c. 1760), which illustrates a series of champion "Race Horses & Stallions. . . . Represented in [a] Variety of Attitudes . . . their genuine, but Concise Pedigrees & Performances . . . calculated for the Utility and Entertainment of the Nobility and Gentry as well as Breeders." Here, at last, the truth is revealed, the purpose of these pictures was first utility and second entertainment: not a word, be it noted, about art. This serves to emphasize how inappropriate it was for Edward Edwards (1808) to apply the tenets of the aesthete to the work of Richard Roper: "a painter of

sporting pieces, race-horses, dogs and dead game. He lived sometime in Little St. Martin's Lane, was an exhibitor at the rooms in Spring Garden in 1761 and the succeeding year, but did not long survive that period. His powers as an artist were not considerable, yet sufficient to satisfy the gentlemen of the turf and stable."[4]

For the sportsman these paintings were designed to be read, both literally and metaphorically, for the information they contain. As a result, the "portrait" of an individual horse or dog is shown on elevation like an architectural drawing for a facade, together with an inscription and dimensions in the manner of a design drawing (cat. 31). These paintings are part of a long and honorable tradition in Britain and range in date, subject matter, and dimension from the life-size painting dated 1594 of a gray horse that hangs at Hatfield House, Hertfordshire, to the "great trout that is near an ell [45 in.] long" whose portrait was seen by Izaac Walton at the Gorge Inn at Ware.[5]

As a more objective attitude to likenesses developed, so artists adopted a more scientific approach. Stubbs' *Anatomy* marks the beginning of this trend in animal portraiture. By the early nineteenth century, John F. Herring (1795–1865) and also Joshua Shaw (1776–1860) built large "painting rooms" that were provided "with conveniences to receive the animals."[6]

Despite these innovations, the quality of work produced by English sporting artists varied enormously from the proficient to the naive. Even within one family such as the Clowes of Chester, the difference is striking from one member of the family to another. Daniel Clowes (1774–1829) produced adequate work but was nevertheless eulogized by a contemporary as a painter who "excelled in animal painting. He was particularly happy in his peculiar mode of representing the semi-transparency of skin and the silkiness of coat, of that noble animal the race horse, which was his favourite study."[7] He also painted farm animals. On the other hand, his son

Henry Clowes Sr. (1799–1871) created altogether more enjoyably naive work in a thoroughly vernacular idiom; he advertised in the Chester General Directory for 1840 as a "House and Sign Painter."[8] His horses generally have improbably long bodies and short legs, while his *Chester and the River Dee* (private collection) is a delightful pastoral of the imagination in which topographical information has apparently been mapped with the accuracy of memory rather than from direct and immediate observation.

Important though paintings of horses and dogs may have been, other animals and other sports were also represented by artisan artists. A four-leaf screen, probably painted in the north of England and dated 1746, may be read as an index of the range of sports and pastimes commonly enjoyed at that time. Inevitably this screen makes reference to racing, but hunting, shooting, fishing, and gambling (cards and dice) are also prominent, with bathing as a rather surprising conclusion to the scheme. Other subjects represented by these sporting artists include cock fighting, bear baiting, and ratting (in which a dog was set to kill a group of rats within the confined space of a rat pit). The decline in paintings of, or related to, these "sports" may be loosely associated with the legislation introduced, in the course of the nineteenth century, to prohibit these activities. Curiously it was these measures that led to the further development of boxing, although the bare-knuckle contests of old were prohibited. Bear baiting was outlawed in England in 1835, so that paintings produced after that date illustrate illicit meets sometimes taking place at night in barns by artificial light.[9] The effect of the legislation outlawing these blood sports seems to have been uneven. Although cock fighting was officially prohibited in Great Britain by law in 1849, paintings of this subject, or of champion birds, continued to be produced for several decades thereafter. The 1855 portrait of Lord Cardigan's prize cockerel (cat. 41) was painted by

John Vine of Colchester (1808–67), one of the many specialists in animal portraiture.[10] Sadly, in an age of freak shows, this artist was equally well known for having stunted arms and as a child toured the country in a caravan as a curiosity. Vine triumphed over his disadvantages to produce very fine works that possess that almost heraldic eye for a good silhouette, a feature so typical of paintings in the vernacular.

Perhaps the finest vernacular painting ever created in England is, nominally, about rowing: Walter Greaves' *Hammersmith Bridge in Boat-Race Day* (1862). It is, of course, about much more than boating. It is a highly sophisticated composition in which hundreds of figures have been formalized within the structure of the bridge. It is an astonishing achievement and all the more remarkable since the canvas is reasonably large (36 x 55 in.) and Greaves was only about sixteen years of age at the time he contrived this elegant arrangement of tone and color.[11]

In the introduction to *The Sports and Pastimes of the People of England* (1801), Joseph Strutt was of the opinion that "In order to form a just estimation of the character of any particular people, it is absolutely necessary to investigate the Sports and Pastimes most generally prevalent among them." For those who share Strutt's view, nothing can be more English than the vernacular portrayal of these leisure pursuits.

NOTES

1. *One of the earlier exponents of this art, Francis Barlow (1626–1704), was unusual in that he was apprenticed to a "face painter" named Sheperd. Horace Walpole,* Anecdotes of Painting in England, *4th ed. (1786), 2:218.*

2. *Introduction,* British Sporting Painting 1650–1850 (*exh. cat. London: Hayward Gallery, Arts Council Exhibition, 1974), 11.*

3. *Walpole,* Anecdotes *(1786), 3:120.*

4. *Edward Edwards,* Anecdotes of Painters *(London, 1808), 11.*

5. *Izaac Walton and Charles Cotton,* The Complete Angler, *Part 1, Chapter 5.*

6. *A. M. W. Stirling,* A Painter of Dreams *(1916).*

7. *Chester Courant (March 17, 1829), obituary.*

8. *C. N. Moore and P. J. Boughton,* The Clowes Family of Sporting Artists (*exh. cat. Chester: Grosvenor Museum, 1985).*

9. *See James Ayres,* English Naive Painting 1750–1900 (*London and New York: Thames and Hudson, 1980), pl. 70.*

10. *W. Gurney Benham, "John Vine of Colchester: A Remarkable Armless Artist,"* Essex County Standard *(Dec. 26, 1931).*

11. *Walter Greaves'* Hammersmith Bridge *is in the collection of the Tate Gallery, London. The Greaves brothers, Walter and Henry, later produced imitations of J. M. Whistler's* Nocturnes *(Hunterian Museum, Glasgow) and very pedestrian topographical views of Chelsea. Walter Greaves also painted some striking portraits, including Thomas Carlyle (National Portrait Gallery, Edinburgh).*

Inn Sign:
The Godolphin Arabian

After Thomas Butler (active 1750–59)
Late 18th century (1783?)
Oil on board
76.2 x 89.5 cm (11 1/2 x 15 3/4 in.)
Norfolk Museums Service,
 Strangers Hall Museum, Norwich

Numerous representations of this near-legendary stallion exist. The horse, which was named after the Earl of Godolphin, died in 1753, and was one of three from which most of the thoroughbreds of late eighteenth- and nineteenth-century England descended, the others being the Darley Arabian and the Byerly Turk. The Godolphin Arabian, with his unusually high crest, stood at about fifteen hands. He was a brown bay with some white on his off-side (right) hind "heel." His features are all carefully represented in this painting and in others of the same subject.

The first serious attempt to document the pedigree of thoroughbreds was made in England in 1791. Before that date, portraits of this kind were vital to breeders. A very closely related painting to this is the *Godolphin Arabian* by Thomas Butler in the collection of H.M. Queen Elizabeth. The inscription on the painting in the royal collection gives particular emphasis to "The Performance of his Posterity," for it was this stallion that was considered "to have refresh'd the English Blood more than any Foreign Horse ever imported."

Although the inn sign has been slightly cut down, it is clearly inscribed: "THE GODOLPHIN ARABIAN/BEEVOR'S FINE NOG." There is no known reference to an inn of that name in Norwich, although James Beevor (died 1818) was a Norwich brewer who was in business at 86 Magdalen Street by 1783 and later moved to 72 St. Giles, Broad Street. Nog was a particularly strong beer.

The painting in the queen's collection is illustrated by Stephen Deuchar in *Sporting Art in Eighteenth-Century England* (1988), 140.

Chestnut Arabian

Artist unknown,
 after J. Wooton (1678–1765)
Mid 18th century
Watercolor on paper
27.3 x 19.8 cm (10 3/4 x 7 3/4 in.)
Beamish, The North of England
 Open Air Museum

This watercolor is inscribed "Chestnut Arabian imported into England by Fitzhugh Esq. the property of Mr. Chas. Willson."

The importation of Arabian horses into England began in the early seventeenth century with the so-called Markham Arabian. At a later date, other stallions were significant (see cat. 38), including Willson's Arabian (1740–60). All of these imported horses were named after their owners. The chestnut Arabian, though the property of Willson, was brought to

England by the Earl of Kinoul, British Ambassador at Constantinople, where he cost £2,001. This stallion covered a number of mares in the north of England, which may well account for the provenance of this picture.

The watercolor is perhaps a preparatory study for an oil painting.

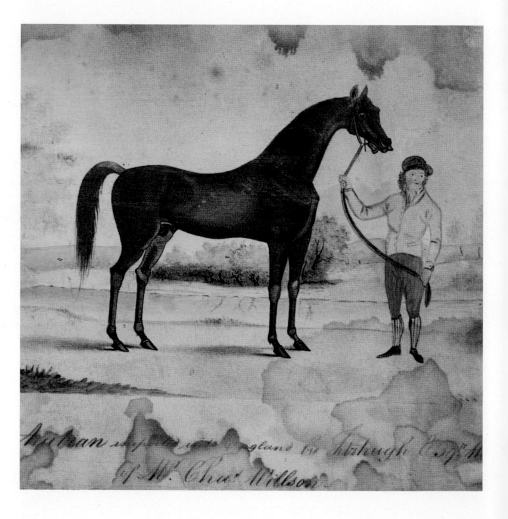

40

An Appaloosa Stallion

H. Milnes (signed and dated)
1839
Oil on canvas
30 x 40 cm (12 x 16 in.)
Iona Antiques, London

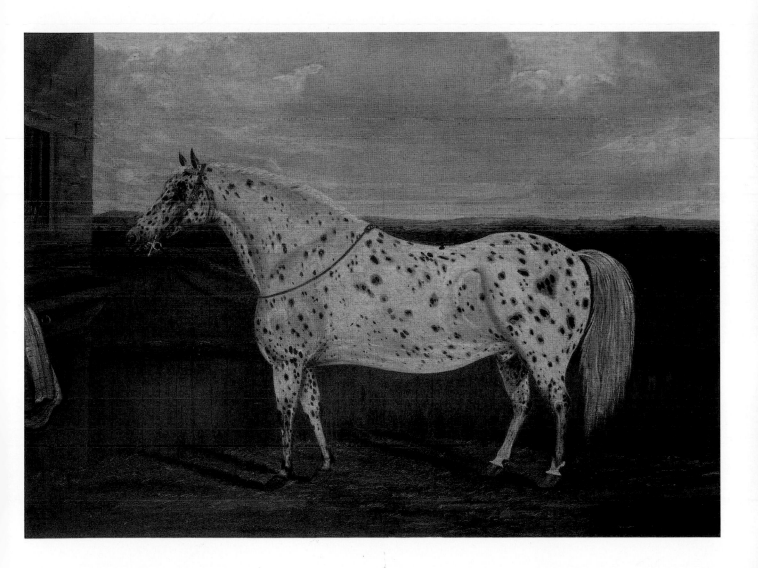

Lord Cardigan's Fighting Cockerel: Champion of Essex

John Vine of Colchester (1808–67)
 (signed and dated)
1855
Oil on board
26.25 x 18.75 cm (10 1/2 x 7 1/2 in.)
Iona Antiques, London

Much of Vine's work was for clients in and around Colchester. Although he was severely disabled, Vine is known to have painted animal portraits in Gloucestershire, Wiltshire, and Cheshire.

 Cock fighting was prohibited by law in Great Britain in 1849 but, as the evidence of this painting shows, it persisted, especially in rural areas.[1]

NOTE
1. *See "Old English Game Fowl,"* Country Life
 (Dec. 11, 1926).

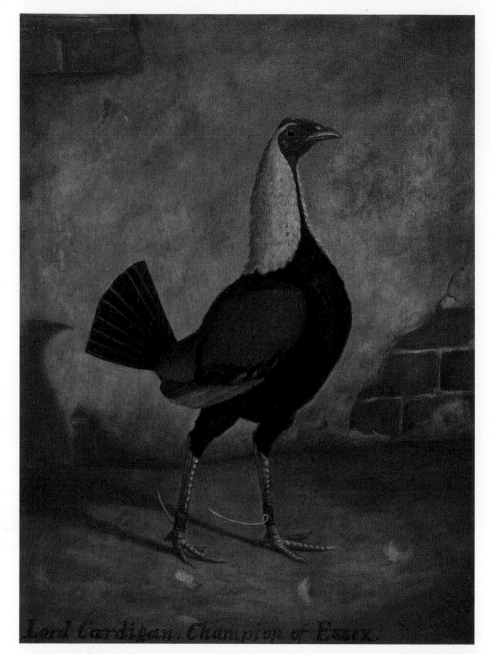

Racing Pigeons

E. H. Windred (signed and dated)
1922
Oil on canvas
39.8 x 50 cm (15 1/2 x 19 1/2 in.)
Peter Moores Foundation

The vernacular artist often owed more to the truths of the mind's eye than to observed fact. It was an approach that perfectly matched some purposes, for example pride of ownership, as with racing of all kinds, including pigeons.

The painting is inscribed at the left: "Mr. J. Whitnell's Blue Cheq Cock 'Favorite' 1920.6906.1920. All Stages/to Exmouth. 1921 3rd Symington 3rd Bournemouth 4th Dol. 1929 All/Stages to Marennes Winning 6th London Marennes Club"; and at the right: "Blue Cheq Hen. 11. 199. Flown. 1911 Chard. 1912 Exmouth. 1913/Nantes Marennes. 1924 Rennes Marennes 1915–16–17–18. Not/Flown. 1919 Tavistock 1920 Dol. Marennes. 1921 Dol. Rennes. & San/Sebastian Winning 6th Prize NE[C?]."

This painting was formerly owned by Mr. and Mrs. Andras Kalman.

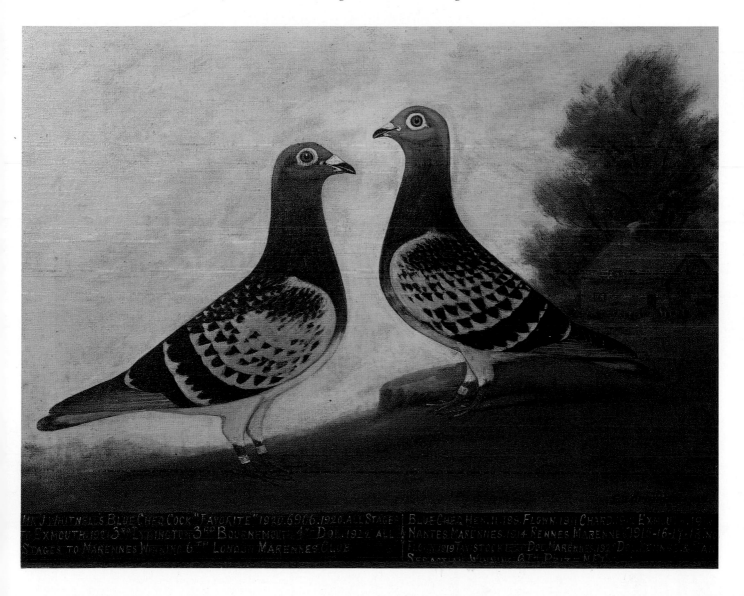

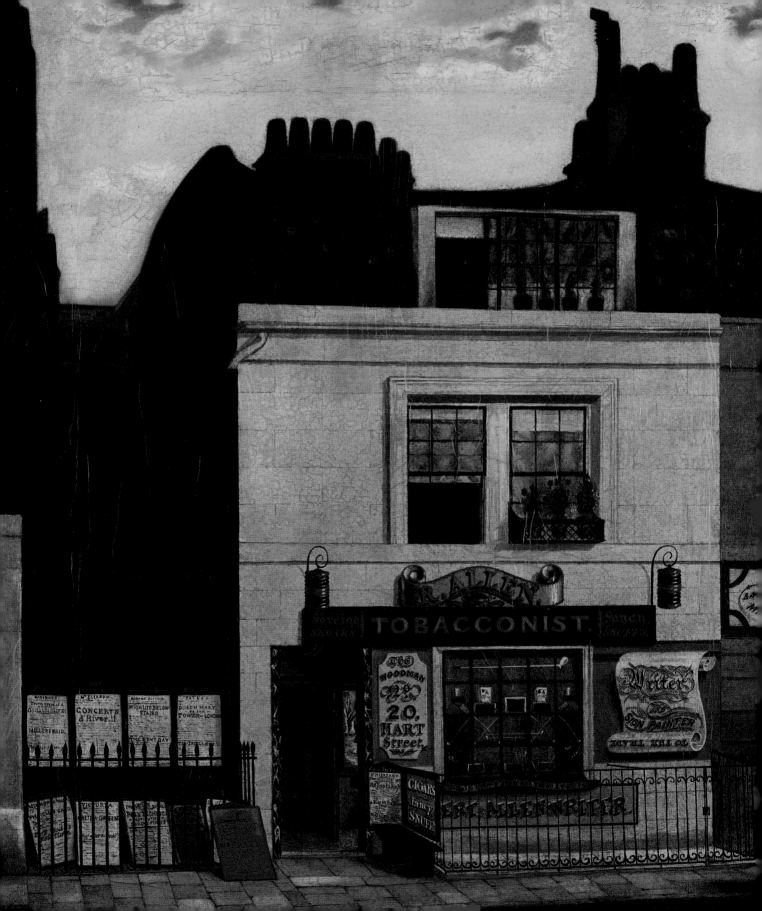

topographical paintings of the first half of the eighteenth century shows the City as it arose from the ashes of the Great Fire of 1666. In many ways it represents the ideal urban scheme of its time. While the contemporaneous views may be idealized, they are nevertheless true in many of their particulars. Houses are shown of a reasonably consistent height, which in turn related to the social standing of their occupants and the streets in which they stood. The whole city was presided over by the great dome of St. Paul's, which, in concert with the spires of the City churches, created a fully orchestrated skyline. There was, though, another char- acteristic of the City that was far more immediate and colorful for those who passed along the sidewalks. This feature was of great visual impact and of undoubted practical value, namely the street signs: the means by which an inn, a shop, or even a private house could be identified in an age when street numbering was virtually unknown. As can be seen in Thomas Bowles' mid-eighteenth-century engraving of Cheapside (fig. 21), these signs projected out from the building frontage on wrought-iron brackets just above the level of the ground-floor ceiling. Most are shown in elaborately carved frames, and each sign would have been

gaudily colored and gilded to maximize its impact, the neon sign of the eighteenth century. In addition, "each shop-keeper [was] filled with a noble ambition to project his sign a few inches farther than his neighbour."[1] It was probably the immediacy of these signs, rather than the more distant prospects of town planning, that dominated the street scene as experienced by Londoners in the first half of the century. In large cities such as London and nearby Westminster, signs were so practical a necessity that the demand for them was considerable. As a result there developed a whole school of sign makers centered on Harp Alley, Shoe Lane, Fleet Street, in the City. Their work involved bringing together three important and distinct crafts: painting, carving, and smithing.

The origins of this "high street heraldry" go back to medieval and even Roman times. Delightful though these signs may have been, they were by the seventeenth century regarded as something of a hazard, for if no properly maintained they could fall on passersby causing serious injury. Consequently, the building regulations that were introduced after the Great Fire of 1666 included a clause intended to outlaw the use of pendant signs. Instead, developers were expected to install stone signs carved in high relief. These were built into the brick front

of the street elevations of the buildings (fig. 22).
However, these signs were far less visible when
viewed from a distance along the street than were the
pendant signs. This was one reason why the
regulations were widely flouted; another was that
there was very little enforcement. Predictably, the old
hanging signs returned as did the hazard they
occasioned. In 1718 a sign in Bride's Lane, Fleet
Street, was so heavy that it dragged down the front of
the house to which it was attached, killing four
people.[3] Episodes such as this, coupled with
increasing numeracy, made street numbering a safer,
more logical, and viable alternative from the mid
eighteenth century.[4] These events were to lead
inexorably to legislation that, with the apparent
exception of inns, was designed to outlaw the use of

pendant signs. As early as November 1762, "the signs in Duke's Court, St. Martin's Lane [Westminster] were all taken down and affixed to the front of the houses"[5] and this was later enforced throughout the City of Westminster by statute.[6] By about 1770, most signs and other projections and "annoyances" on buildings were removed in the London area on the insistence of better enforced local by-laws passed by the Parliament at Westminster.[7] By the last decade of the century, most cities and towns were subject to similar measures.

The signs in use in the first half of the eighteenth century were many, various, and gaudy. Addison (1710) made reference to "our streets [that] are filled with Blue Boars, Black Swans and Red Lions not to mention Flying Pigs and Hogs in Armour with other creatures more extraordinary than any in the deserts of Afric."[8] According to a French visitor to England in 1719, these signs were "generally adorned with carving and gilding; and there are several that, with the branches of iron which support them, cost above a hundred guineas"[9] (see fig. 23).

There were, it would seem, two basic types of signs, which might be termed the generic and the particular. Thus a bunch of grapes became firmly associated not with one inn or public house but with all premises licensed to alcohol: the generic sign. Accordingly, an additional emblem was necessary to identify a particular inn or public house. Even so there was ample scope for confusion, and early trade cards not only illustrate the sign, but also give explicit instructions as to the location of the particular address: "at the corner of . . ." or "opposite the Church of Saint"

Although three-dimensional signs dating from before the 1760s have survived in reasonable numbers (fig. 24), and numerous wrought-sign irons have remained attached to eighteenth-century

Fig. 23. Trade card of Thomas Betts, mid 18th century, Victoria & Albert Museum, London. This card illustrates the elaboration of some sign irons.

buildings, English sign boards from this period are now very rare. This is no doubt in part because, in their day, they were not generally considered as art in polite circles. Even so, there were occasions when a sign might inspire some enthusiastic comment. In January 1743, *The Spectator* reported that "the other day, going down Ludgate Street [London] several people were gaping at a very splendid sign of Queen Elizabeth, which far exceeded all the other signs in the street, the painter having shown a masterly judgement and the carver and gilder much pomp and splendour. It looked rather like a capital picture in a gallery than a sign in the street."[10]

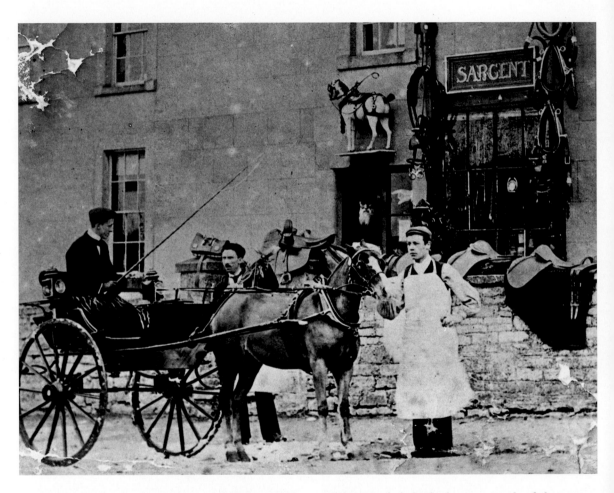

At the popular level, Clarkson's elaborate £500 sign of Shakespeare that once hung at the corner of Little Russell Street and Drury Lane in the capital was "a thing that country people would stand and gaze at," and that the corner of the street "was hardly passable."[11]

The exhibition by the fictitious Society of Sign Painters organized by William Hogarth in Bonnell Thornton's rooms in Bow Street, London, in March 1762[12] signaled the high-water mark of the sign as an art form in England. The demise of these emblems did not go unmourned, and a number of obituaries were published. One of the best of these appeared in a little-known and now rare pamphlet in which William Williams asserted the importance of practical training for artists as well as the need for academic schooling, which the (Royal) Society of Arts did so much to encourage. Williams continues:

"Then strange to tell! an order went forth for the abolition of signs to counteract them, signs were at that time the nursery and reward of painters, for great sums were expended on those ornaments, and the best artists of the age employed in executing them, 'twas necessary to be sure to alter their situation (which were become a nuisance) but not to abolish them entirely, and now the bull, the lion &c. are fled, and left only their names behind; formerly too, coaches were embellished with historic or fancy compositions &c. which gave employment to genius, now those beautiful ornaments are disused, are removed to make room for the unmeaning stuff or purchased heraldry [ormolu mounts], vain ostentations of upstart pride! another, and 'tis almost a shame to mention so depraved a taste, but that many an artist has been hurt by it, I mean that ridiculous and disgusting fashion of introducing shades, that ABC of the art which the genteelest apartments are disgraced and blackened by a group of caffries [woolen velvet hangings]. These were no little blows given to the arts."[13]

The reference to carriage painting is of relevance to sign painting and was an important source of employment for the decorative painter: for example, a craftsman such as Michael Edkins of Bristol. In addition to the numerous kinds of painting he engaged in, Edkins also applied oil gilding to weather vanes, that sculptural art that combined the skills of smiths, coppersmiths, and painters. Weather vanes were of course practical in intent no matter how decorative they may have become. Whirligigs on the other hand were, for a vernacular art, unusually playful. Both weather vanes and whirligigs were found in town and country and were probably once common to much of Europe: in France they were known as *girouettes*.[14] In America, with its dry climate, these wooden wind toys have

Fig. 25. Street in Clovelly, Devon (detail), c. 1900, photograph, Everett Collection. Note the two whirligigs on the arm supporting the sign, a soldier on the left and a sailor on the right.

survived in great numbers, but in the damp of England many have decayed and they are now quite rare, and usually rather late in date (cats. 60 and 61). Thomas Hardy has left an account of an unusually fickle turncoat of a whirligig: "In the large stubbard-tree at the corner of the garden was erected a pole of larch-fir, which the miller had bought with others at a sale of small timber in Damer's Wood one Christmas week. It rose from the upper boughs of the tree to about the height of a fisherman's mast, and on top was a vane in the form of a sailor with his arms stretched out. When the sun shone upon this figure it could be seen that the greater part of

his countenance was gone; and the paint washed from his body so far as to reveal that he had been a soldier in red before he became a sailor in blue. The image had, in fact, been John, one of our coming characters, and was then turned into Robert, another of them, this revolving piece of statuary could not, however, be relied on as a vane, owing to the neighbouring hill, which formed variable currents in the wind."[15]

So close is this description to a pair of whirligigs (a sailor and a soldier) recorded in a photograph of Clovelly taken in about 1900 (fig. 25) that it is tempting to believe that Hardy, with his architect's eye and West Country connections, is describing these North Devon examples.

For those artists whose gallery was the high street and whose patrons were tradesmen, the street itself could, on occasion, be the subject of their work. Newton's *View of Pottergate* in Richmond, Yorkshire, is a case in point. For Newton, like many jobbing painters before him, signs, or at least "sign writing," remained an important source of employment. Although the legislation concerning the more heraldic form of sign severely circumscribed this aspect of the work of the artisan artist, the use of emblems persisted. Once again Thomas Hardy, with his eye for detail, gives evidence for this in his account of a hiring fair in the fictional county town of Casterbridge: "Among these [laborers], carters and waggoners were distinguished by having a piece of whip-cord twisted round their hats, thatchers wore a fragment of woven straw, shepherds held their sheep-crooks in their hands; and thus the situation required was known to the hirers at a glance."[16]

A remarkably similar description from the early eighteenth century is given by Daniel Defoe in his description of "the poor servants" who offered themselves for hire at the mop fair in Bloxham, Oxfordshire, who distinguished themselves "by holding something in their hands, to imitate what labour they are particularly qualified to undertake; as the carters a whip, the labourers a shovel, the wood men a bill, the [textile] manufacturers a wool comb and the like."[17]

In much the same spirit, some tools used in particular crafts were converted into larger-than-life emblems carved in wood and carried by craftsmen in various processions to symbolize their respective trades (cat. 70). It was thus, in these fundamental ways and among all levels of society, that emblems remained a powerful force in the land, from the authority vested in the crown to the banners under which early trade unionists marched.[18]

NOTES

1. *J. Larwood and J. C. Hotten,* History of Signboards *(1866), 16.*

2. *In the seventh year of the reign of Charles II, "no signboard shall hang across the street, but that the sign shall be fixed against the balconies, or some convenient part of the side of the house";* Larwood and Hotten, *History, 16.*

3. Ibid., 27.

4. *If this seems late for the introduction of street numbering, it might be recalled that road signs for various destinations were ordered by statute as late as 1697. So new were these to Celia Fiennes when visiting Lancashire that she describes them in some detail: "at all cross wayes there are Posts with Hands pointing to each road with the names of the great town . . . that it leads to";* Christopher Morris, ed., The Journeys of Celia Fiennes *1685–c. 1712 (London, Sydney, Exeter: Macdonald/Webb and Bower, 1982), 164.*

5. *Daily News (Nov. 1762), quoted by Larwood and Hotten,* History, 28.

6. *2. Geo III c 21.*

7. *Larwood and Hotten,* History, 28–29.

8. *Joseph Addison,* The Spectator *(April 2, 1710).*

9. *Larwood and Hotten,* History, 26.

10. Ibid., 37–38.

11. *J. T. Smith,* Nollekens and His Times *(1828; London: Turnstile Press, 1949), 13–14, quoting the reminiscences of Thomas Grignon and John Crace.*

12. *For a full account of this exhibition see the Appendix to Larwood and Hotten,* History.

13. *William Williams,* An Essay on the Mechanic of Oil Colour *(Bath, 1787), 10–11 (Copy in Bath Public Library, Reference Dept.). This is almost certainly the William Williams (b. 1727) who was Benjamin West's first teacher of painting in Pennsylvania. Williams returned to his native Bristol where he died in 1791. See also James Ayres,* The Artist's Craft *(Oxford: Phaidon, 1985), 17–18.*

14. *Two girouettes may be seen in the Musée d'Art et Traditions de la Guérinière, Ile de la Noirmoutier, France.*

15. *Thomas Hardy,* The Trumpet Major *(1880; London: Macmillan paperback edition, 1962), 11–12.*

16. *Thomas Hardy,* Far From the Madding Crowd *(1874), Chapter 6.*

17. *Daniel Defoe,* A Tour through the Whole Island of Great Britain *(1724; new edition abridged and edited by P. N. Furbank, W. R. Owens, and A. J. Coulson, New Haven: Yale University Press, 1991), 178–79.*

18. *John Gorman,* Banner Bright: An Illustrated History of theBanners of the British Trade Union Movement *(London: Allen Lane, 1973).*

Horse and Gig

Artist unknown
Mid 19th century
Oil on paper, laid on canvas
67.31 x 106.66 cm (26 1/2 x 42 in.)
Private Collection

In George Sturt's *Wheelwright's Shop* (1923), the author recalls the English countryside in the second quarter of the nineteenth century when "farmers had not risen to the grandeur of a dog-cart or the respectability of a gig"; instead they traveled to market by more humble means, the dung cart.

Exhibited: Neglected Heritage 1760–1900, *Rutland Gallery, London, 1987.*

44

Waiting Outside No. 12

Artist unknown
Mid 19th century
Oil on canvas
59.6 x 86.3 cm (23 1/4 x 34 in.)
Peter Moores Foundation

This painting was once part of the
collection of Mr. and Mrs. Andras
Kalman.

Illustrated: J. Ayres, English Naive Painting
(1980), pl. 48.

Inn Sign: The Ship

Artists unknown
Mid 18th and early 19th century
Oil on panel
60 x 60 cm (23 5/8 x 23 5/8 in.)
Salisbury and South Wiltshire Museum

The obverse of this double-sided sign is painted with what appears to be a mid eighteenth-century representation of a Man-of-War in the style of the marine artist Peter Monamy (1689–1749).[1] The reverse, inscribed "THE SHIP/HOME BREW'D BEER/BY THOMAS COOKMAN," appears to date from the second quarter of the nineteenth century. This sign is believed to have come from The Ship, No. 3 High Road, Britford, near Salisbury, Wiltshire.

Three families of Cookmans lived in Britford in the first half of the nineteenth century. Recent research by John Chandler has shown that a Thomas Cookman was born on January 1, 1774, and was possibly identical with the person of the same name listed in the 1851 census as a pensioner, probably an ex-serviceman (a sailor?) from the Napoleonic Wars. The Britford tithe map of 1840 does not show a Ship Inn, but it is possible that Thomas Cookman ran an informal beer house from his own home—see the inscription "HOME BREW'D BEER"—as permitted by the 1830 Beer Act.

NOTE
1. Monamy, a native of Jersey, was apprenticed to a house- and sign-painter on London Bridge.

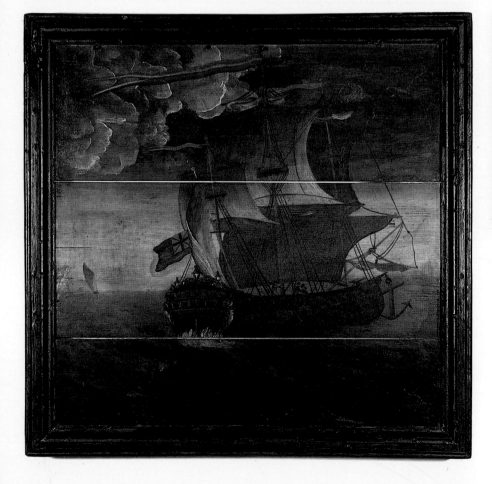

46

View of the North Inch of Perth

David Junor (1773–1835)
c. 1810
Oil on canvas
64.77 x 86.36 cm (25 1/2 x 34 in.)
Private Collection

In common with a number of topographical views of eighteenth- and nineteenth-century towns and cities, this painting shows how abrupt could be the transition from an urban to a rural situation. The suburb was yet to be invented.

Junor is an interesting example of an artist who stands at the threshold between the "polite" and the "vernacular," the provincial and the urbane, and thus demonstrates that "naive" is a relative rather than an absolute term in the visual arts. In 1798, Junor was appointed as drawing master at Perth Academy, Scotland, at an annual salary of £15, with the additional appointment as writing master at £12 p.a. He relinquished the latter post in 1801 and retired in 1830 with an annuity of £50 from Perth Town Council. Typically for such schoolmasters, Junor also took private pupils for drawing, painting (portraits and landscapes), and painting on velvet.

Four topographical views by Junor were published as engravings in *Sconiana* in 1807 by James Morison. Today Junor is possibly best remembered as the teacher of a number of members of the Royal Scottish Academy, including David Octavius Hill (1802–70), Thomas Duncan (1807–45), and Mc Laren Barclay (1811–86).

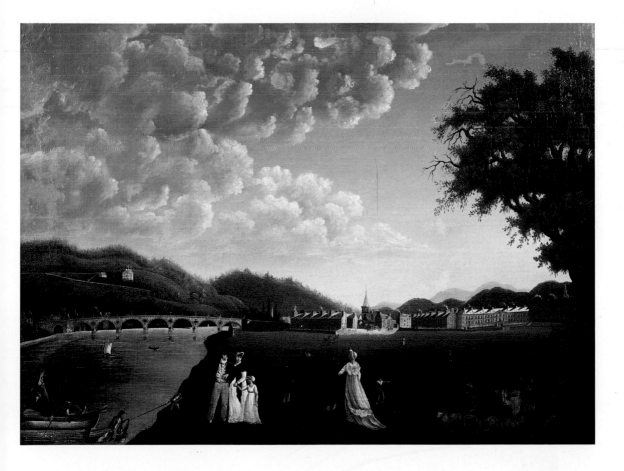

Trade Sign: The Golden Fleece

Carver unknown
18th century
Carved and gilded wood
84.37 x 83.12 x 30 cm
 (33 3/4 x 33 1/4 x 12 in.)
Norfolk Museums Service,
 Strangers Hall Museum, Norwich

The Golden Fleece was the traditional sign of the woolen draper. This example advertised the premises of Elam Skoyles, formerly Riches & Skoyles, outfitters and hatters in Davey Place, Norwich. The firm ceased trading in 1908.

Illustrated: J. Ayres, British Folk Art (1977), 36.

48

Dummy-board Figure: Soldier

Artist unknown
c. 1700–1725
Oil on board
182.88 x 69.85 x 1.27 cm
(72 x 27 1/2 x 1/2 in.)
Hull Museums, Art Galleries and Archives

The exact function of dummy-board figures is a matter of speculation, but they seem to have been made to trick the eye (trompe l'oeil) as an amusement. Representations of servants are particularly common, but children and animals were also represented in this way. It has been suggested, with little supporting evidence, that the figure of a "red-coat" such as this may have been used on the main street of the town as a sign for a recruiting booth.

According to the Dutch author Arnold Houbraken (1719), dummy-board figures were invented by the artist Cornelius Bisschop (1630–1674). However, extant examples go back at least to the early seventeenth century. As with chimney boards, they range in character from the highly sophisticated to the vernacular.

This piece has a Hull provenance going back to the eighteenth century.

We are indebted to Arthur Credland for information on this and other items from Hull Museums.

Illustrated: Clare Graham, Dummy Boards and Chimney Boards *(1988), 19.*

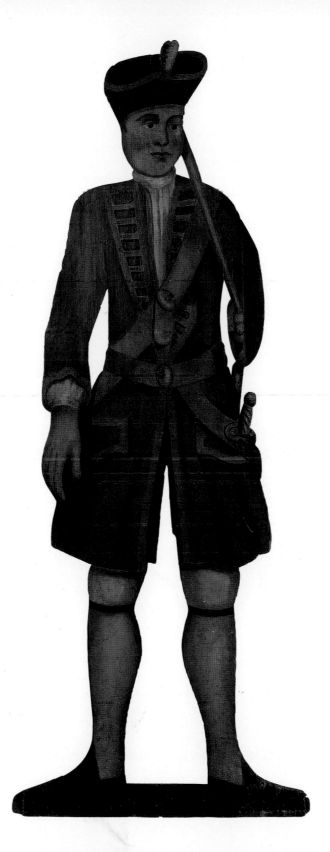

49

Gunsmith's Trade Sign

Artist unknown
Second quarter 18th century
Carved and painted fir
Overall height 78.74 cm (31 in.)
The Judkyn/Pratt Collection

In heraldic terms, this figure is painted "proper," that is to say naturalistically. All the polychrome decoration is old, but only on the figure's face, which is treated with consummate sensitivity, is the paint probably original. The information in the fragmentary manuscript label pasted to the back may have been transcribed to the typed label now pasted to the underside of the plinth. This label makes reference to the figure having been the sign of "Samuel Lighter: Gunsmith to the Duke of Arundel and Duke of Richmond." This gunsmith has not been traced, but the Duke of Norfolk at Arundel Castle was (as their descendants remain) a near neighbor of the Duke of Richmond at Goodwood Park, both in West Sussex.

The sign takes the form of a hunt servant in livery, hence the approximate dating of this figure. Its supreme quality points to its being the work of the Harp Alley School of sign makers. Note the real flintlock mechanism in the gun, suggesting that this was a counter-top figure rather than a sign used out-of-doors.

The products of some naive carvers could, as here, be highly sophisticated, even though their work would not have been considered acceptable to those who subscribed to the conventions established by the academic sculptors of their day. Indeed, the status of woodcarving as an art declined as the importance of marble sculpture rose to meet the demands of Neo-classicism. The proportions of this figure are similarly remote from classical precepts. In retrospect, while vernacular and academic art may be seen as distinct in their conventions, they nevertheless arrive at an equality of achievement.

This figure formerly graced the collection of Hiram J. Halle of Pound Ridge, New York, whose connoisseurship is best known in regard to American folk art.

Illustrated: J. Ayres, British Folk Art (1977), 17.

Exhibited: America and British Folk Art, *U.S. Embassy, London, 1976;* The Art of the People, *Cornerhouse Arts Centre, Manchester, 1985–86;* A Common Tradition, *University of Brighton, 1991;* Judkyn/Pratt Collection British Folk Art Collection, *Peter Moores Foundation, 1994–95.*

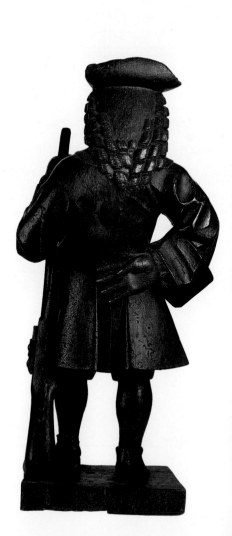

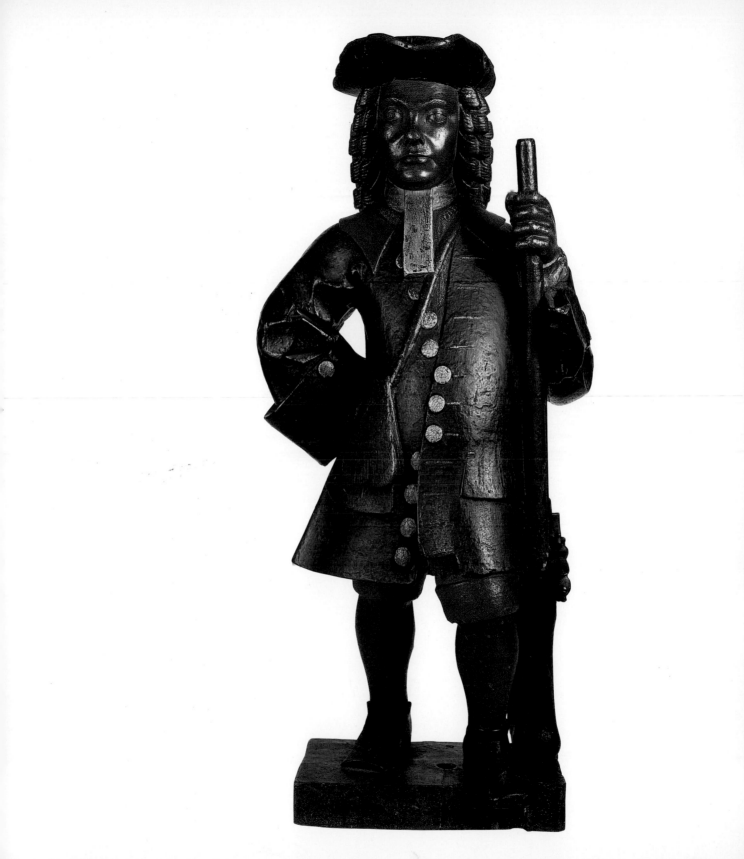

50

Trade Sign: Highlander

Artist unknown
Mid 18th century
Carved and painted fir
Overall height 93.98 cm (37 in.)
The Judkyn/Pratt Collection

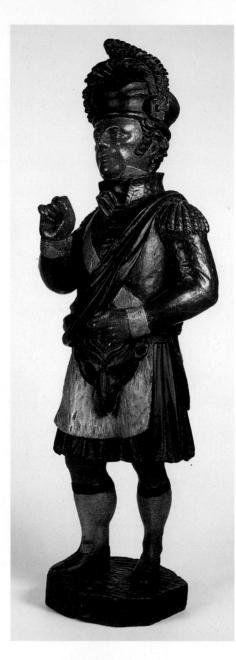

After the Act of Union between England and Scotland in 1707, Glasgow became one of the chief ports for the importation of American tobacco. Consequently, the figure of a Highlander became a common sign for a tobacconist. Highlanders are frequently represented, as here, holding a snuff mull of horn with a pinch of snuff in the raised hand.

In the 1720s the shop of the tobacconist David Wishart ("at ye Highlander, Thistle and Crown," Coventry Street, London) became something of a Jacobite rendezvous. Wishart was one of the first tobacconists to use the figure of a Highlander as a sign, but the Blackamoor and the tobacco roll were more traditional subjects for signs at these shops.

Illustrated: J. Ayres, British Folk Art *(1977), 41.*

Exhibited: America and British Folk Art, *U.S. Embassy, London, 1976;* The Art of the People, *Cornerhouse Arts Centre, Manchester, 1985–86;* A Common Tradition, *University of Brighton, 1991;* Judkyn/Pratt Collection British Folk Art Collection, *Peter Moores Foundation, 1994–95.*

51

Tobacconist's Sign: The Highlander

Artist unknown
Mid 18th century
Carved and painted wood
77 x 30 cm (29 x 12 in.)
Museum of London

This figure of a Highlander as a sign for a tobacconist's shop is shown in the familiar attitude: one hand holding a ram's-horn snuff mull, the other hand held high with a pinch of snuff.

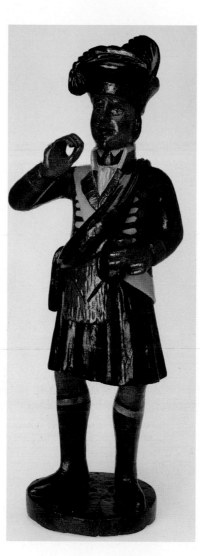

Tobacconist's Sign:
The Blackamoor

Artist unknown
Mid 18th century
Carved and painted wood
81.3 x 43.2 x 30.5 cm (32 x 17 x 12 in.)
The Wills Collection of Tobacco
 Antiquities at Bristol Industrial Museum

A number of signs became traditional
for tobacconists' shops, among them
the tobacco roll (see cat. 53), the
Highlander (see cats. 50 and 51), and
the Turk. None of these emblems so
effectively conveys the source of this
herb as the Blackamoor, which stood
for the slave labor that nurtured the
tobacco crop. In addition, the kilt and
headdress of tobacco leaves are an
implied reference to the first Ameri-
cans and possibly inspired the
carved cigar-store Indians of
the United States.

53

The Tobacconist's Shop

Robert Allen
1841
Oil on canvas
71 x 61 cm (23 x 20 in.)
Museum of London

Robert Allen was by trade a sign writer who had a tobacconist's shop at 20 Hart Street, Grosvenor Square, London (shown here). In addition to the traditional signs for such a shop (the pair of tobacco rolls flanking the fascia board), Allen painted a sign of *The Woodman* (fig. 26) after Barker of Bath's famous painting, which is just visible inside the open door of the shop. Other examples of Allen's work as a sign writer include the Thames steamer service provided by the *William George* and the *Royal Adelaide* and the theater bills for Macready in *As You Like It* and Madame Ventris in *High Life Below Stairs*.

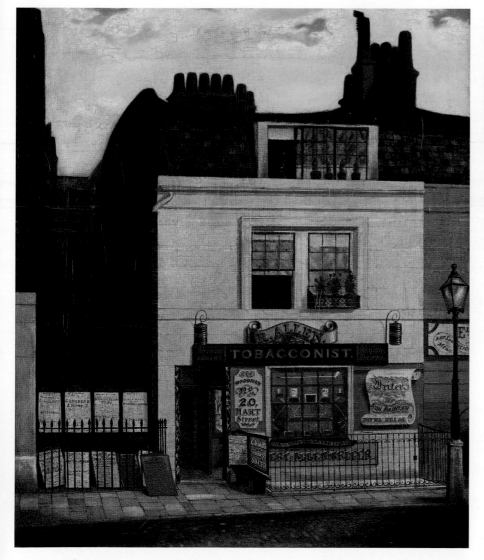

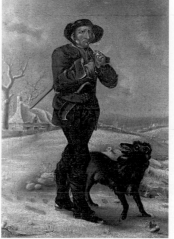

Fig. 26. The Woodman, *oil on canvas, Museum of London. The sign writer Allen painted this work after Bartolozzi's print, which in turn was after the painting by Barker of Bath.*

Cathedral Steps, Wakefield

G. H. Hepworth (signed and dated)
1852
Oil on board
60.3 x 83 cm (23 3/4 x 32 1/2 in.)
Peter Moores Foundation

The cathedral city of Wakefield is in West Yorkshire. Other versions of this painting, with somewhat different color schemes, are known. They were possibly painted by the artisan whose sign is shown on the extreme right of the picture.

This painting was formerly in the collection of Mr. and Mrs. Andras Kalman.

Illustrated: J. Ayres, English Naive Painting (1980), pl. 37.

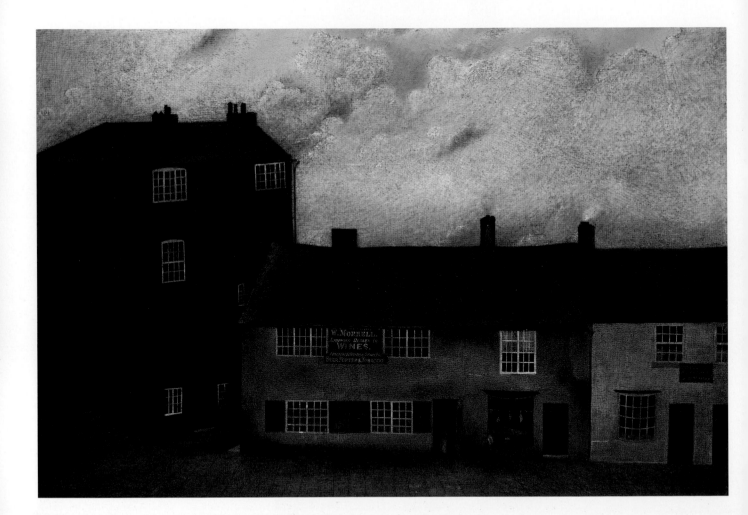

55

The Old Fishmarket, Norwich

Charles Hodgson (signed and dated)
1825
Gouache on paper
28.75 x 39.37 cm (11 1/2 x 15 3/4 in.)
Norfolk Museums Service,
 Norwich Castle Museum

The artist, Charles Hodgson, was the
father of the Norwich School painter
David Hodgson (1798–1864). Many
vernacular painters copied the work of
academic artists; in this case the father
copied the son.

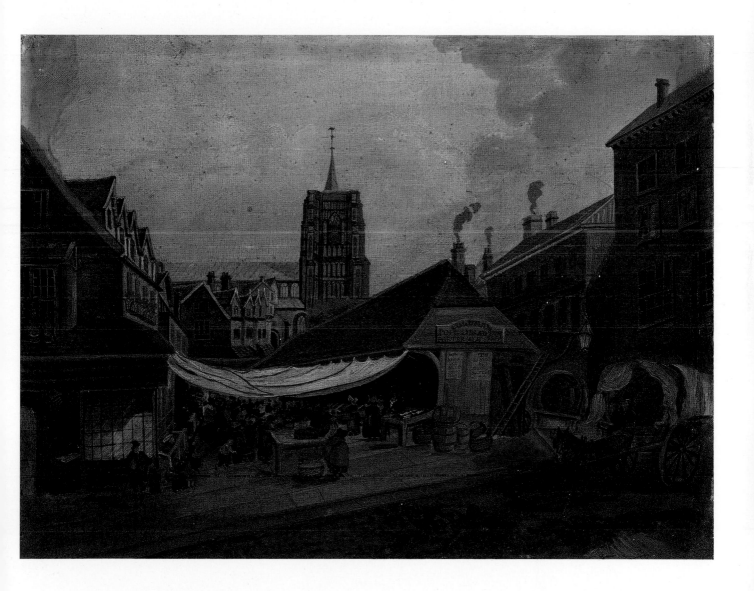

56

*The Lady of the Lake Inn,
Hammersmith, London*

J. Chalmers (signed and dated)
1857
Oil on canvas
86.9 x 97.1 cm (34 1/4 x 38 1/4 in.)
Peter Moores Foundation

This inn survives, somewhat altered, as
the Eagle. The painting was formerly in
the collection of Mr. and Mrs. Andras
Kalman.

Illustrated: J. Ayres, English Naive Painting
(1980), pls. 34, 34a.

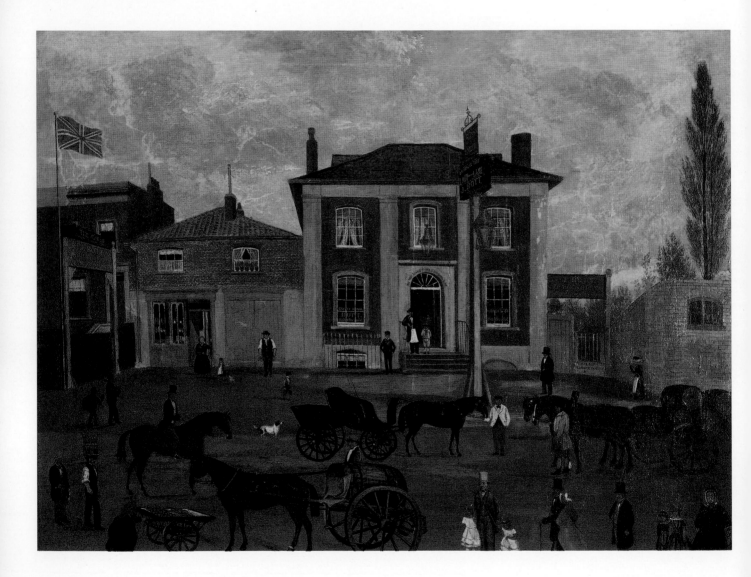

View of Cremorne Bridge

Artist unknown
c. 1870
Oil on canvas
65.4 x 95.8 cm (25 3/4 x 37 3/4 in.)
Peter Moores Foundation

Cremorne Bridge, on the border between Chelsea and Fulham in London, was completed in 1863 and carried the West London Joint Railway south across the Thames to Clapham. It was a broad-gauge line, as the locomotives in this picture show.

It is just possible that this is one of the topographical pictures painted jointly by Walter and Henry Greaves, the Thames boatmen based at Chelsea Reach. It is

fairly typical of the sort of work they did after they became acquainted with the American painter James McNeill Whistler around 1863. Cremorne pleasure gardens, at the extreme western end of Chelsea, were painted by both Whistler and the Greaves brothers.

The painting was formerly in the collection of Mr. and Mrs. Andras Kalman.

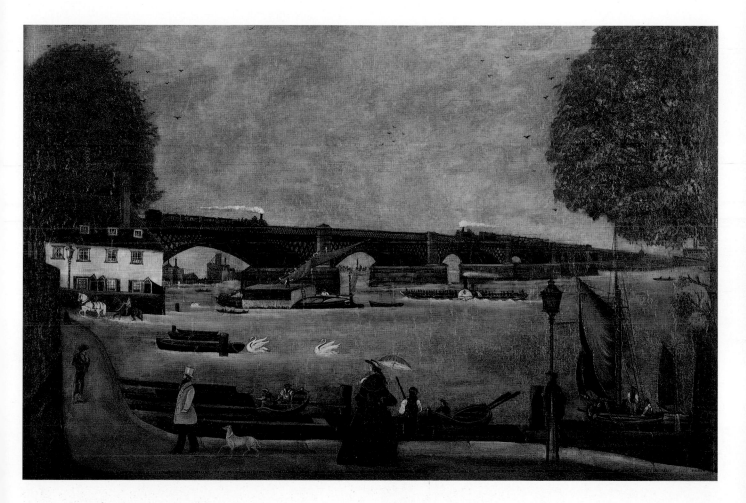

Butcher's Shop

Artist unknown
Late 19th century
Carved and painted wood and glass
71.12 x 46.99 x 35.56 cm
 (28 x 18 1/2 x 14 in.)
Judkyn/Pratt Collection

Three-dimensional model butchers' shops such as this are rare, although those in high relief set in a glass-fronted, cross-banded mahogany shadow box are quite common.[1] These may have once met some educational role, designed to be studied rather than played with as toys. The cuts of meat and types of carcasses are shown with some accuracy.

For exhibition purposes, the solid-wood yet removable backboard of this example has been replaced with plexiglass to reveal a room over the shop.

Illustrated: J. Ayres, English Naive Painting *(1981), pl. 30.*

Exhibited: America and British Folk Art, *U.S. Embassy, London, 1976;* The Art of the People, *Cornerhouse Arts Centre, Manchester, 1985–86;* A Common Tradition, *University of Brighton, 1991;* Judkyn/Pratt Collection British Folk Art Collection, *Peter Moores Foundation, 1994–95.*

NOTE
1. *For an example, see sale catalogue of the Little Collection, Sotheby's, New York, January 29, 1994, lot 94.*

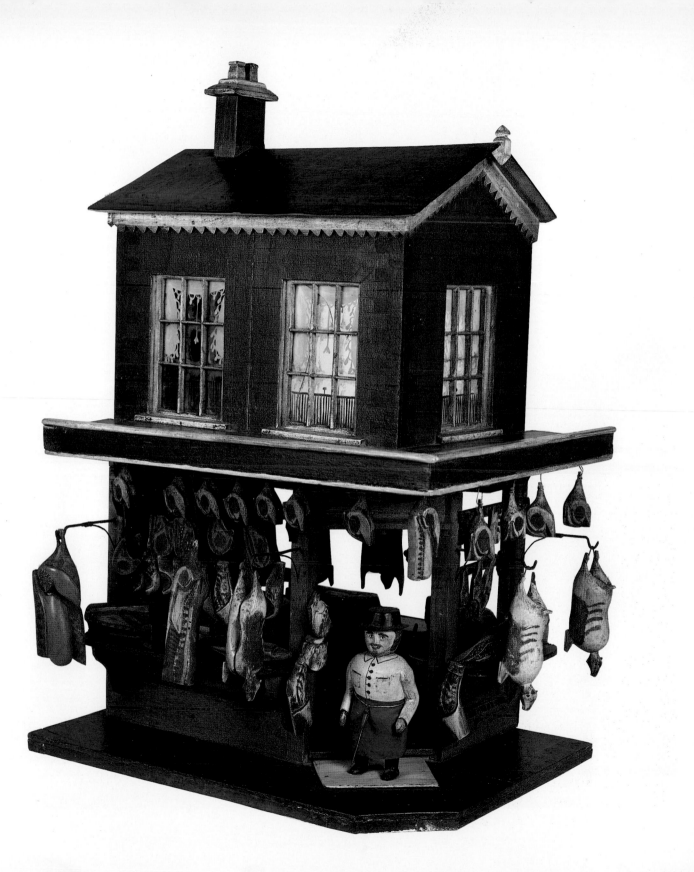

59

Street Scene, Philadelphia,
Co. Durham

R. Young (signed and dated)
1899
Oil on canvas
47.5 x 77.5 cm (19 x 31 in.)
Beamish, The North of England
 Open Air Museum

The view shows two rows of coal miners'
cottages. The stone-built pit houses
probably predate the brick-built row.

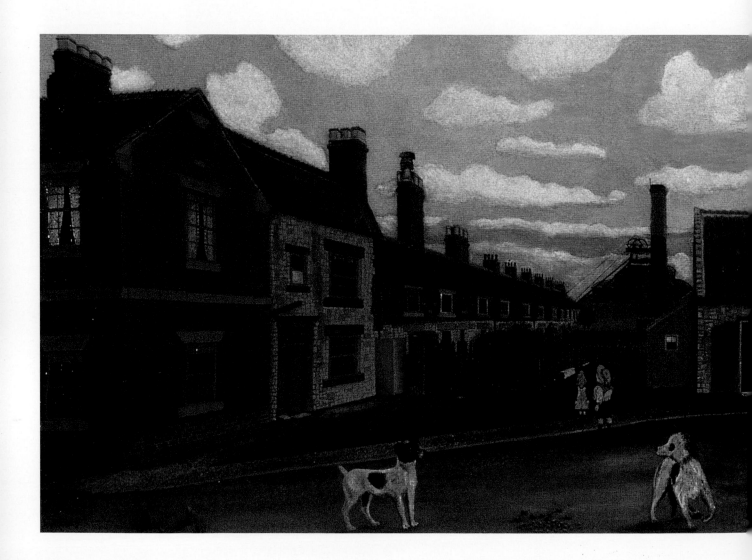

60

Scotsman Whirligig

Artist unknown
Late 19th century
Painted wood
Height 46 cm (18 1/2 in.)
Private Collection

This whirligig was first noted as a greenhouse decoration in around 1900 at Shotley Bridge, County Durham, North of England.

Postman Whirligig

Artist unknown
c. 1900
Carved and painted wood
 and sheet metal
Height 35 cm (14 in.)
Peter Moores Foundation

Although whirligigs were once quite common in England (fig. 27), few of them have survived in the damp climate.

 This whirligig was formerly in the collection of Mr. and Mrs. Andras Kalman.

Fig. 27. *Artist unknown,* Sketts Cottage, *mid 19th century, oil on canvas, Birmingham City Museum and Art Gallery. Note the whirligig on a post in the garden.*

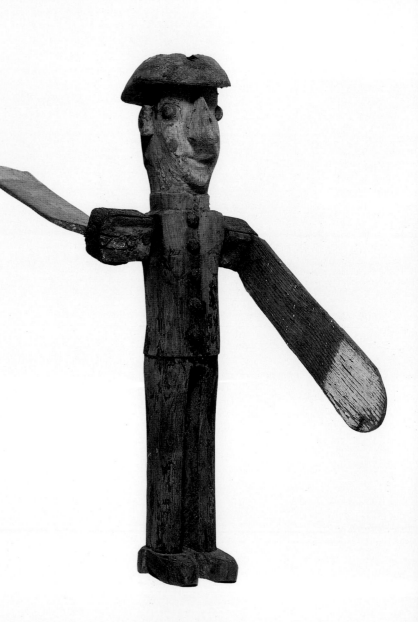

62

Cockerel

Artist unknown
1862 (dated)
Weather vane in sheet copper
74 x 72 cm (29 1/2 x 28 3/4 in.)
Beamish, The North of England
 Open Air Museum

The weather vane carries various inscriptions, including "R. Shaw 1882," "J.C.R. 82," "T.H. May 29 1862," "W. Dobson," and "J. Trenham." It was presumably made by one of these individuals in 1862 and repaired by others on the dates given.

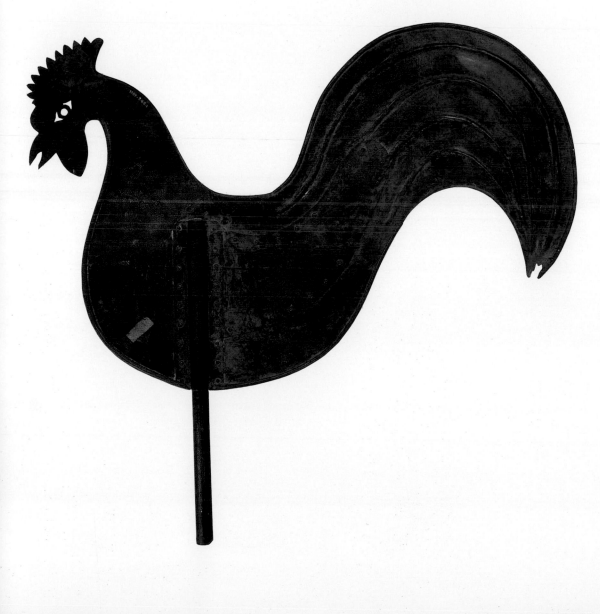

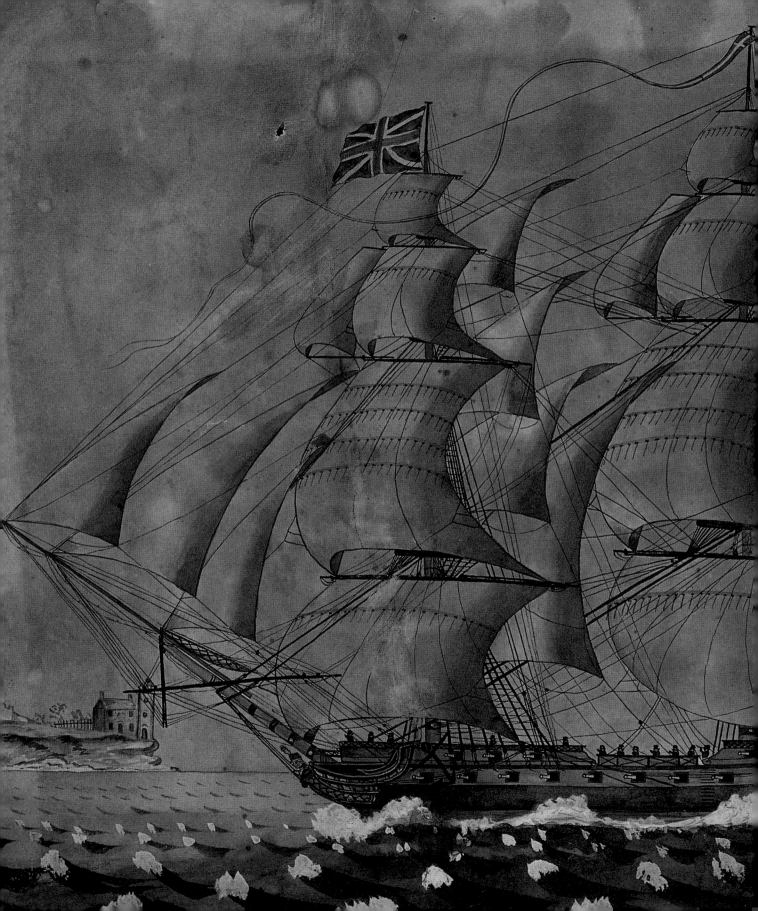

The Mariners

The arts of the seafarer in eighteenth- and nineteenth-century England were, by definition, international. While artisan art may often be universal in its values, the global influences to which the mariners of a great colonial power were subject were peculiar to them. A ship was an ambassador for its home port and it was, therefore, important that it should appear "ship-shape and Bristol fashion." In addition to the maintenance and organization of a vessel, its decoration could further advance that reputation. For ships of the line[1] an ambassadorial role was official, a matter of foreign policy. There can be no doubt that these objectives were widely held by European naval powers. The navy, so Louis XIV's minister Colbert believed, should be able "to carry to foreign shores magnificent testimony to the grandeur of the King of France."[2] Much the same was true of the British Royal Navy. In the seventeenth century and into the first quarter of the eighteenth, British naval vessels consistently carried figureheads in the form of a lion rampant, one of the supporters to the royal coat of arms. After 1726, a much wider choice of emblem was permitted, and these usually represented the name of the vessel they adorned. As a direct result of this policy, the old lion figureheads were retired to find employment as inn signs (fig. 28). Hogarth illustrates one in his engraving *Canvassing for Votes* (plate 2 in the series *The Election*, 1757).

The carving used to embellish vessels of the Royal Navy in the eighteenth and early nineteenth centuries presents a remarkable paradox, a vernacular art in the service of the crown. These were carvings worked with the vigor of the artisan tradition that, with its use of painted and gilded decoration, perpetuated the heraldic conventions of a medieval past. This was an artisan art in the service of the state, an art that made no concessions to the aesthetics of the ruling elite or the artists who customarily worked in their service. Despite its international influences and its official position, there can be no doubt that ship carving, like other artisan arts, was consigned to a secondary status by "polite society." The following observations on shipbuilding and decoration appeared in *The Complete Dictionary of Arts and Sciences* in 1764: "There is no certain rule for laying them [ships] down; this is

left entirely to the fancy and taste of the artist, which, as we have more than once observed, is not often of the most delicate degree, or corrected by truth and judgement; witness the barbarous and unnatural mixture of Gothic and Chinese ornaments "clumsey heroes and fat headed gods" on the same ship, the monstrous issue of a savage conception and wayward genius, as deformed and perverse as their own cant timbers."[3]

Perhaps inevitably, with the arrogance of which only designers are capable, some outsiders presumed to have ventured into this closed shop of boat building and carving, among them the architect William Kent with his designs for a state barge. Even in these circumstances the workshop tradition was so secure that this "designer vessel" retains all the strengths of the vernacular idiom without fully succumbing to the "delicate degree" of the drawing board.[4] Not that the individuals apprenticed in the shipyards were unmindful of aesthetic considerations. A good example of this was William Sutherland. His book *The Ship Builder's Assistant* (1711) begins, in effect, with his curriculum vitae, which demonstrates that his skills went back well beyond the limited horizons of one lifetime: "Tis the product of 32 Years Study and Experience for 'tis well known that I have been so long imploy'd in her Majesty's Service and that of her Royal Predecessors; so that I may say I was in a manner born a Seaman, as most of my ancestors were. My Grandfather was Foreman to the Shipwrights in her Majesty's Yard at Deptford[5] 30 Years, my Uncle Mr Bagwell died Master Builder of her Majesty's Yard at Portsmouth, my Father and several of my Relations were Master Carpenters in the Royal Navy."

Sutherland's book includes an important chapter headed "Of Beauty," the first sentence of which reads: "This Branch teaches to deck or adorn a Ship or Such like Machine, with that symmetry of the Parts, as to render it agreeable to every spectator . . .

but with the Proviso, that the Beautifying may be no Detriment to the other good Properties." Sutherland then goes on to give some indication on "how to beautify her [a ship] with Rules for Shaping the Head and Stern or Galleries. . . . All of which will be necessary to be known and agreed upon, to save the trouble of Alternatives and garnishing Ships divers times, which is very chargeable."

As so often in books of this kind, Sutherland seems to be directing his remarks primarily at potential clients (with warnings about costs) rather than to those in the trade. Even so, he does include a "boasting" drawing for setting out a lion figurehead.

Sutherland's point that the embellishment of ships was expensive was taken up by the Admiralty, which attempted to make economies by restricting extravagant bow and stern decorations. In 1703 and again in 1796 the Admiralty issued directions to this effect. These instructions seem to have been widely ignored, and publications on ship carving such as *A New Book of Ornaments . . . in Carving Ships* (London, 1799) continued to appear. It is evident that the naval dockyards, with or without the imprimatur of the Admiralty, set the pace for ship decoration. In this way the tradition for wood carving on a truly architectural scale was kept alive in English dockyards, for timber had long since ceased to be an important part of the external elevations of buildings in England and wood carving was refined almost to zero in the Neo-classical interiors of the late eighteenth century.

The decline in ship carving, when it came, was a result not of a change of taste but of technical innovation; it was to be displaced by the iron hull of the steam-driven ship. The iron plates of Brunel's *Great Britain* (1845) may have accommodated wood decoration, but wood was no longer an integral part of the structure, and for this reason its future was jeopardized. Nevertheless old habits die hard, and vessels enlivened in this traditional way continued to ply the oceans of the world. Joseph Conrad's *Lord*

Jim (1900) opens with the description of a ship chandler's shop in the Far East "where you can get everything to make her seaworthy and beautiful, from a set of chain-hooks for her cable to a book of gold-leaf for the carvings of her stern."

With the decline in the demand for new work, ship carvers were compelled to find other outlets for their skills. Mercifully for them, steam power, which had removed one source of employment, opened up possibilities in another area, the steam-driven fair. The various rides and stalls created for the fair have been aptly described by David Braithwaite as "fairground baroque."[6] Their burden of ornament was often executed by such former ship carvers as A. E. Anderson of Bristol who in 1865 worked in Commercial Row, Mardyke, and in 1911 was in business at Dock Gate Lane, Hotwells. Consequently many of the values of the ship carvers of old were passed on, via the fairground, to the first decades of the twentieth century.

Another dockland trade is that of painting. Typical of the late eighteenth- and early nineteenth-century craftsmen of this type were Bowen and Fuss of 29 Artichoke Lane, Near Sampson's Gardens, Wapping (just to the east of London on the north bank of the Thames). They advertised themselves as "Painters and Glaziers in General" and added for good measure "N.B. Ships' Likenesses Taken."[7] The connection between ship painting and the painting of ships could be quite close. A significant minority of these craftsmen who began work in the dockyards painting ships' hulls moved on to become easel painters, the pierhead painters[8] as they are known today. The true ship's likeness was akin to a naval architect's drawing but with the presence of some artistic license to permit a rear elevation of the stern to be combined with the figurehead shown in profile. These paintings often display considerable knowledge of naval architecture such as one would expect of seamen or craftsmen reared in the dockyards.

In the *Autobiography of an Artisan*, Christopher

Thomson recalls a seaman-artist, a deserter from the Navy who had twice been "flogged through the fleet" and whose back was lacerated, "all cicatriced and many coloured." The Thomson family gave illicit shelter to this "poor wretch" during the brief period (c. 1810) when they ran the Ship Inn on Trippet Street near the docks in Hull. Thomson continues: "During his stay with us, his favourite amusement was the drawing of ships; in which he used to give me lessons, describing the masts, and the various ropes, and explaining to me their uses; he also prided himself upon a rare colour for the tinting of ship's sails—it was a sailor-like composition—a solution of tobacco water; this with Indian ink, gamboge, and vermilion, constituted his palette for ship painting."[9]

Clearly the function of "the masts and the various ropes" was part of the anatomy of a ship that marine artists were expected to convey with accuracy. Thus many of these painters remained locked within the diagrammatic yet decorative conventions of their trade. Some of these individuals moved on to become fully fledged artists specializing in seascapes. Edward Edwards cites two examples: Charles Brooking (1723?–59) who "had been bred in some department in the dockyard at Deptford, but practiced as a ship painter," and John Cleveley (c. 1711–77) who also began in the same dockyard.[10] In addition to London, other major ports provided the necessary patronage for pierhead painters, including Liverpool[11] and Hull.[12] In Liverpool, Miles and Samuel Walters, father and son, were perhaps the most significant marine artists from the late eighteenth to the late nineteenth centuries. Of these, Miles Walters (1774–1849) was the authentic voice

of the vernacular painter. The son of John Walters, an Ilfracombe shipwright, Miles served his apprenticeship in the shipyard and spent some time at sea before becoming a pierhead painter in Liverpool, where he is known to have been practicing as an artist by 1832, and possibly ten years earlier. Dorothy Brewington's *Dictionary of Marine Artists* quotes his trade label, which advertises his "Real Oil Paintings on Canvas/Neatly finished/Portraits of Ships/Taken by scale, in a seaman-like manner." His technical knowledge of ships and his experience as an artist is further established by the concluding sentence, which states that "the Artist in his Youthful Days worked in a Mould Loft and has been 13 years at Sea and has painted upwards of 200 Ships in the last Six Years and sent them to all corners of the World." The painting of *The Hercules, an American Packet Ship Entering the Mersey,* attributed to Miles Walters, summarizes his style and gives substance to his sales pitch.[13]

At Kingston upon Hull on the east coast, where the Baltic trade was dominant, a significant school of pierhead painters emerged. These men were well qualified to create easel paintings in a "seaman-like manner." Prominent among these was Robert Willoughby (1768–1843) who described himself as a "house, ship and sign painter." In his ship portraits and nautical pieces he arrived at a certain conventionalized sophistication, but his more land-based compositions reveal his hand to be that of the artisan. On at least one occasion the figures in his quayside views are known to have been undertaken by Thomas Brooks (c. 1773–1850), a house and ship carver, gilder, glazier, and picture-frame maker.[14]

As with so many aspects of marine art, the ship's likeness was an international idiom so that by the nineteenth century Danish, Neapolitan, American, and even Chinese artists were producing strikingly similar images. While most of these painters were men who began work in the shipyards, one early nineteenth-century English female artist (Ann R. Cook) is known to have painted ship portraits in a remarkably seaman-like manner.[15]

Ship carving and the painting of ships' likenesses were land-based occupations, although many of the exponents had experience of serving at sea. There were, however, other crafts or arts that were the preserve of sailors. Among these were macrame, an extension of the sailors' ever-present need to tie secure knots, and wool-work pictures, which involved skills similar to those of sewing canvas in the repair of sails and the maintenance of clothes. Most of these embroideries date from the second half of the nineteenth century, with the majority illustrating vessels of the Royal Navy. This suggests that they were not generally made by merchant seamen. The occasional soldier's wool-work picture may have been made under the tutelage of an R.N. seaman on the long voyage out to India.[16] The few known examples of wool-works that show American vessels were probably made by English seamen such as George H. Russell, who was born in 1844 but settled, later in life, in the village of Sacketts Harbour on Lake Ontario.[17]

While American sailors do not seem to have taken up embroidery, scrimshaw, the engraving or making of household objects from marine ivory, was common to whalers on both sides of the North Atlantic. In recent years Janet West has shown[18] that an important outpost of the British school was located in Australia. The narwhal tusk, as the supposed horn of the unicorn, possessed mythic powers since early medieval times and was, for this reason, often given the added luster of carved relief work. In contrast, scrimshaw was more domestic in intent, its period of greatest popularity and importance being from the late eighteenth to the mid nineteenth centuries. Christopher Thomson, who served on the Hull whaling ship *Duncombe* in 1820, recalled that he was "often employed in what the sailors dignified by the title of 'bone carving,' which art consisted in cutting on the bone, with a penknife

divers cyphers of the initials of their sweethearts, with borders of diamonds, squares and vandykes, or 'tooth ornaments'; the interstices were filled up with chalk and oil, which brought out the pattern; as in addition to the given round of ornaments, I could add panels of whales, ships, birds, and the Prince of Wales' feathers—the latter was a stock ornament at that the period; besides, if it had not been so, what tar [sailor], in 1820, could be so disloyal as to forget the Prince Regent, afterwards George IV, of 'pious memory'? For these ornate decorations I received sundry mess-pots of grog."[19]

The use of chalk to fill and emphasize the engraved line indicates that Thomson employed dark brown baleen rather than white marine ivory, for which lamp black was the most common in-fill. "Vandykes" is an allusion to the lace collar with its zig-zag border so typical of the Flemish artist's portraits. Thomson's comments on the Prince Regent of "pious memory" indicates a nice sense of irony.

Important though Herman Melville's well-known description of "scrimshandering work" in *Moby Dick* (1851) may be, Thomson, as a seaman who had actually been engaged in this craft, provides some significant insights. He makes no claim for scrimshaw as art ("dignified" by the term "bone carving"), but emphasizes its potential as a means of earning payment in alcoholic beverage, probably rum. As with so many forms of vernacular art, these low aspirations inspired high levels of achievement.

NOTES

1. *Before steam navigation, a ship of the line was a man-of-war large enough to take its place in a line of battle.*
2. *Edwin O. Christiensen,* Early American Woodcarving *(1952; reprint, New York: Dover, 1972), 18.*
3. *Rev. Temple Henry Croker and other editors,* The Complete Dictionary of Arts and Sciences *(London, 1764), see Naval Architecture.*
4. *State Barge designed by William Kent in 1732 for Frederick, Prince of Wales, and preserved in the National Maritime Museum Greenwich.*
5. *It is tempting to speculate that Sutherland or his grandfather may have known the great carver Grinling Gibbons, whom the diarist John Evelyn (1620–1706) claimed to have discovered at Deptford.*
6. *David Braithwaite,* Fairground Architecture *(London: Hugh Evelyn, 1968).*
7. *Ambrose Heal Collection of Trade Labels, 90.15, Department of Prints and Drawings, British Museum, London.*
8. *Roger Finch,* The Pierhead Painters: Naive Ship Portrait Painters, 1750–1950 *(London: Barrie and Jenkins, 1983), a worldwide survey of those who painted ships and shipping.*
9. *Christopher Thomson,* The Autobiography of an Artisan *(London, 1847), 48–49.*
10. *Edward Edwards,* Anecdotes of Painters *(London, 1808).*
11. *A. S. Davidson,* Marine Art and Liverpool: Painters Places and Flag Codes 1760–1960 *(Wolverhampton: Waine Research Publications, 1986).*
12. *Arthur G. Credland,* Marine Painting in Hull Through Three Centuries *(Hull: Hull City Museums/Hutton Press, 1993).*
13. *Peabody Museum, Salem, Massachusetts.*
14. *Credland,* Marine Painting in Hull, *37.*
15. *A signed example of Ann R. Cook's work,* A Barque Off Fowey, Cornwall, *oil on canvas, 39 x 48 in., was exhibited at The Rutland Gallery, London, in November—December 1965.*
16. *See James Ayres,* English Naive Painting 1750—1900 *(London and New York: Thames and Hudson, 1980), plate 143, A Present from India" by" J. Wackett 4th Battalion Rifle Brigade, in which the technique may be that of a British sailor, although the design seems to derive from Tantra art of the Indian subcontinent.*
17. *Jonathan Fairbanks, "The Yarns of a Sailor in Yarn,"* The Magazine Antiques *(Sept. 1929).*
18. *Janet West, "Scrimshaw in Australia with special reference to the 19th Century Part I,"* The Great Circle *Part I, 8:82–95; in the same journal 9:26–39, "Scrimshaw in Australia . . . Part II."*
19. *Christopher Thomson,* The Autobiography of an Artisan *(London, 1847), 152. For Thomson and his generation, "Greenlander" seems to have been a synonym for a whaling ship. He attributes the start of this "fishery" in Hull in around 1766 to "the active and enterprising spirit of Mr. Standidge" who first invested in a ship for this purpose, 117–18. Thomson cites the development of town gas as the reason for the decline in whaling: "gas houses could generate brilliant illuminations" (end of Chapter 5).*

HMS Hector

Artist unknown
Dated 1743
Oil on canvas
77.5 x 125 cm (31 x 50 in.)
Hull Museums, Art Galleries and Archives

This is one of the earliest pictures from the Hull School of pierhead painters. The painting shows the ship almost as a dockyard half-hull model, but in reality in its newly launched condition (without masts) and displaying the flags that would mark such a ceremony. These include the Royal Standard (center) and the Admiralty flag of a gold anchor on a red field.

Hugh Blaydes' shipyard was located at Hessle Cliff on the north bank of the Humber from at least the seventeenth century. The yard built at the minimum fifteen vessels for the Royal Navy, the largest being the *Temple* (1758), which carried seventy guns. HMS *Hector* was a fifth rate of forty-four guns.

Illustrated: A. G. Credland, Marine Painting in Hull through Three Centuries *(Hull, 1993), pl. 1.*

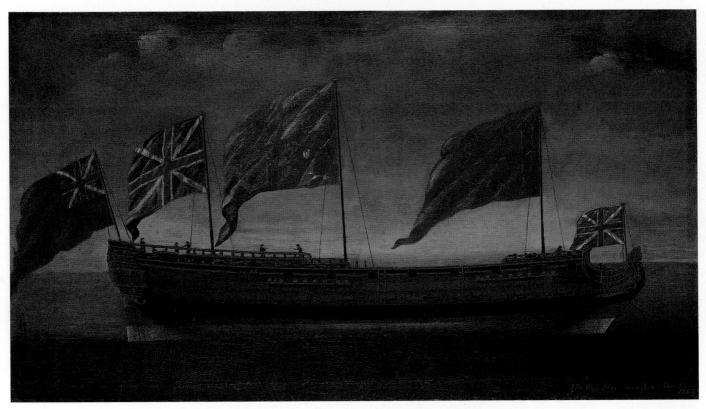

64

A Beam View of His Majesty's Frigate Hussar, *44 Guns, Lost on the Saint Rocks, Feby the 8th 1804*

William Morrison
c. 1804
Watercolor on paper
53 x 63 cm (22 x 27 in.)
The Gall Allan Collection

Morrison seems to be unrecorded elsewhere, but the watercolor may well have been painted by a seaman such as the artist described by Christopher Thomson in *The Autobiography of an Artisan.*

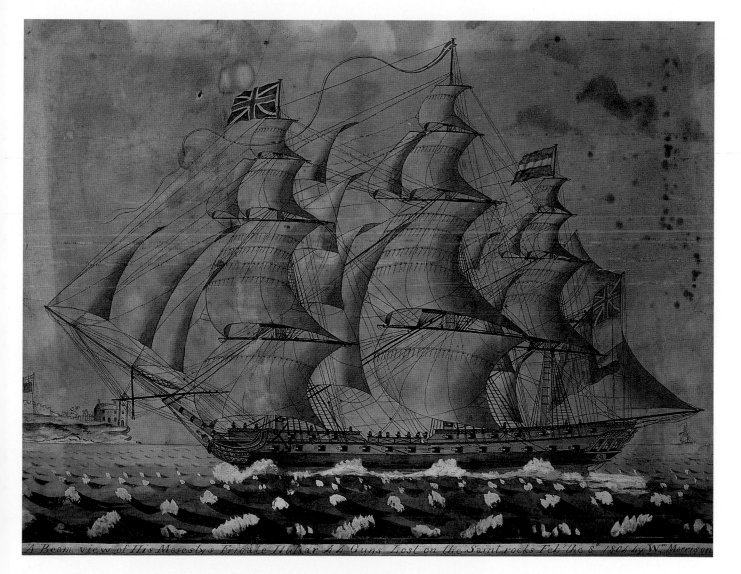

A Patriotic British Seaman

Artist unknown
c. 1810
Scrimshaw engraving on sperm
 whale's tooth
45.31 x 4.38 cm (18 1/8 x 1 3/4 in.)
Hull Museums, Art Galleries and Archives

The name "Cornelia" inscribed on the
sailor's shirt refers to a fifth-rate ship of
thirty-two guns that was built in 1808
and broken up in 1814.

 The drawing is pricked and stippled,
a system of engraving scrimshaw that
may well have derived from pricking a
design through a paper pattern. While
lampblack was most commonly used
to reinforce the effect of the engraving,
colored inks (as here) were also used.

Illustrated: J. West and A. G. Credland,
Scrimshaw: The Art of the Whaler
(1995), 67.

Exhibited: Scrimshaw, *Hull, 1995.*

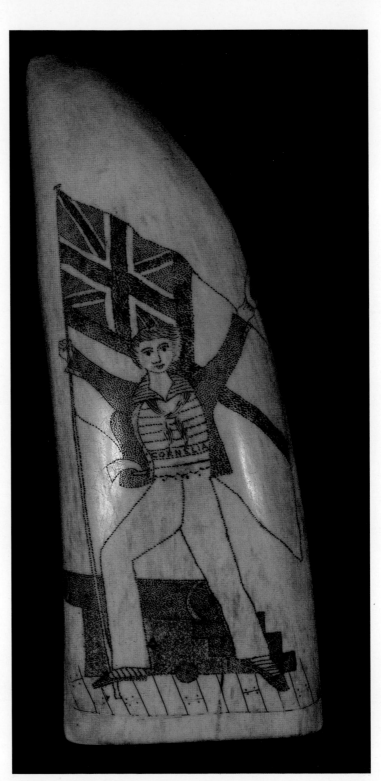

Patriotic British Emblems

Artist unknown
c. 1860
Scrimshaw engraving on walrus tusk
45.31 x 4.38 cm (18 1/8 x 1 3/4 in.)
Hull Museums, Art Galleries and Archives

It is just possible that this walrus tusk with its engraved Prince of Wales feathers and his motto "Ich dien" (I serve) celebrates the marriage of the Prince of Wales, Albert Edward, to Princess Alexandra of Denmark in 1863. Bombing during World War II destroyed the records, but were the provenance known to be Hull, the visit of Queen Victoria to the city is a more likely source of inspiration: note the "VR" (Victoria Regina) and crown, the star and garter of the Order of the Garter, the Union Jack, and a British tar (sailor). The engraving even includes the motto of Emperor Constantine the Great, "In Hoc Signo Vinces" (In this sign I conquer).

Illustrated: J. West and A. G. Credland, Scrimshaw: The Art of the Whaler (1995), 35.

Exhibited: Scrimshaw, Hull, 1995.

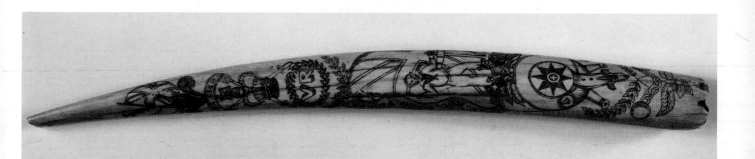

Sperm Whale Hunt and HMS Acorn *Capturing the Spanish Slaver* Gabriel, *July 6, 1841*

Artist unknown
After 1841
Scrimshaw engraving on whale jawbone
15.31 x 30.9 cm (6 1/8 x 12 1/4 in.)
Hull Museums, Art Galleries and Archives

Scrimshaw was an international art. This plaque is related to other unsigned examples in the United States such as those in the Kendall Whaling Museum, Sharon, Massachusetts, and the Nantucket Historical Association.

The capture of the slave ship is shown in an inset at the top left, and some of the boarding party of marines are shown at the top right. From 1792, a number of acts were passed by the British Parliament to encourage the abolition of slavery internationally. In 1806, it became an offense for British merchants to supply slaves to foreign settlements, and this act was further reinforced in 1807 and 1811 when the offense became a felony punishable by transportation to a penal colony. The Royal Navy was charged with patrolling the British dominions to assist with the enforcement of these laws, as shown here.

Illustrated: J. West and A. G. Credland, Scrimshaw: The Art of the Whaler (1995), 40.

Exhibited: The Artist at Sea, *Arts Council of Great Britain Touring Exhibition;* Scrimshaw, *Hull, 1995.*

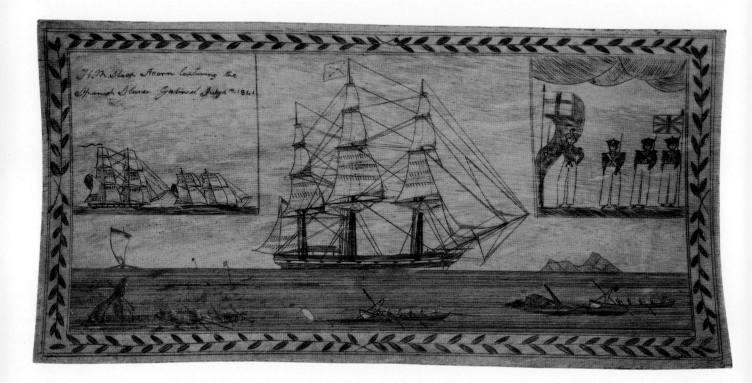

68

The House of William Westerdale

Attributed to Robert Willoughby
 (1768–1843)
c. 1815
Oil on canvas
61.25 x 81.25 cm (24 1/2 x 32 1/2 in.)
Hull Museums, Art Galleries and Archives

Although the attribution to Willoughby is traditional, there is little reason to doubt it on stylistic grounds, and the date is reasonable. His earliest signed canvas is dated 1803, by which time his achievement was such that earlier works by Willoughby must have existed or remain unrecognized. He was one of the most important of the Hull pierhead painters, with a particular interest in portraying whaling vessels. In 1812 he exhibited examples of his glass models in miniature (including a ship), but in general he advertised himself as a house, ship, and sign painter and was thus firmly part of the artisan tradition.

Willoughby's treatment of sailing vessels was accurate and generally convincing. However, his understanding of academic perspective could be uneven, while his handling of the human figure was such that on at least one occasion he employed an artist named Brooks to do figure work. This was most probably the house and ship carver, gilder, glazier, painter, and picture-frame maker Thomas Brooks.

William Westerdale was a mast, block, and pump maker, and his house was one of the first to be built (c. 1815) on Pier Street, Hull. This then-newly reclaimed land was built up from the spoil excavated from the Humber dock, which opened to shipping in 1809. Willoughby was commissioned (presumably by Westerdale) to paint a number of canvases showing Westerdale's yard in Savil Street, Hull.

Note the hand-cranked ferris wheel in the left foreground.

Illustrated: A. G. Credland, Marine Painting in Hull through Three Centuries *(Hull, 1993), pl. 11, p. 166.*

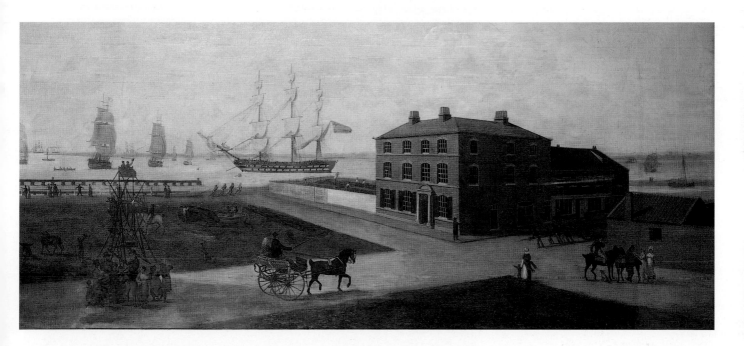

69

Cooper's or Vintner's and Shipwright's Sign

Artist unknown
Early 19th century
Oil on panel
76.5 x 60 cm (30 1/2 x 24 in.)
Museum of London

This is a typical example of the work of a "decorative painter," as craftsmen specializing in this sort of work came to be known. It is possible that this is a vintner's sign, since establishments selling alcoholic beverages seem to have been exempt from the by-laws that were introduced from 1760 to prohibit the use of signs. Note the vessel of the Royal Navy on the stocks prior to launching (see cat. 63) and the Noah's Ark crest (see cat. 70).

Shipwright's Processional Ax

Artist unknown
First quarter 19th century
Carved and painted wood
Length 180 cm (72 in.)
Bristol Museums and Art Gallery

This processional ax was the work of a ship carver. It was used until 1826 by those members of the Worshipful Company of Shipwrights, a craft guild, who were employed by Charles Hill and Sons of Bristol.

The Noah's Ark carved in relief on the ax head was a highly appropriate symbol for shipwrights.

The collections at Bristol City Museum include a further two ceremonial axes of this type, a number of scaled-up caulking irons, and two panoramas that illustrate the progress through the city of such a procession (fig. 29). From these it is evident that many trades were represented, each being identified by its craft tools and by scale models of its stock-in-trade.

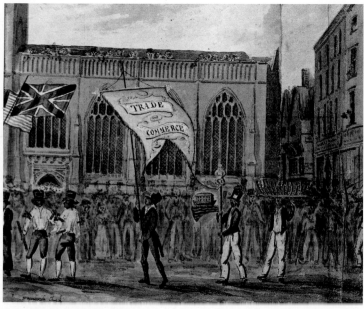

Fig. 29. Henry Smith, The Chairing of Mr. Bright in Bristol (detail), c. 1820, watercolor on paper roller panorama, 12 x 160 in., City of Bristol Museum and Art Gallery. Note the American and British flags (far left) and the shipwright's processional ax identical to the example shown here.

Figurehead from the PS London

Carver unknown
1827
Carved and painted wood
Height 86.36 cm (34 in.)
Hull Museums, Art Galleries and Archives

Most figureheads were given poly-
chrome decoration. The comparatively
modern white paint on this curvaceous
female figure implies a certain Greek-
revival sophistication reminiscent of
the work of the American ship carver
William Rush (1756–1833). It is
known that Rush's figurehead *The
Indian Trader,* on the ship *William Penn,*
excited great admiration in the Pool of
London when the ship was anchored
there; ship carvers made drawings and
took plaster casts of the ship's head.

The paddle steamer *London* was built
for the Hull Steam Packet Co. and in
1828 was chartered by Gee, Loft and
Co. for the Hull to Hamburg route.
After a year she returned to the coastal
waters of the east coast of England,
operating between her home port and
London. Built originally with a net
tonnage of 107 and 107 feet in length,
the *London* was extended to 120 feet in
1842 and scrapped in 1861.

Figurehead from the Sirius

Artist unknown
c. 1837
Carved and painted wood
132.08 x 40.64 x 177.8 cm
 (52 x 16 x 70 in.)
Hull Museums, Art Galleries and Archives

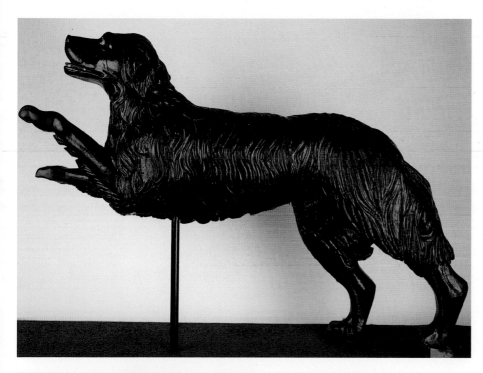

Fig. 30. Arrival of *Sirius* in New York in 1838 *(detail), courtesy of The Mariners' Museum, Newport News, Virginia. Notice the figurehead at the bow of the vessel.*

Although built for the coastal waters of the Irish Sea, the *Sirius* was the first vessel to make the Atlantic crossing entirely under steam. She arrived in New York on April 22, 1838, having left Cork on April 4. The *Great Western,* Brunel's great ship, arrived a few hours later, having left Bristol four days after *Sirius* left Ireland.

Sirius or Dog Star (Canis Major) is the brightest in the night sky. It was associated by the Romans with the hottest part of the year, a notion that survives in the term "dog days." The figurehead, inevitably in the form of a dog, originally held a star in its forepaws.

The figurehead was salvaged in Ballycotton Bay, Ireland, and acquired by Sir Edward Bates (1816–96), the Liverpool shipowner and a director of the Cunard Steamship Company. He subsequently gave it to his father-in-law, Alderman Thomas Thompson (1785–1865), the Hull shipowner, merchant, and sometime mayor. Thompson later presented the figurehead to the Hull Literary and Philosophical Society, whose collections form the core of the municipal museums established in Hull in 1901.

This is the first time that this figurehead has crossed the Atlantic for more than 150 years (see fig.30).

Illustrated: H. P. Smyth, The B and I Line *(1984), 181, and numerous other publications.*

Exhibited: Conquest of the Sea, Hull, 1961.

Figurehead from the Undaunted

Artist unknown
Mid 19th century
Carved and painted wood
Height 121.92 cm (48 in.)
Private Collection

A figurehead in the form of an ordinary
seaman is rare, while an example
carrying the name of the vessel (in the
sailor's hatband) to which it was once
attached is particularly unusual. In
addition, few ships' figureheads retain
so much early (if not original) paint.
This example was found in Devon.

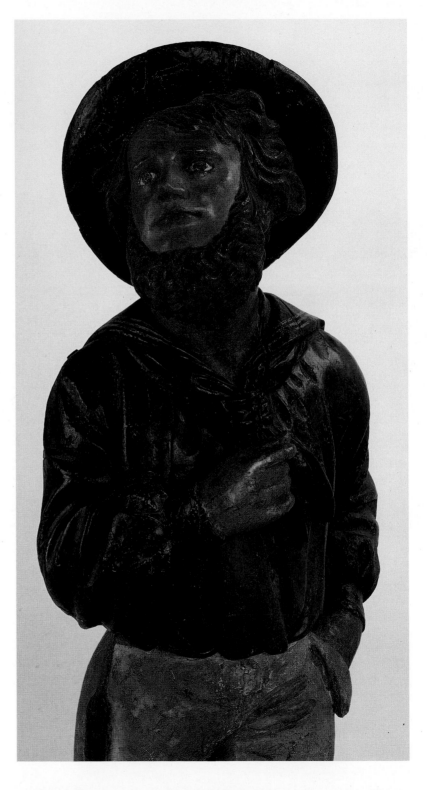

74

The Steam Packet
Royal Charter

Artist unknown
Mid 19th century
Oil on canvas
82.5 x 107.5 (33 x 43 in.)
Hull Museums, Art Galleries and Archives

The name of this vessel is attached to the paddle box. The *Royal Charter* entered service in 1831, providing a ferry service across the river Humber between Kingston upon Hull (on the north bank of the river) and Barton upon Humber to the south. She carried passengers, cargo, and mail, the latter indicated by the postal service ensign with the galloping post boy on the flag. The vessel is shown leaving Barton, with the north bank of the river in the distance and a brig in full sail to the right.

Illustrated: A. G. Credland, Marine Painting in Hull through Three Centuries *(Hull, 1993), pl. 4.*

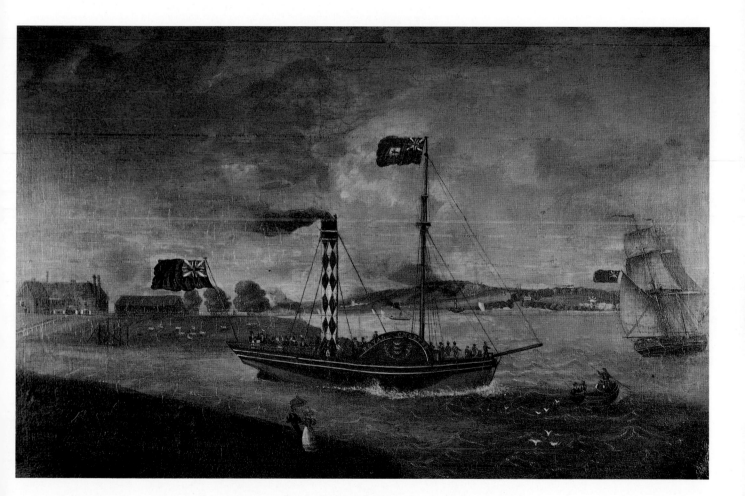

Britannia and a Sailor

Artist unknown
Second half 19th century
Wool-work picture embroidered
 on canvas
55.1 x 74.2 cm (21 1/2 x 29 1/4 in.)
Peter Moores Foundation

The central motifs of this image include a ship and a monument which, being centered by Horatio Nelson's name, presumably represent his flagship *Victory* and his monument in St. Paul's Cathedral in the City of London.

This object was formerly in the collection of Mr. and Mrs. Andras Kalman.

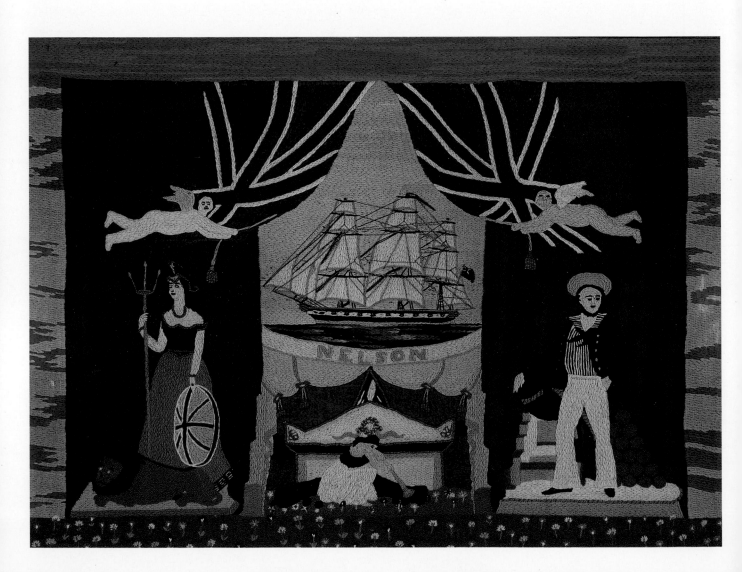

76

Ships by a Coastline

Artist unknown
Third quarter 19th century
Wool-work picture embroidered on
 canvas in contemporary "Oxford" frame
43.18 x 68.58 cm (17 x 27 in.)
The Judkyn/Pratt Collection

Wool-work pictures of ships were generally made by sailors serving in the Royal Navy. In some ways it was an extension of their trade: the maintenance of sails and of their own clothing. This is a particularly unusual example in that it includes no less than five vessels (one is more common) and a shoreline with houses. One of these houses, with a mast flying a white ensign standing in the garden, is presumably the official residence of the commander of the shore establishment. Although the white ensign is now the flag of the Royal Navy as a whole, it was, until 1864, confined to the White Squadron. The "wire" on the garden fence is made of gold braid from an officer's uniform.

Illustrated: J. Ayres, English Naive Painting *(1981), pl. 129;* J. Ayres, British Folk Art *(1977), 79.*

Exhibited: America and British Folk Art, *U.S. Embassy, London, 1976;* The Art of the People, *Cornerhouse Arts Centre, Manchester, 1985–86;* A Common Tradition, *University of Brighton, 1991;* Judkyn/Pratt Collection British Folk Art Collection, *Peter Moores Foundation, 1994–95.*

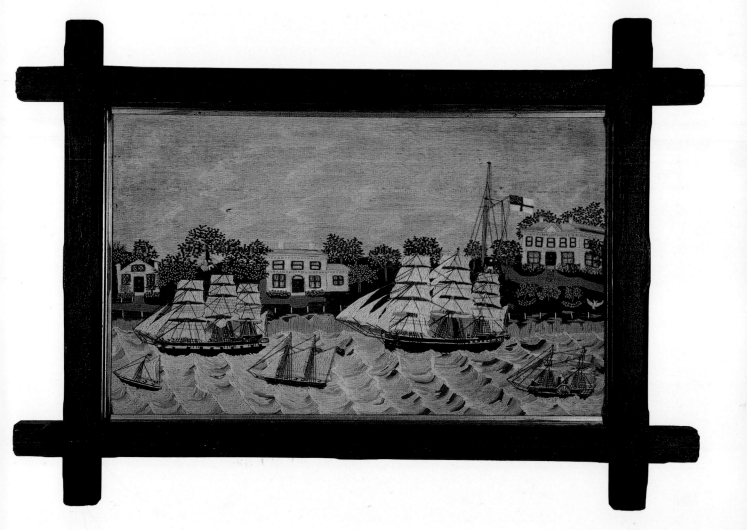

77

Ship Flying the Royal Standard

Artist unknown
c. 1890
Woolwork picture embroidered
 on canvas
49.53 x 60.96 cm (19 1/2 x 24 in.)
The Jane and Grierson Gower Collection

This vessel is "dressed overall" with signal flags, perhaps in celebration of Queen Victoria's birthday, May 24, which was to become Empire Day.

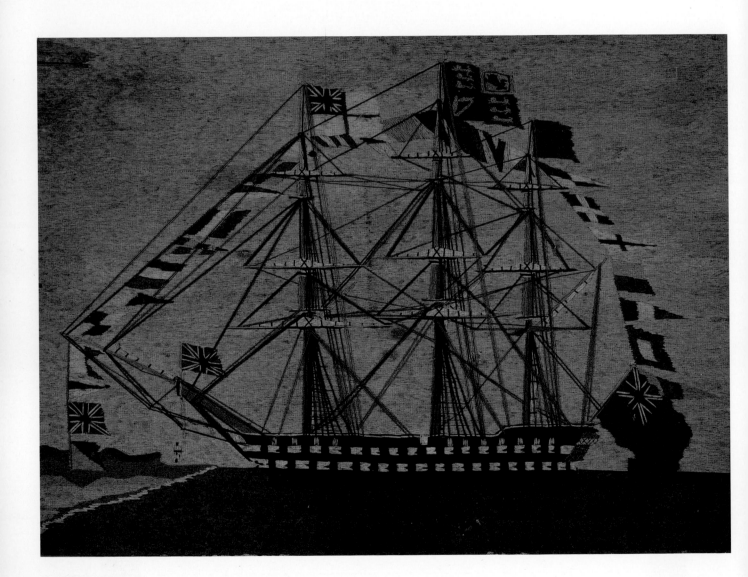

78

Sail/Steam Vessel

Artist unknown
c. 1880
Silk embroidered on canvas
24.13 x 34.29 cm (9 1/2 x 13 1/2 in.)
The Jane and Grierson Gower Collection

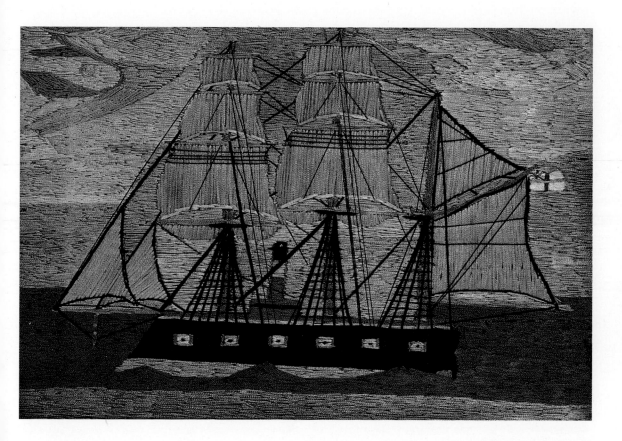

Steam and Sail: Two Warships

Artist unknown
c. 1890
Oil on canvas
53.34 x 86.36 cm (21 x 34 in.)
The Jane and Grierson Gower Collection

The last sailing battleship built for the Royal Navy was HMS *Queen*, which was launched on May 15, 1839 (fig. 31). Representations such as this illustrate the coexistence of the old and the new. There is an illegible copperplate script along the top of this canvas.

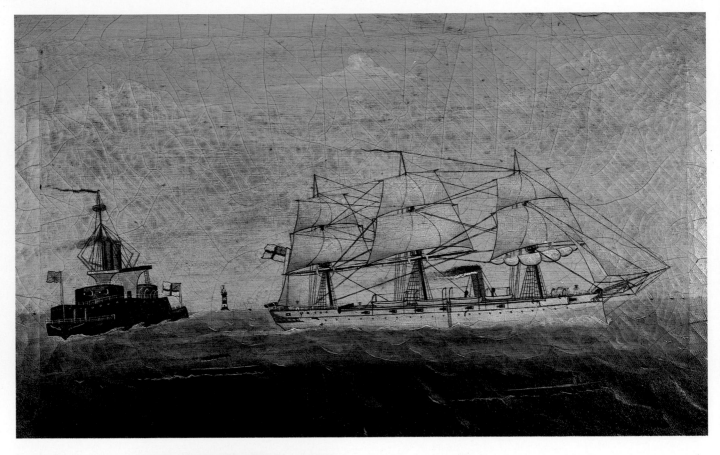

Fig. 31. HMS Queen, Malta, May 24, 1851, seaman's wool-work picture, The Judkyn/Pratt Collection. HMS Queen was launched March 15, 1839. The date embroidered on the picture was Queen Victoria's birthday.

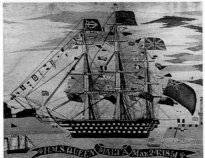

80
Anonyma *Flying the Red Ensign*

Artist unknown
c. 1880
Oil on paper
21.59 x 38.1 cm (8 1/2 x 15 in.)
The Jane and Grierson Gower Collection

The red ensign, familiarly known as the "Red Duster," includes the Union Jack in a canton. Until 1864 this flag was flown by the Red Squadron of the British Navy, but it is now flown by British merchant ships.

Note the remains of an inscription along the top of this painting.

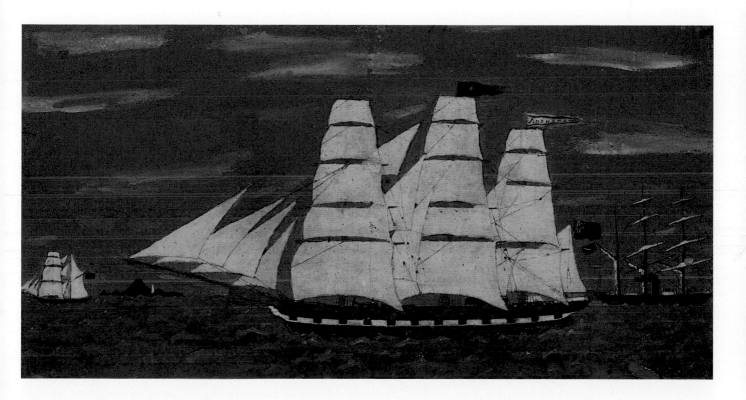

Reeving Block in the Form of a Fish

Artist unknown
19th century
Carved ash
Length 45.72 cm (18 in.)
The Birmingham Museums and
 Art Gallery

Reeving blocks such as dead-eyes were used to lengthen a rope on a sailing vessel. By passing the ends of two ropes through the various holes in this device it was possible to unite two lines. This example has a hole running through its mouth and eight holes across its body.

82

Sailmakers' Liner

Maker unknown
c. 1700–1800
Lignum vitae
12.7 x 4.25 x 4.25 cm
 (5 x 1 5/8 x 1 5/8 in.)
The Birmingham Museums and
 Art Gallery

83

Sailmakers' Liner

Maker unknown
c. 1700–1800
Wood
15.88 x 4.5 x 1.9 cm
 (6 1/4 x 1 3/4 x 13/16 in.)
The Birmingham Museums and
 Art Gallery

84

Sailmakers' Liner

Maker unknown
1774 (dated)
Walrus ivory
10 x 4.4 x 2.6 cm
 (4 x 1 3/4 x 1 in.)
The Birmingham Museums and
 Art Gallery

 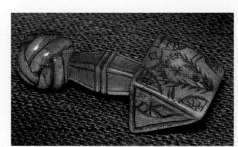

These sailmakers' tools were also known as markers, presses, rubbers, and smoothers. They were used for smoothing the seams in canvas. The walrus ivory example includes reference to that other craft of the seaman, the tying of knots, the liner being terminated by a carved Turk's-head knot.[1]

NOTE
1. Edward H. Pinto, Treen (London: G. Bell and
 Sons, 1969), 269, fig. 288.

Whitby Harbour

R. Dudley
c. 1890
Oil on canvas
72 x 103 cm (30 x 36 in.)
The Gall Allan Collection

Dudley seems to have been a native of the northeast of England. This painting and two others in the same collection (*Walking in Derbyshire* and the *Headland Whitby*) were acquired in South Shields near Newcastle upon Tyne.

Both coal boats and fishing boats are shown in the harbor.

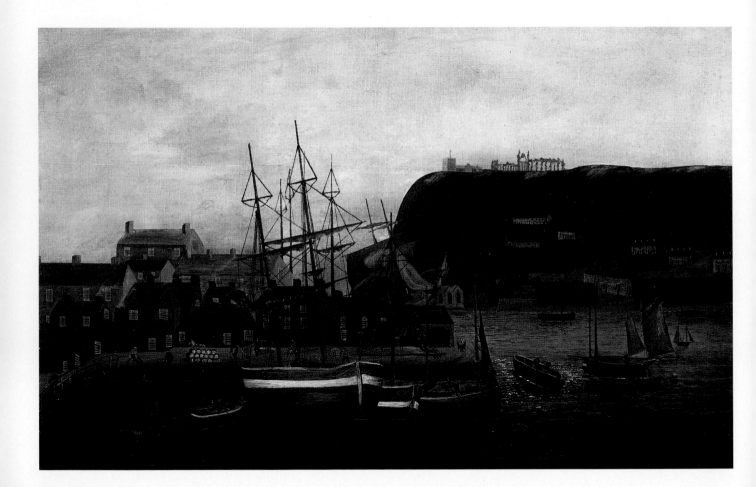

86

The Creel of Fish

Artist unknown
c. 1840
Oil on canvas
58.42 x 71.12 cm (23 x 28 in.)
Malcolm Frazer Antiques, Manchester

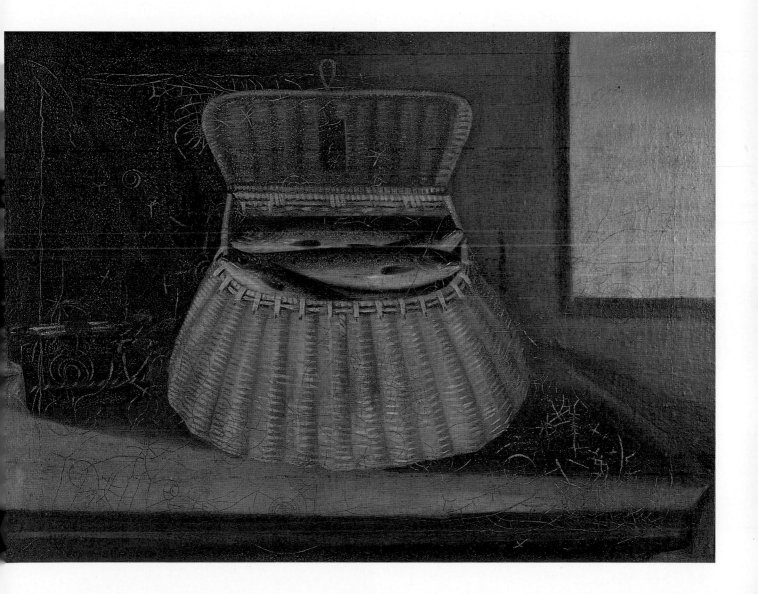

87

The Barque Casma

Artist unknown
Last quarter 19th century
Oil on canvas
58.42 x 86.36 cm (23 x 34 in.)
Private Collection

The *Casma* was a three-masted iron-built
barque of 649 tons. The vessel was built
by W. H. Potter & Co. of Liverpool in
1869.

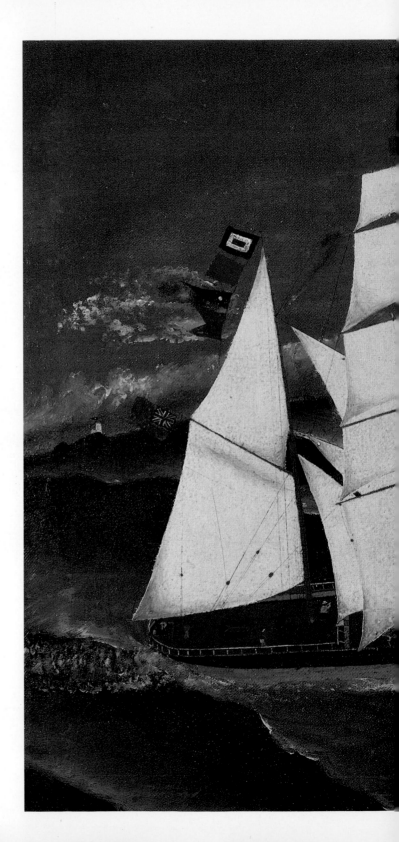

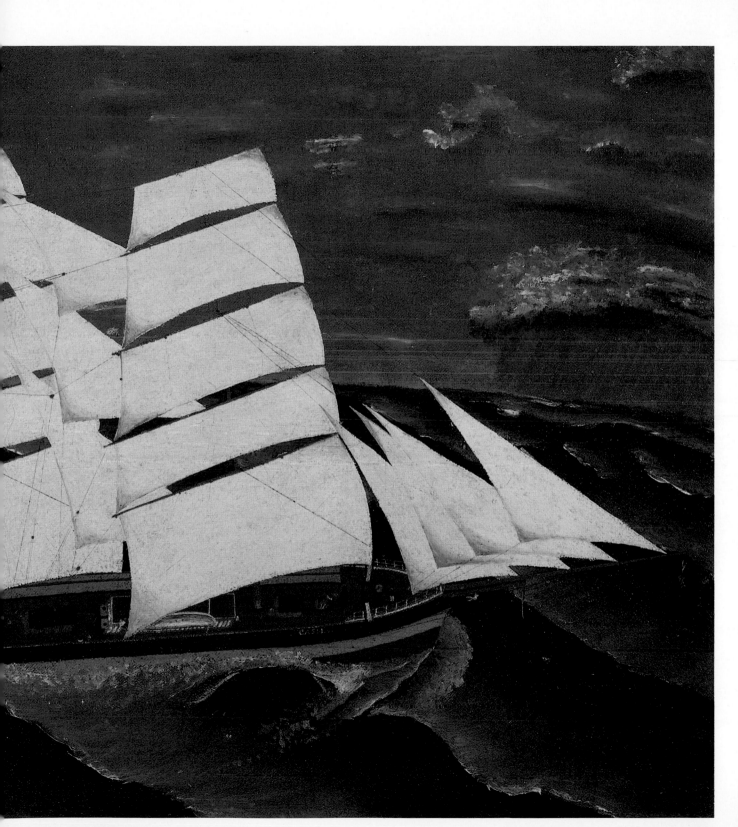

The Travelers

If the vernacular arts are in part defined by their regional nature, the arts of the travelers were somewhat anomalous in that, like those of the mariners, they drew on national and international influences. The full evolution of the arts of itinerant people in England was dependent upon improved transport systems. These were developments of the eighteenth century, but it was the age of steam that was to revolutionize transport and travel. The vernacular arts of the travelers were to blossom within the framework of this aspect of the industrial revolution. Among the travelers, a series of communities were established that became defined, not by their geographical location, but by their way of life. Industrial- ization did not destroy the artisan arts. Responsibility for that may more probably be attributed to the growth of literacy and the consequent decline of the oral traditions.[1]

The Roads

In the eighteenth century, roads were to become essential to the extremes of society. Accordingly it was the "carriage folk" who were to become the patrons of carriage painting, a vernacular art in the service of the elite. Ethnic minorities, such as Romanies or Gypsies, and others who formed segments within the predominant population, for example tinkers and diddicoys (non-Gypsy itinerants), would order vehicles reflecting their cultural values and needs from nonitinerant craftsmen.

In the years before the various turnpike trusts were established, long-distance wheeled transport was slow and cumbersome. For this reason many travelers, including Romanies and diddicoys, were confined to simply walking or using pack horses. Consequently their possessions were few and, as with most migratory people, their potential for developing a material, visual culture was severely circumscribed. Even in these circumstances the peddler's staff could become a sculptural object (cat. 88), so powerful is the human desire for visual embellishment. The traveling fair, as portrayed in Hogarth's *Southwark Fair* (1733), brought color and life to towns by means of highly portable painted cloths. In general, though, it was Mr. McAdam (1756–1836) and his roads[2] that made possible the construction and use of Romany wagons. Similarly, the traveling circus was a creature of this self-same efficient network of roads. As a result it became possible for great timber edifices, replete with rich embellishment, to roll across the face of Victorian and Edwardian England.

Eighteenth-century paintings and prints of Gypsy encampments show them to have comprised shelters made of a few twigs bent over and covered with canvas to form shelters akin to wigwams.[3] Significantly, William Howitt makes no reference to "living vans" in his chapter on Gypsies in his *Rural Life of England* (1844)[4] although Dickens, in *The Old Curiosity Shop* (1840), does describe such a vehicle. This van belonged to Mrs. Jarley, who ran a traveling wax-work show: "It was not a shabby, dingy, dusty cart, but a smart little house upon wheels, with white dimity curtains festooning the windows, and window shutters of green picked-out with panels of staring red, in which happily-constructed colours the concern shone brilliantly.

"Neither was it a poor caravan drawn by a single donkey or emaciated horse, for a pair of horses in pretty good condition were released from the shafts and grazing on the grouzy grass. Neither was it a Gypsy caravan, for at the open door (graced with a bright brass knocker) sat a Christian lady, stout and comfortable to look upon, who wore a large bonnet trembling with bows. And that it was not an unprovided or destitute caravan was clear from this lady's occupation, which was the very pleasant and refreshing one of taking tea . . . the steps being struck by George, and stowed under the carriage, away they went.

"When they had travelled slowly forward for some short distance, Nell ventured to steal a look around the caravan and observe it more closely. One half of it—the moiety in which the comfortable proprietress was then seated—was carpeted, and so partitioned off at the farther end as to accommodate a sleeping-place, constructed after the fashion of a berth on board ship, which was shaded, like the little windows, with fair white curtains, and looked comfortable enough, though by what kind of gymnastic exercise the lady of the caravan ever contrived to get into it, was an unfathomable mystery. The other half served for a kitchen, and was filled-up with a stove whose small chimney passed through the roof. It held also a closet or larder, several chests, a great pitcher of water, and a few cooking utensils and articles of crockery."[5]

From this description of a showman's van it is

evident that the chief features of such vehicles were in place by the late 1830s when Dickens was writing these lines. By the later part of the century, several distinctive wagons had evolved, including the Burton, Reading, Ledge, Bow-top, and Open-lot.[6] These were made for Romany clients by Gorgio (non-Romany or Gypsy) wheelwrights and wagon builders. The chief feature of these vehicles was the ribbed construction of the body, which provided an external skeleton to sustain the matchboard walls. These ribs were elaborately chamfered to reduce weight to a minimum while retaining the maximum bulk of the scantlings at all joints. The faceted surfaces that resulted provided clear-cut zones that were painted in contrasting colors. All of this resulted in an object of great visual appeal that was nevertheless rooted in the practicalities of construction and weather-proofing.

Although Romany wagons were constructed by Gorgio craftsmen, maintenance and redecoration was often carried out by the owners. For example, in the years prior to the First World War, a gypsy named Thelmy Marshall made a pair of "side screens" (presumably porch brackets). On being asked if their pierced designs represented trees or foliage, Marshall responded, "No, just plain nothing, only sweet suent curves."[7]

In contrast to the lightweight horse-drawn Romany wagon, the showman's car and his fairground rides offered the greatest scope for wood-carvers. By the end of the nineteenth century a number of firms came to dominate this field, among them Fenwick of Newcastle-upon-Tyne, William Keating of Wythenshaw, R. J. Woodfin of Tewkesbury, and the great Orion Sons and Spooner of Burton-on-Trent. One company was to become preeminent in the decades around 1900, Frederick Savage and Co., Ltd., of King's Lynn, Norfolk. Indeed Savage himself, as the proprietor of such an important company, became a pillar of Victorian

King's Lynn, and the town is still commanded by a frock-coated bronze portrait of this gentleman, the very figure of bourgeois success. Much of that success was dependent upon the wood-carvers and decorative painters and gilders who created these animated objects, these literally moving rides. Although the basic designing was done in the King's Lynn drawing offices, the templates or "boasting drawings" generated there were sent by Savage's to their North London workshops (26 Cross Street, Islington). It was there that the carving was carried out, mainly by immigrant Italian craftsmen, which explains the alien and florid nature of so much of this work. Even so, Savage's master carver in the first decades of the twentieth century was an Englishman named Arthur Bailey. The painting and decorating of this firm's soft-wood carvings was carried out by the subcontractors "W. Sconce & Sons, Scenic Artists, Lynn," whose chief painter was Charles Mumford with the specialist oil gilding being executed by R. and B. Frost (father and son).[8]

The Canals

Water transport, where it was naturally available, was the most efficient, convenient, and cheap method of conveying people and goods. In the first half of the eighteenth century (and earlier), a number of rivers, which were previously impassable, were made navigable. Once this was achieved, attention turned to the construction of canals, especially in the last decades of the eighteenth century and the first quarter of the nineteenth. The canals prospered only briefly, for they were soon to be eclipsed by railways.

The type of canal and the boats that plied them were largely determined by the ventures of the Duke of Bridgwater (1736–1803) near Manchester. These industrial developments, including his canal, were masterminded by the millwright-turned-engineer James Brindley. In 1790, the Irish bricklayer-

architect James Cavanagh Murphy visited Bridgwater's canal and described its "long Narrow boats."[9] A dozen years later another visitor, the Swede Eric Svedenstierna, noted that these twenty-ton barges were constructed of timber or of "iron plates."[10] Although these iron vessels were expensive, they were efficient and long-lasting too; above all they established a standard that others would follow.

Although timber-built narrow boats remained the most common, those of iron could most easily be embellished with painted decorations of a kind that was to become thoroughly traditional to both types of vessel. What, though, was the source of this tradition? No one has done more to elucidate this seemingly intractable question than Tony Lewery.[11] He has disposed of at least one long-held theory. In the prosperous early days, a canal boat was crewed by a man and a boy whose permanent home was on dry land. With the decline of the canals, these boats became viable only if crewed by a man and his unpaid wife and children whose home was aboard. It was at this point, so the hypothesis went, that the feminine influence introduced painted decoration and ornamental detail. Lewery has demonstrated that this interpretation may not be sustained by the facts. The decline of the canals, as a consequence of the growing might of the railways, may be dated to the mid nineteenth century, and yet, so Lewery asserts, the whole repertoire of painted canal-boat decoration was arrived at between 1820 and 1845.

Some of the devices painted on narrow boats have a quite straightforward origin, such as the name of the company operating the boat, always in white lettering because of canal by-laws. The use of clubs, hearts, diamonds, and spades as motifs clearly derives from the card games with which the man and boy who crewed the early boats whiled away the hours. Most problematic of all are the familiar roses and castles that are the predominant feature of this work. It is here that reference is sometimes made to the flowers and castles painted on clock dials and other examples of cottage japanning. John Hollingshead (1858) describes the cabin doors of narrow boats displaying "a couple of landscapes, in which there is a lake, a castle, a sailing boat and a range of mountains, painted after the style of the great teaboard school of art."[12] This "great teaboard school of art" was certainly important, and about a quarter of a century before was referred to by J. T. Smith (1766–1833) when reminiscing about "a class of persons" who in his "boyish days would admire a bleeding heart-cherry upon a Pontipool [sic] tea-board, or a Tradescant-strawberry upon a Dutch table."[13] It is this Dutch tradition for painted decoration, widely adopted in England, that may offer the most probable ultimate, if not direct, source for the roses and castles of the narrow boat. Lewery cites the traditional painted decoration found in Hindeloopen in the northeast Netherlands. Certainly the Dutch were deeply involved in constructing the drainage canals of the area known as The Holland in East Anglia. The connection may even have extended to the narrow boats themselves. When Svedenstierna visited the canals of "the recently deceased Duke of Bridgwater," he noted "a passenger boat, drawn by horses in the Dutch fashion."[14]

Canal-boat painting was most often the work of the shipyard painters, but some bargees also developed a skill for this art. And a considerable skill it was, for the art lay in its calligraphic spontaneity. From the mid nineteenth to mid twentieth century, canal boats with their painted decoration were an ever-moving gallery, which blossomed in the countryside and enlivened the dark satanic mills past which they glided.

NOTES

1. *This was certainly the view of the late E. P. Thompson in relationship to his study of "Rough Music." In this context, the Elementary Education Act of 1870 is of great significance, since it offered free education to those who, in the past, were unable to afford such a luxury.*

2. *The engineer John Loudon McAdam (1756–1836) developed his ideas for the construction of roads at an early age, but it was the fortune he made in New York while he lived there, between 1770 and 1783, that enabled him to put those ideas into practice on returning to his native Scotland.*

3. *See, for example, the mezzotint after George Morland's* Benevolent Sportsman, *illustrated in* J. Ayres, British Folk Art *(1977), 49.*

4. *William Howitt,* The Rural Life of England *(London, 1844), 165.*

5. *Charles Dickens,* The Old Curiosity Shop *(London, 1840).*

6. *C. H. Ward-Jackson and Denis E. Harvey,* The English Gypsy Caravan *(1972; Newton Abbot: David and Charles, 1973).*

7. *Edward Harvey, "English Gypsy Caravan Decoration,"* Journal of the Gypsy Lore Society *17, no. 3 (1938).*

8. *James Ayres,* British Folk Art *(London: Barrie and Jenkins, 1977), 61.*

9. *Reference to "Narrow boats," manuscript journal of J. C. Murphy, Drawings Collection of the Royal Institute of British Architects, London, pp. 12–14.*

10. *Eric T. Svedenstierna,* Tour of Great Britain 1802–3 *(1811); reprint, Newton Abbot: David and Charles, 1973), 84.*

11. *A. J. Lewery,* Narrow Boat Painting *(1974; reprint, Newton Abbot: David and Charles, 1979). His most recent work on the subject is particularly useful: Tony Lewery, "Rose, Castle and Canal: An Introduction to the Folk Art of English Narrow Canal Boats,"* Folklore *(The Folklore Society, London) 106 (1995), 43–56.*

12. *John Hollingshead, "On the Canal,"* Household Words *(1858; reprint, Stoke Bruerne: Waterways Museum, 1973).*

13. *J. T. Smith,* Nollekens and His Times *(1828; reprint, London: Turnstile Press, 1949), 134.*

14. *Svedenstierna,* Tour, *177, also gives reference to English canals "walled vertically with bricks like the Dutch ones," 86.*

88

Peddler's Staff

Artist unknown
1810–1820
Carved and painted blackthorn
 (hawthorn)
Height 170 cm (67 in.)
The Birmingham Museum and Art Gallery

This exceptional staff is a variant on the
peddler's pack stick or packman's staff,
which the peddler used to carry his
bundle of goods and possessions. In this
instance the staff is terminated by a
carved figure. This figure shows a seated
woman wearing a mob cap, taking snuff.
The staff presumably acted as a form of
mobile sign for a snuff peddler.

Lakeland Pack Horse: "The Bell Mare"

Artist unknown, possibly "R. T."
Dated 1757
Oil on canvas
53 x 78 cm (26 x 39 1/4 in.)
Kendal Museum

In the days before there were adequate roads, pack horses provided one of the principal methods of transporting freight. It was therefore appropriate that William Morris should have used the pack horse as a symbol of England's preindustrial past in his poem *The Wanderers:*

Forget six counties overhung with smoke,
Forget the snorting steam and piston stroke,
Forget the spreading of the hideous town,
Think rather of the packhorse on the down,
And dream of London, small and white and
ㆍclean,
The clear Thames bordered by its gardens green.

Pack-horse routes were generally far more direct than roads for wheeled vehicles, since horses could travel "up hill and down dale" with comparative ease. This horse is shown transporting a wool sack and sports tumbler bells and red ribbons.

Bristol City Art Gallery owns a remarkably similar version of this painting. It measures 137.16 x 182.88 cm (54 x 72 in.).

William Buckenham's Linen Cart

Artist unknown
Early 19th century
Oil on canvas
40 x 33.02 cm (15 3/4 x 13 in.)
Norfolk Museums Service,
 Rural Life Museum

William Buckenham was a linen manufacturer at South Lopham, Norfolk. The county, in common with all the counties in East Anglia, is well known for being very flat. The mountains shown in this picture are therefore entirely fanciful.

Illustrated: J. Ayres, English Naive Painting *(1981), pl. 86.*

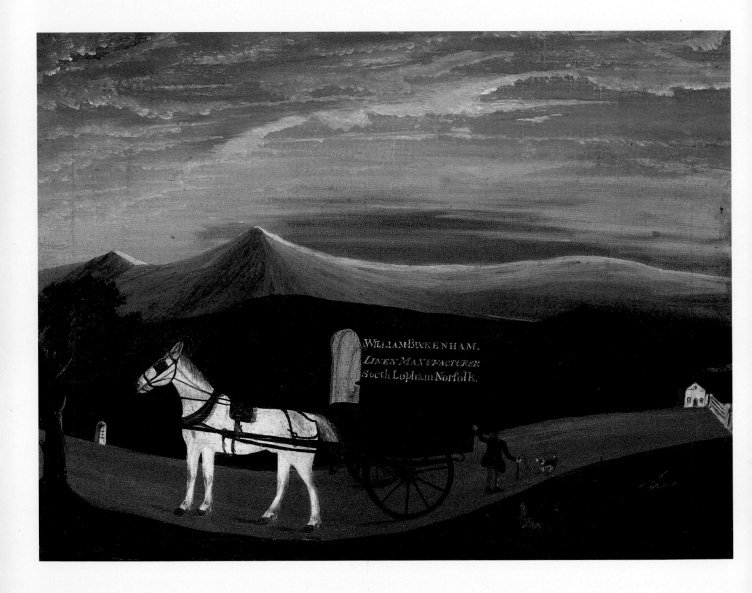

Burgee (Vane) from a Wherry

Artist unknown
Early to mid 19th century
Painted sheet iron
flag 218.44 x 53.34 cm (86 x 21), figure
 114.3 x 58.42 (45 x 23)
Norfolk Museums Service,
 Bridewell Museum

A wherry is a light shallow vessel used in inland waterways and propelled by oars or sail. The pivot of the vane was a device of sheet iron, known as the gate. In its simplest form, the vane took the pattern of a six-pointed star, but was usually more complicated and more decorative. A common device was a serrated circle containing an emblem cut out or painted on it. Vanes with human figures on the opposite side of the gate were very popular. They were generally known as Jenny Morgans after the heroine of a popular song of that name. It has been suggested that this style of vane was first made for the wherry *Jenny Morgan*, built by Petch Brothers of Norwich around 1856. The figure of a Jenny Morgan or Welsh girl was not the only figure used, as female figures of various kinds, and even male figures, made their appearances in later years.[1]

These burgees are reminiscent of the masthead figures found in the United States.[2] This example was found in Horning, Norfolk.

NOTES
1. *See Robert Malster,* Wherries and Waterways *(Lavenham, 1971).*
2. *See Nina Fletcher Little,* Little by Little *(1984), 65.*

The Painting and Decoration of Canal Boat Utensils

Cats. 93 and 94 are in the Braunston style made famous by Frank Nurser in the early to mid twentieth century. Most boat yards had their own painters who had their personal styles. The variation frequently rests in the pattern of brushstrokes that make up the symbolic rose. These styles are also very clear in the castles, a fine example of which appears on the base of a hand bowl in this exhibition (cat. 94). When the hand bowl was hung in the cabin, this castle would have been clearly visible.

Little is known of the painters of the late nineteenth and early twentieth centuries. Their artistry was applied to utensils that were subject to the rigors of life on the canal boat. Once chipped, dented, or damaged, these objects were either repainted or thrown away. The survival of reasonably early examples such as these may be attributed to their finding homes on land, for example to decorate a canal-side pub.[1]

NOTE

1. This information was kindly supplied by Tony Condor of the National Waterways Museum.

Water Jug

Artist unknown
1896
Painted galvanized iron
37 x 42 x 31 cm
 (14 1/2 x 16 1/2 x 12 1/4 in.)
Northampton Museums

While Tony Lewery[1] has argued persuasively that roses and castles painted on canal boats and their plenishings

evolved in the second quarter of the nineteenth century, virtually nothing from that period has survived. This water jug is one of the earliest known dated examples.

NOTE

1. See Tony Lewery, Flowers Afloat (Newton Abbott: David and Charles, 1996).

93

Water Jug

Artist unknown
c. 1910
Painted galvanized iron
Height 52.7, diam. 33 cm (20 3/4, 13 in.)
National Waterways Museum, Gloucester

The near-calligraphic painting of castles and roses was traditional to the boats that plied the inland waterways of England. The tradition persists. The Braunston style, the style of this water jug, is typical of the work found in and on the narrow boats in the south of England. Braunston in Northamptonshire was the location of an important boat yard that fostered this style of painting.

This example is of the standard three-gallon water jug. It was generally to be seen standing on the cabin roof to the left of the steerer and on the far side of the stove chimney. One or two jugs would contain the ready-to-use drinking water supply. This water was poured from the jug to either the hand bowl or straight into a cooking container. When the boat was moving, jugs were attached to the cabin roof by string to prevent their being knocked off by a branch or a low bridge. Boats did not have integral water tanks.

Until the First World War, canals in most areas were clean, and drinking water was dipped straight from the canal. Boatmen knew that in certain places fresh spring water came directly into the canals and would fill their jugs at those points. Later, taps were installed at locks and recognized tying-up points.

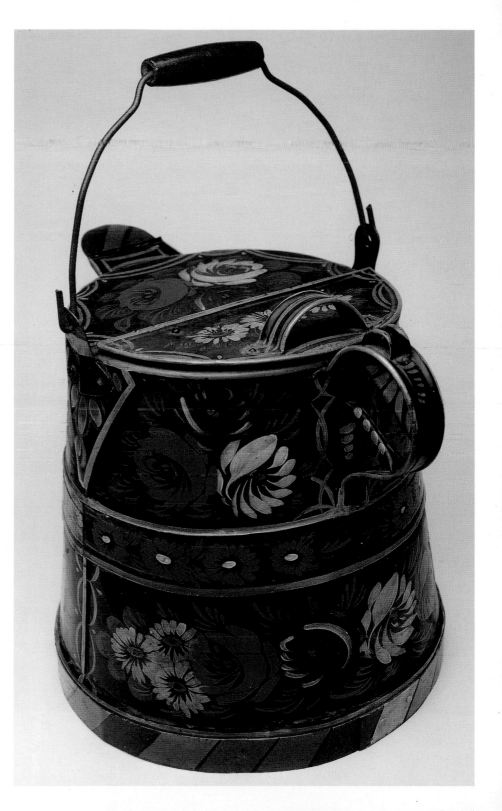

Hand Bowl

Artist unknown
c. 1910
Painted galvanized iron
Height 17.145 (6 3/4), diam. 22.86 (9),
 length 52.07 cm (20 1/2 in.)
National Waterways Museum, Gloucester

The traditional roses and castles were painted on all manner of objects, not least the narrow boat itself. In this case the castle is on the underside of the hand bowl. Earlier examples of this work, as here, represent roses in a more naturalistic and less conventionalized form than later work.

Hand bowls were used to transfer clean water from the water can for cooking purposes. The hand bowl is also designed to sit flat on a cabin top or side, where it might be used for washing the body, washing dishes, or cleaning vegetables. Often misnomered as dippers, hand bowls were much more common on boats than the related dipper. Dippers have rounded bottoms and are used purely as scoops. The hand bowl often hung just inside the cabin to the left of the door close to the stove.

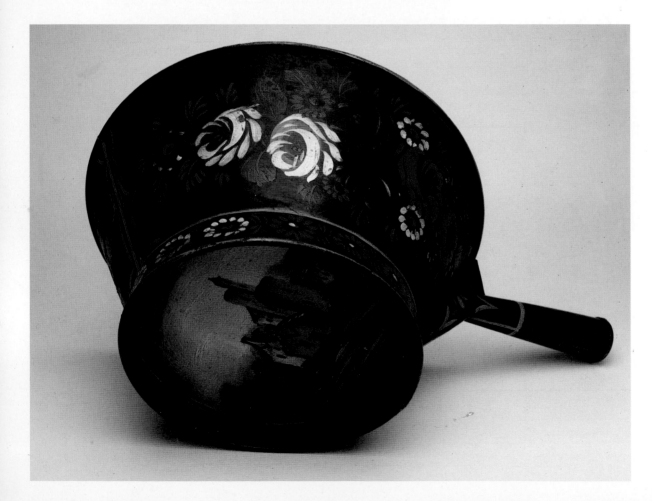

95

Roundabout Horse

John Robert Anderson (c. 1829–1909)
c. 1900
Carved and painted fir and ash
68.58 x 114.3 cm (27 x 45 in.)
The Jane and Grierson Gower Collection

This English roundabout horse reveals the influence of the German *karussell* thoroughbreds. Its small size is typical of the hand-cranked "dobby horses" made for juvenile merry-go-rounds, which comprised a total of some twenty-four horses. This example continued in service, touring fairgrounds in England, until purchased by the present owners in 1960.

John Robert Anderson was the son of John Anderson, a ship carver in Deptford, London, who in 1830 was employed by the Royal Engineers at Chatham to make a model fortress for "the Military Academy in America." In the early 1840s the younger Anderson was apprenticed,

as a ship carver, to his maternal grandfather, Robert Price Williams, in Bristol.

In later life, the decline in the ship carvers' trade compelled J. R. Anderson to turn, more and more, to the carving of "Show Fronts, Roundabout Horses and Animals of all Descriptions &c." At his death in 1909 the business passed to his two sons, John and Arthur, although John Jr. did not long survive his father. Arthur Anderson continued the firm, but with his death in 1936 the making of fairground gallopers died with him.

Illustrated: G. Weedon and R. Ward, Fairground Art *(1994), 34.*

The Fox Hunt

Workshops of C. J. Spooner
c. 1900
Carved and painted wood
45.72 x 139.7 cm (18 x 55 in.)
The Jane and Grierson Gower
 Collection

This carving is part of a rounding board, the cornice or fascia that surmounted a merry-go-round or roundabout, although this example has been flattened. When complete, the frieze represented much of the fox hunt including the fox and hound shown here, additional hounds, and even the huntsmen and their horses. To achieve this, considerable liberties were taken with scale, but these were convincingly obscured within the scrollwork. At each end of this section there are the numerals "5" and "6" to assist assembly.

In 1875, the Lion Carriage Works were established in the Staffordshire brewing town of Burton-on-Trent. At an early stage, the company began working for showmen, as the proprietors of fairground attractions were known.

George Orton, the owner of the company, used a number of carving firms to decorate his products. One was that of Charles John Spooner (1871– 1939), who, after having been apprenticed at the unusually late age of eighteen, established his business in 1892. Five years later Spooner married Orton's daughter. The business connection became very close, although the two firms did not merge until 1925.

In addition to his fairground work, Charles John Spooner also produced rocking horses.[1]

This carving was formerly in the collection of Lady Bangor.

Illustrated: J. Ayres, British Folk Art *(1977),*
60.

NOTE
1. *See G. Weedon and R. Ward,* Fairground Art
 (1994), 24—33.

The British Isles

Perth•

NORTH SEA

SCOTLAND

•Newcastle upon Tyne

•Philadelphia

•Whitby

•Richmond

•York

•Hull
•Wakefield •Barton upon Humber

•Rochdale
Liverpool• •Manchester
IRELAND •Wythenshaw
 Ruthkin• •Chester ENGLAND
Caernarvon• Wrexham•
 Chirk• •Madeley
 •Burton-upon-Trent •King's Lynn
IRISH SEA •Lichfield •Loughborough
 •Norwich
 •Braunston
 •Cambridge
Aberystwyth• WALES Bloxham
 •Tewkesbury •
 •Northleach •Colchester
 Ilfracombe• •Gloucester •Hatfield
 Pontypool• •Oxford
 Bristol• Windsor• •London
 Butcombe• •Bath Reading• •Westminster
Weston-super-Mare• •Twickenham
 Urchfont•
Braunston• Somerton• •Salisbury •Tunbridge Wells
Clovelly• •Britford
 •Arundel •Brighton

ENGLISH CHANNEL

FRANCE

TWO HUNDRED YEARS OF ENGLISH NAIVE ART

Select Bibliography

Ayres, James. *British Folk Art*. London: Barrie and Jenkins, 1977; Woodstock, N.Y.: Overlook Press, 1977.

_____. *English Naive Painting 1750–1900*. London and New York: Thames and Hudson, 1980.

Braithwaite, David. *Fairground Architecture*. London: Hugh Evelyn, 1968.

_____. *Savage of Kings Lynn*. Cambridge, England: Patrick Stephens, 1975.

Brears, Peter. *North Country Folk Art*. Edinburgh: John Donald Publishers, 1989.

Burke, Peter. *Popular Culture in Early Modern Europe*. 1978; revised edition, Cambridge: Scolar Press, University Press, 1994.

Carrington, Noel, and Clarke Hutton. *Popular English Art*. London: King Penguin/Penguin Books, 1945.

Cooper, Emmanuel. *People's Art: Working-Class Art from 1750 to the Present Day*. Edinburgh: Mainstream Publishing, Edinburgh Publishing, 1994.

Credland, Arthur G. *Marine Painting in Hull Through Three Centuries*. Hull: Hull City Museums/Hutton Press, 1993.

Credland, Arthur G., and Janet West. *Scrimshaw: The Art of the Whaler*. Hull: Hull City Museums/Hutton Press, 1995.

Davidson, A. S. *Marine Art and Liverpool Painters, Places and Flag Codes 1760–1960*. Wolverhampton: Waine Research Publications, 1986.

Delderfield, Eric. *Stories of Inns and Their Signs*. Newton Abbot: David and Charles, 1974.

Evans, Hilary, and Mary Evans. *John Kay of Edinburgh, Barber, Miniaturist and Social Commentator 1742–1826*. Edinburgh: Paul Harris Publishing, 1973.

Gill, Margaret. *Professor of Secular Art [George Smart]*. Tunbridge Wells: The Borough Council, n.d. [c. 1980].

Finch, Roger. *The Pierhead Painters, Naive Ship-Portrait Painters 1750–1950*. London: Barrie and Jenkins, 1983.

Fletcher, Geoffrey S. *Popular Art in England*. London: George G. Harrap and Co. Ltd., 1962.

Frere-Cook, Gervis. *The Decorative Arts of the Mariner*. London: Cassell and Co. and Jupiter Books, 1974.

Gorman, John. *Banner Bright: An Illustrated History of the Banners of the British Trade Union Movement*. London: Allen Lane, 1973.

Graham, Clare. *Dummy Board Figures and Chimney Boards*. Aylesbury: Shire Publications, Ltd., 1988.

Hansen, Hans Jurgen, ed. *Art and the Seafarer, A Historical Survey of the Arts and Crafts of Sailors and Shipwrights*. London: Faber and Faber, 1968.

_____. *European Folk Art*. London and New York: Thames and Hudson, 1968.

Hill, Brian. *Inn-Signia*. 2d. ed. London: Whitbread, 1949.

Inn Signs: Their History and Meaning. Brewers Society, London, 1969.

Keay, Ken. *A Narrow Boat Builders Sketch Book*. Warrington: A. J. Lewery, 1993.

Lamb, Cadbury. *Inn Signs*. Aylesbury: Shire Publications Ltd., 1976.

Lamb, Cadbury, and Gordon Wright. *Discovering Inn Signs*. Aylesbury: Shire Publications Ltd., 1968.

Lambert, Margaret, and Enid Marx. *English Popular Art*. London: Batsford, 1951.

_____. *English Popular and Traditional Art*. London: Collins, 1946.

Larwood, Jacob, and John Camden Hotten. *The History of Signboards*. London: Chatto and Windus, 1866.

Lewery, Tony. *Flowers Afloat*. Newton Abbot: David and Charles, 1996.

_____. "Rose, Castle and Canal: An Introduction to the Folk Art of English Narrow Boats." *Folklore* 106 (1995).

_____. *Gold, Silk and Painted Scripture, The Art and Tradition of the Church Banner*. Warrington: Cheshire Libraries, c. 1986.

_____. *Narrow Boat Painting*. Newton Abbot: David and Charles, (1974) 1979.

_____. *Popular Art: Past and Present*. Newton Abbot: David and Charles, 1991.

_____. *Signwritten Art*. Newton Abbot: David and Charles, 1989.

Lord, Peter. *Gwenllian: Essays on Visual Culture*. Llyandysul Dyfed: Gomer Press, Welsh Arts Council, 1994.

_____. *Artisan Painters/Arlunwyr Gwlad*. Aberystwyth: National Library of Wales, 1993.

Melly, George. *A Tribe of One: Great Naive Painters of the British Isles*. London: Rona, 1981.

Mockridge, Patricia, and Philip Mockridge. *Weather-vanes of Great Britain*. London: Robert Hale, 1990.

Mullins, Edwin. *Alfred Wallis: Cornish Primitive Painter*. London: MacDonald, 1967.

Needham, A. *English Weathervanes*. Haywards Heath: Charles Clarke Ltd., 1953.

Norton, Peter. *Ships' Figureheads*. Newton Abbot: David and Charles, 1976.

Pacey, Philip. *Family Art*. Cambridge: Polity Press/Blackwells, 1989.

Stammers, M. K. *Ships' Figureheads*. Aylesbury: Shire Publications, Ltd., 1983.

Turnor, Reginald. *The Spotted Dog: A book of English Inn Signs*. London: Sylvan Press, 1948.

Ward-Jackson, C. H., and Denis E. Harvey. *The English Gypsy Caravan*. Newton Abbot: David and Charles, (1972) 1973.

Weedon, G., and R. Ward. *Fairground Art: The Art Forms of Travelling Fairs, Carousels and Carnival Midways*. New York: Abbeville Press, 1981; London: Whitemouse Editions, 1985.

EXHIBITION CATALOGUES

Alfred Wallis. London: Arts Council, 1968.

Ayres, James. *The Art of the People in Britain and America 1750–1950*. Manchester, Cornerhouse Arts Centre, 1985.

Ayres, James, and Ian McCallum. *American and British Folk Art*. London: Embassy of the United States, 1976.

Bibby, Christopher. *The Age of the Journeyman in English Painting and Pottery*. London: Rutland Gallery, 1969.

Bibby, Christopher. *English Primitives*. London: Rutland Gallery, 1983.

Credland, Arthur G. *John Ward of Hull, Marine Painter, 1798–1849*. Hull: Ferens Art Gallery, 1981.

Durr, A., and Helen Martin. *A Common Tradition: Folk Art in Britain and America*. Brighton: Brighton University 1991.

English Naive Paintings from the Collection of Mr. and Mrs. Andras Kalman, an International Touring Exhibition. London: Kalman, 19—.

Fox, Celina. *London Trade Signs*. London: Cadogan Gallery, 1985.

Green, Lynne. *The British Folk Art Collection. The Peter Moores Foundation ex Kalman Collection*. London: P. M. F., 1993.

Iona Antiques Catalogues. London: Iona Antiques, published annually since 19—.

Lambert, Margaret, and Enid Marx: *English Popular Art*. Reading: University of Reading, Museum of English Rural Life, 1958.

Roberts, Antonia. *Enter Tim Bobbin . . .* Rochdale: Rochdale Art Gallery, 1980.

Spargo, Demelza, editor. *This Land Is Our Land*. London: Royal Agricultural Society, Mall Galleries, 1988.

Starsmore, Ian. *The Fairground*. London Whitechapel Art Gallery, 1977.

PROFESSIONAL/CURATORIAL

British Ethnography Committee of RAI: *Suggestions Concerning Classification, Storage, and Labelling of Objects Illustrating English Life and Traditions*. London: Royal Anthropological Society, 1950.

Higgs, J. W. Y. *Folk Life: Collection and Classification*. London: The Museums Association, 1963.